SHOTS
IN THE DARK

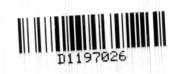

SHOTS
IN THE DARK

TRUE CRIME
PICTURES

GAIL BUCKLAND

COMMENTARY BY

HAROLD EVANS

BASED ON THE COURT TV DOCUMENTARY

A BULFINCH PRESS BOOK

LITTLE, BROWN AND COMPANY

BOSTON • NEW YORK • LONDON

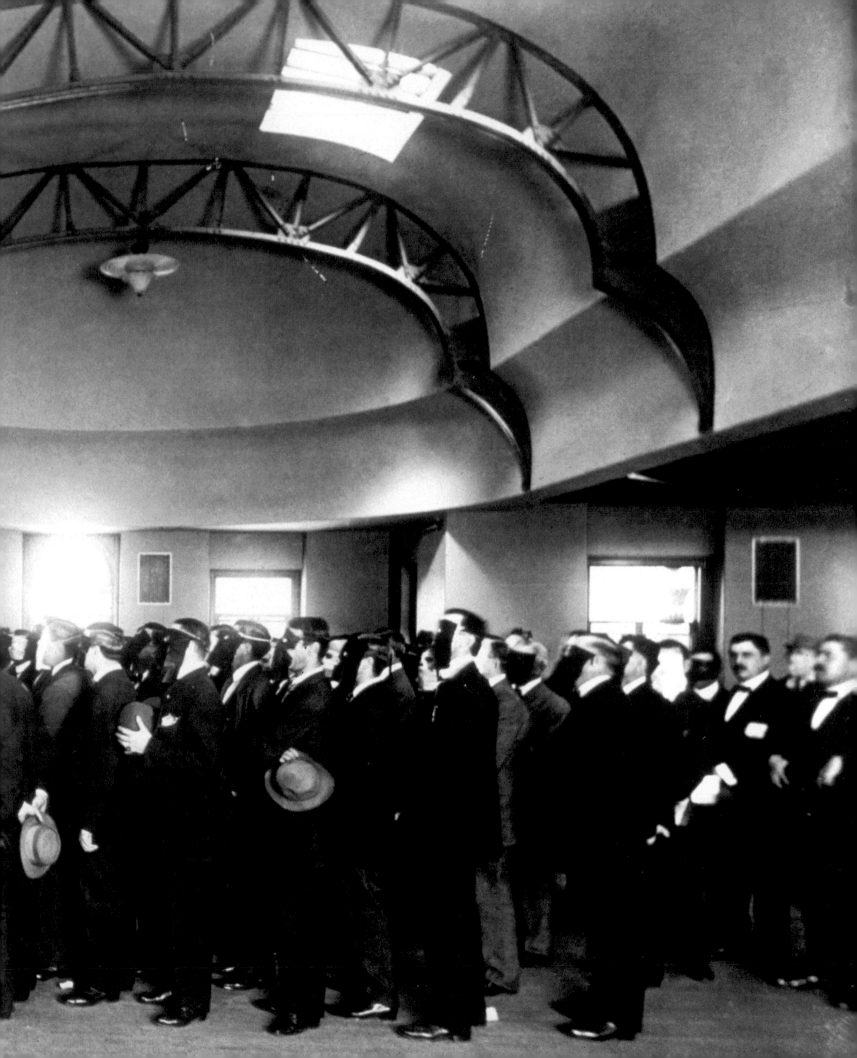

To my children, Alaina Juliet and Kevin, and my sister, Carole Elias,

for their love and support

This book was prepared and produced by Constance Sullivan/Hummingbird Books.

Design and typesetting by Katy Homans

Separations by Robert J. Hennessey

Photographs copyright by individual collections and photographers
A list of photograph credits can be found on page 158.

Text copyright © 2001 by Gail Buckland
"Looking Crime Squarely in Its Disturbing Eye" copyright © 2001 by Harold Evans

First Edition

ISBN 0-8212-2775-0

Library of Congress Control Number 2001135058

Bulfinch Press is an imprint and trademark of Little, Brown and Company (Inc.).

Page 2: New York City Police Department photograph of a homicide, circa 1915.
Pages 4–5: Witnesses to crime need to be protected when identifying suspects. The New York City police once gave a mask to anyone attempting to pick out the perpetrator in a lineup.

PRINTED IN ITALY

Contents

Acknowledgments

8

Preface

9

Looking Crime Squarely in Its Disturbing Eye

Harold Evans

11

Witness to Crime: Forensic Photography

Gail Buckland

27

Crime Scenes

41

Killers

67

Sensational Cases

87

Retribution

105

Gangsters

119

Presidential Assassins

135

Bibliography

156

Photograph Credits

158

Index

159

Shots in the Dark: True Crime Pictures is the result of a team effort by a wonderful group of professionals: Constance Sullivan, master producer of some of the finest of photographic books, had the vision, energy, and expertise to make this volume a reality. Katy Homans, designer extraordinaire, worked magic coaxing images and text powerfully onto the printed page. Robert Hennessey, an unsurpassed craftsman, brought out the richness and potential of each photograph.

My sincere appreciation to Harold Evans, who contributed the introductory essay and kindly read the entire text. Although he did not always agree with my positions or picture selections, he made numerous constructive and thoughtful comments. I also thank Carol Leslie and Michael Sand of Bulfinch Press, who immediately saw the importance of the subject and wanted to publish the book.

There would be no television program or book without the dedicated effort of Jonathan Marder of General Strategic Marketing, who initiated the collaboration among Court TV, Harold Evans, and me. Court TV selected @radical.media to produce the documentary, and Harry and I have had the good fortune of working with a creative group of people: Bari Pearlman and Jack Lechner, producers; Derek Cianfrance, director, cinematographer, and editor; Dave Moore, researcher; and Jon Kamen and Frank Scherma, executive producers. A special thank you goes to Bari, always calm and good-humored, for helping directly with the book.

Cindy Quillinan, editorial assistant to Harold Evans, graciously offered a helping hand and compiled the bibliography. Gerald Posner gave of his time and knowledge to answer questions about the Kennedy assassination. Andy Newman's article on biometric surveillance in *The New York Times* added insight and information on this recent technology. Yorick Blumenfeld and Helaine Blumenfeld introduced me to Dr. James Gilligan, whose book *Violence* was important to my understanding of the prison system and the roots of crime in American society.

Chief Bernard Tracy, of the Westfield, New Jersey, Police Department, obtained the photographs related to the John List case for inclusion here and generously answered many questions. Sergeant Richard Gosnell, of the Rochester, New York, Police Department's Technical Unit, shared material he has gathered on the methodology of police photography. Professor Larry S. Miller permitted me to reproduce teaching materials from his book *Police Photography*. Jim Hely, friend and attorney, explained points of law. Libby Reid gave encouragement and cups of tea. Dan Margolis in Westfield and Peggy Tuck-Sinko in Chicago assisted with research. The fascinating information about early Chicago court cases derives from Peggy's research into old legal records and newspapers.

I am indebted to Dr. Stanley Burns and Elizabeth Burns of The Burns Archive, David Winter of Winter Works on Paper, Richard T. Rosenthal, Arne Svenson, and George Seminara for allowing me to view their unique collections. Matt Fulgham of the Freedom of Information Act and Special Access Records, National Archives and Records Administration, shared his vast knowledge of the Warren Commission Report. Kenneth R. Cobb, head of the photograph department at the Municipal Archives, New York City, made my search through early photographs effortless. Eric Meskauskas, director of photography at the New York *Daily News*, and his colleagues Angela Troisi and Dolores Morrison offered full access to the paper's collection and made reproductions available in record time. Thanks also to Shawn O'Sullivan, author of *New York Exposed: Photographs from the Daily News*, for kindly showing me layouts of her book before publication. Donna Daily, Norman Currie, William Hannigan, and Eileen Flanagan, all of Corbis, provided assistance with their vast and fabulous archive. Chuck Zoeller and Camille Ruggiero made working with Associated Press a pleasure. Janice Madhu of the George Eastman House International Museum of Photography and Film, and Rob Medina of the Chicago Historical Society understood the need for high-quality reproductions and supplied them with expediency.

I am grateful to all the photographers involved, and their agencies, for the courtesy extended to me during my research. I especially thank Carol Jacobsen, Andrew Savulich, and Alex Tehrani for making their pictures so readily available.

My son Kevin's support was essential during the writing of the book. I thank him for his encouragement and love.

Harold Evans and I were invited by Court TV to commemorate its tenth anniversary on the air by helping to create a program and a book on the subject of crime photography. Working with @radical.media, Harry wrote and narrates the television documentary *Shots in the Dark*, and he has contributed a penetrating commentary to my book of the same title. I also participated in the program, as an associate producer.

In my selection of photographs for this book, I do not shirk from reproducing harsh images; the subject is crime, and many of the pictures are not pretty. Photography has the power to make us see, and one of the purposes of this volume is a better understanding of the violence in American society. This is not about mindless voyeurism. The intent is to show real-life images of stories in the news, and not to confine murder, violence against women, drug-related violence, and gangsterism to an intellectual realm without consequence. There is enough fantasy about crime; *Shots in the Dark* looks it squarely in the eye.

We observe much about our world through photographs; we learn through the information they provide and the emotion they elicit. The camera has gone to war, to massacres, to the sites of natural disasters. Photographs of these events, published in the media, help us understand them on a human as well as a historical level. Crime is another type of disaster, just as deadly as those cited. Photography, because it can portray the brutal along with the beautiful, has a role to play in elucidating and eliminating cruelty and injustice.

Since the mid—nineteenth century, police have used photography to fight crime. Newspapers have long published pictures of wrongdoers and crime scenes. Today, the Internet picks up from the tabloids, and disseminates true crime pictures around the world.

Every photograph reproduced here has been selected with consideration. Most of us will find certain of them horrific. They are. I reproduce them because they portray powerfully the contagion of crime in America. The level of shock and drama of forensic photographs can be as great as that of carefully constructed works of art; indeed, artists such as Cindy Sherman, addressing themes of violence against women, for example, adopt graphic and emotional strategies that call to mind crime photography.

As a professor of the history of photography, I know that at every period since the invention of the medium, photography has been attacked for treading on improper ground—even if writers, painters, and filmmakers have been there before. Unquestionably, photography's relationship with reality is unique and can provoke discomfort and outrage. But it can also effectively change thinking and inspire to action. *Shots in the Dark* will, I hope, take the glamour out of crime and bring us back to reality.

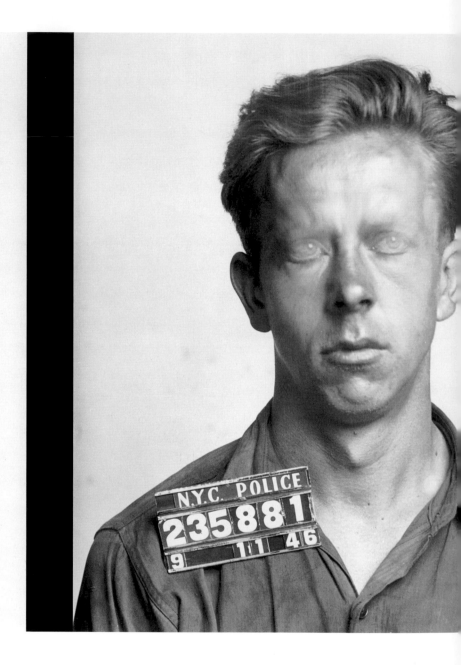

You can barely look at a single spread in this book without a tumult of emotions. Pity for the victims, revulsion for the killers. Fear that but for providence it might be you—or me!—on the bloody bed, in the gutter, on the slab. Admiration for those who have to deal professionally with the pornography of violence. Wonderment at how justice may be sought in the detritus of homicide. Excitement at our illicit entry into a dark, secret world. And guilt. Guilt that we are even looking, at once repelled and drawn in by a fretful curiosity.

Gail Buckland has selected some highly disturbing images for this book. As she indicates, there are some I would have forgone, but she is right that a book on crime photography cannot escape the fact that crime is brutal, ugly, obscene. I would rather none of these photographs had been taken; I would rather none of the crimes had been committed. I believe, however, that we are ill served by contemplating crime only in the abstract, as a statistic, a court report, a headline, or a trend. If we confine ourselves to a cognitive exercise, we miss the visceral impact of crime on people's lives, and photography serves that purpose well—and others, too.

The photography of crime is a subject of brutal simplicities and infinite perplexities. It is different from all other documentations of social reality. There is shock in the images of squalor and deprivation by Jacob Riis or Bruce Davidson; in the battlefield horrors memorialized by Robert Capa and Larry Burrows; in the drug culture exposed by Eugene Richards. But we know the purposes of the photographer, more or less; we can identify with the impulses of the reformer and the humanitarian. We can understand why Margaret Bourke-White reproached herself for trying to make a fine composition of the obscenity of Nazi concentration camp skeletons: art has no place in the documentation of evil. In all those examples, the shock lies in the content of the photograph, not much in our psychic correspondence with it.

With the crime photograph, the image may shock, but we may be even more tormented by our relationship to it. The photograph of the nineteen-year-old Hollywood model Judy Dull reproduced on page 52 is a case in point. On the face of it, this is a titillating picture of an attractive young woman, caught perhaps with her lover in some sexual game of bondage. Think that for a fleeting second and then learn the devastating reality that she has been tied up by a monster called Harvey Glatman, who specialized in luring pretty young women to their deaths. There is unbearable tension in contemplating this scene and knowing the sequel. The anguish in having our eye to the keyhole is complicated and magnified by another piece of information, extraneous to the image but integral to its viewing. The photograph was taken by her killer. The identity of the photographer transforms the meaning. It was part of his vile satisfaction. So we are not only intruding here. Our participation, it could be argued, serves the perverted obsession of a murderer. He is not to know this, having been executed long ago, but the metaphysics are highly disturbing. We are seeing exactly what he saw. We are traumatically in his skin.

Looking Crime Squarely in its Disturbing Eye

Harold Evans

It is apparently not unusual for serial killers to take photographs of their victims. Jeffrey Dahmer spent hours recording on film his sexual transgressions and mutilations. Such appalling images may serve a purpose. To the detective, they may yield a clue; to the juror, a conviction; to the psychologist, insights into the pathology of the psychopath. The rest of us do not want to risk our mental well-being by seeing them. What should we see? This is a sensitive subject for crime photography, one I will return to. The courts generally seek to protect the broad public from exposure to horror. In the O. J. Simpson murder trial, the prosecution mounted big display boards of photographs taken at the autopsies of Nicole Simpson and Ronald Goldman. These were relevant to show that the fatal knife wounds were inflicted with great force, and the prosecution wanted also to make the murders so overwhelmingly real that the public would cry out for punishment of the perpetrator. The defense team and the victims' families succeeded in having the photographs concealed from television cameras and the press. The images of the gouged and lifeless bodies were shown to the jury alone. For nine days of testimony, the press saw only the backs of the display boards—and the stricken faces of the jurors. Reporters protested. They insisted on seeing the grisly pictures to gauge how they affected the jury's view of the evidence. Judge Lance Ito finally ruled that one reporter from each newspaper or TV or radio station would be allowed to see what the jury saw. He surely had to do that on First Amendment grounds, but I think he was right not to allow the autopsy photographs to be shown on television. The nightmare scenes would have added little to our understanding of what had happened. Even the supposedly case-hardened reporters were speechless at what they saw. Some of them were so shocked they reckoned that the jurors, seeing them day after day,

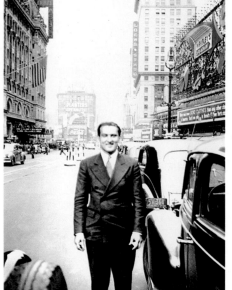

might have been sickened enough to feel that their emotions were being exploited by the prosecution.

The reverberations of criminal photography are complex. The image itself may be anodyne. Take a look at George Cvek, posing in his double-breasted suit in Times Square in July 1940. Cvek was the mayor of Boys Town, the youth rehabilitation community in Omaha, Nebraska, founded by Father Edward Flanagan. The handsome, smiling Cvek was not a victim. He was a killer. This time it is the photographer who has put himself and his loved ones at risk. Cvek liked having his picture taken by people who befriended him as he hitchhiked across the country. His habit was to beg a ride, pose for a snapshot en route, then sometime later return the generosity by visiting the home of the transient benefactor and strangling the man's wife. Cvek confessed to robbing and assaulting sixteen women. Of course, it was foolish of Cvek to have himself photographed by so many who could identify him; he paid for his vanity by going to the electric chair in Sing Sing.

Cvek wanted to make a celebrity of himself, and the camera was his conspirator. The camera has been an instrument of a great deal of social reform, of art and of inspiration, but it is shamelessly

neutral. It does not flinch from bloodshed. The lens is as unforgiving as the bad guys. Some of the photographs Gail Buckland has very originally collected of victims of crimes of passion and crimes of greed are hard to look at. Yet that is the cruel reality of violence, the way most of us learn what murder means, and it's the way we learn what killers look like—when their mug shots stare out from Wanted posters, and when they are caught. The camera helps in this. It is not a mute witness, never has been. It can detect. It can indict and it can shame. The alleged perps hang heads, cover faces, and we read these postures as implicit acknowledgments of guilt. This is satisfying, although it is inherently unfair. But the camera can glamorize, too. Caught in the instant flash of fame, gangsters, like movie stars, are turned into celebrities. John Gotti or Sammy "The Bull" Gravano in the 1990s received the same kind of treatment as Frank Costello sixty

years before. In Bill Meurer's photograph, Costello, emerging from prison on the Rikers Island ferry on May 23, 1937, is the cynosure of cameramen and the grinning teenagers excited by the excitement. The celebrated tabloid photographer Arthur Fellig, better known as Weegee, remarked on how the big-time crooks rejoiced in their notoriety. "I knew all the guys in Murder, Inc., very well," he wrote. "Take Dutch Schultz, Jack Legs Diamond and Mad-Dog Goe and Lefty Gordon, anyone you can mention. I used to photograph them when they were alive. They were very nice guys. They

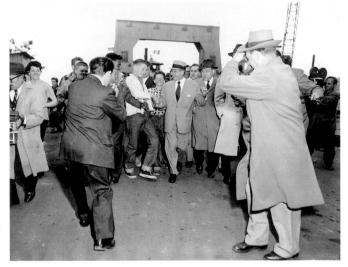

didn't try to cover up. The only ones that tried to cover up were the young punks who really saw too many movies. They thought I was waiting for them, so they covered up. I would say, 'Listen, you punk! Wait till you get a reputation. Then I'll be taking your picture.'"

The camera cannot lie. We used to say that before manipulation became too easy with the computer. But the epigram still gives power to the work of the policeman with a camera—the evidence photographer, as he is called. What kind of evidence can be attested by the photographs he takes with such meticulous care? In the O. J. Simpson case, physical evidence was illustrated by photographs of hair, bloody gloves and socks, a knit cap, the bloodstained seat of his Ford Bronco and fiber from it matching fiber found at the murder scene, the imprint of bloody tracks made by a pair of size-twelve expensive

and uncommon Bruno Magli loafers, and the bloodstained Aris Isotoner Leather Light gloves discarded by the killer. To tie the gloves to Simpson, the prosecution presented photographs of him at sporting events wearing identical gloves, and his wife's credit card receipt for two pairs—a chain of evidence that broke when the prosecution challenged Simpson to try on the gloves found at the crime scene and he famously struggled to do so.

Thousands of crime objects and crime scenes are photographed in this way in the hope of reconstructing the crime, establishing an identity, finding a clue, disconcerting the defense—or the prosecution. Robert Morgenthau, the Manhattan district attorney, is so convinced of the value of the on-site photograph that he has organized a video unit independent of the police. His office dispatches its own videocameramen without waiting for a police evidence photographer to show up. In the Los Angeles investigation of the murder of an unknown woman, a photograph was circulated of her silver shoes and pearl necklace as a means of establishing who she was and, in turn, who her assailant might be. Evidence photographs help determine contested matters. Suicide or murder? Could the shot really have been self-inflicted with the weapon found where it is? What can we deduce from the posture of the victim, and can we convince a jury of laymen and laywomen? Could the shot really have come from the corner if the victim is lying here? What is the position of the spent cartridges? Whose are the footprints in the snow? What is the significance of the skid marks on the road? The circumstances of death must be documented, but photographs can provide crucial evidence of the circumstances of life. By the time of trial, an abused child, a battered wife, the victim of a mugging or a hit-and-run driver may have recovered from injury. A photograph taken when the person is hurt speaks more eloquently than language of "contusions and abrasions." The video recording of an interrogation of a suspect may discount the claim that a confession was made under coercion. The Manhattan District Attorney's Office obtained the conviction of the killer of a violinist because its staff was so scrupulous in recording the voluntary nature of the suspect's confession. The camera's uncensoring eye has not infrequently recorded a piece of evidence, part of the jigsaw, that escaped the naked eye—a scratch visible only on enlargement, a button ripped from a jacket, a name written accusingly in the last moments of life. In one of the earliest cases in which photography helped win a conviction, handwriting was photographed on small scraps of paper retrieved from a wastebasket in the Grand Hotel, in New York, where one Dolly Reynolds was beaten to death on August 16, 1898. It was enlarged for the jury by a handwriting expert and brought into close proximity with enlargements of a prescription written by a dentist, Dr. Samuel J. Kennedy. He was convicted.

The evidence photographer can provide props for the reconstruction of a crime, but he cannot rewind Time. The photographs are invariably taken at a different hour of the day, in different lighting. The defense, too, may turn up with photographs of the scene. Look, the witness could not really have observed what happened, from this angle and in the light prevailing at the time. The camera cannot

lie, maybe, but it can be highly selective, an accessory to untruth. When we take a photograph, we put four edges around a set of facts and exclude others. And a photograph can change emphasis: a long lens can make things and people seem closer than they really were. It is up to the defense to challenge photographs that seek to convict. Photography has proved innocence, although judges have had to be convinced that a photograph is evidence. Tom Mooney, a Wobbly agitator, was accused of planting and detonating a bomb that killed ten people attending a parade in San Francisco on July 22, 1916. The defense found snapshots, taken by a Willie Hamilton, of Mooney and his wife, Rona, watching the parade from the roof of 975 Market Street, more than a mile from where the bomb was planted. In the background, clearly visible on enlargement, was a jeweler's clock; the time on it was 2:01, five minutes before the explosion. There was no way, given the nature of the bomb, that Mooney could have been on the roof at 2:01 if he was detonating a bomb. But the district attorney argued against the admissibility of a photograph and the judge ruled in favor of the prosecution. Even though a crucial witness admitted perjury, Mooney was in prison for twenty-two years before being pardoned. And it is now considered fairly certain that the bomb was the work of German saboteurs.

The evidence photographer has competition—sort of. His focus is documentation. The other photographer rushing to the crime scene is the pressman. His focus is drama.

Tabloid photographers have been our proxy in this shadow world of our fears, our griefs, our anxieties, our more morbid curiosities. They are as bold as ever they were, but their scope is more limited today by authority. A photograph in this book shows one of the last public executions in the United States, held on August 14, 1936, when 20,000 people turned out in Owensboro, Kentucky, to watch a black man fall through the trapdoor. A photograph of the execution of Allen Lee Davis in Florida on July 8, 1999, appeared on the Internet. It was ruled that no photographs would be allowed at the execution of the convicted bomber Timothy McVeigh in Terre Haute, Indiana. While it was decided that several hundred people in Oklahoma City might watch on closed-circuit television, no television or still cameramen would be permitted to record the death scene, and media access to the death chamber would be limited to ten observers.

New York's rambunctious *Daily News* still takes a great interest in crime, but Edward Kosner, its editor in chief, told me he would not publish a picture of an uncovered corpse from a city killing, although he would hesitate less with a picture from overseas. So perhaps there has also been some change in public taste since the 1920s. The *Daily News,* of course, is the newspaper that first enabled the world to see a woman die in the electric chair, on the morning of January 13, 1928. Twenty-four people were allowed to witness the previous night's execution of Ruth Snyder, wife and mother, who was condemned with her lover, the pliant Henry Judd Gray, for the premeditated bludgeoning and strangling of her husband in his bed. Twenty of the witnesses were newspapermen; photographers

were specifically barred. Tom Howard posed as a writer but smuggled in a tiny camera. It was strapped to his ankle. When Mrs. Snyder's body heaved against the surge of current, Howard slyly raised his pant cuff and triggered the shutter from a cable that ran inside his pant leg into his pocket. It took all of seven minutes for Ruth Snyder to die. The *News* rejoiced in its scoop, the first photograph of an execution in Sing Sing. In the American imagination, Sing Sing meant death row. More executions took place there from 1891 to 1963 than in any other American prison: 614. The *News* caption spared no detail: "Her helmeted head is stiffened in death, her face masked and an electrode strapped to her bare right leg. The autopsy table on which her body was removed was beside her." The photograph and the gloating were furiously denounced as a vile and nauseating violation of human decency, notably by rival newspapers that had not hesitated to publish every gruesome detail from the trial. The *News* retorted: "The incident throws light on the vividness of reporting when done by camera instead of pencil and typewriter. We think that picture took the romance out of murder." It certainly took the romance out of a judicial killing, but the public voted with its pennies: 500,000 extra copies of the paper were snapped up.

The outcry did the *Daily News* no harm. When the newspaper began in 1920, it gave only six percent of its space to crime. By 1930, that had risen to twenty-three percent. Circulation soared to

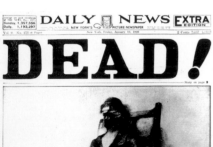

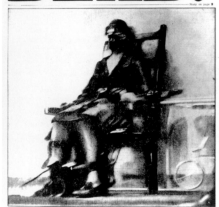

RUTH SNYDER'S DEATH PICTURED:—This is perhaps the most remarkable exclusive picture in the history of criminology. It shows the actual scene in the Sing Sing death house as the lethal current surged through Ruth Snyder's body at 11:06 last night. Her helmeted head is stiffened in death, her face masked and an electrode strapped to her bare right leg. The autopsy table on which her body was removed is beside her. Judd Gray, mumbling a prayer, followed her down the narrow corridor at 11:11. "Father, forgive them, for they don't know what they are doing" were Ruth's last words. The picture is the first Sing Sing execution picture and the first of a woman's electrocution.

more than a million by the end of 1925, on its way to a peak of 5 million for the Sunday edition in 1948, with lashings of crime photos.

The *News* front page "Dead!" was the climax of a murder case in which photography had played a big role. The police identified Henry Judd Gray, while he was on the run, from a portrait photo in a bag Mrs. Snyder had left at the Waldorf-Astoria Hotel. An Indian mystic was called by the defense to say that he could read photographs psychically and that, on the basis of pictures of Ruth Snyder, she could not have committed the murder because she was not hypnotic and therefore incapable of influencing her lover to join the alleged plot. The jurors were more moved by a bloody bedroom picture captioned: "The body of Albert Snyder photographed by police in the exact position it was found."

The individual's right to privacy came last, and hardly ever more so than when photographers got into the ward where Dutch Schultz lay dying. His entire life and death can be seen as a series of tabloid photos. Schultz—real name Arthur Flegenheimer—was a notorious extortionist. (In the picture on page 17 he awaits a not-guilty verdict in a tax case while reading a magazine article about famous murders.) A young new special prosecutor of organized crime, Thomas Dewey, was making it hot for New York's mobsters, so Schultz planned to have him shot at breakfast in a drugstore on October 25, 1935. Schultz was beaten to the draw—not by Dewey but by Charles "Lucky" Luciano, the top Mafia leader in the city—and the one who ended up dead was

Schultz himself. Luciano reasoned that killing Dewey would only intensify the war against the gangsters, and he was not averse to adding Schultz's gambling and shakedown rackets to his drug-running.

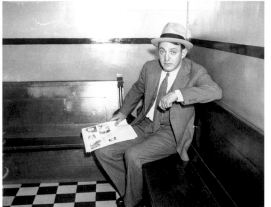

So on October 23, Murder, Inc., hit men sanctioned by Luciano came in through the back entrance of Newark's Palace Chop House and shot Schultz and two of his pals. Schultz clung to life in hospital, murmuring a mystifying stream of words—and leaving us with a mystifying and demeaning series of pictures of his last twenty-two hours. How did the press get to photograph him repeatedly while he lay there fighting for his life? In one picture he pulls himself up to look at the bullet holes in his abdomen. In another, after his death,

a group of rubberneckers hovers around his head. There is no sign of nurse or doctor present in any of these invasive photos. The exhibition is appalling, by any standards, and yet we look. So it is with the photograph of Betty and Rosella Nelson, a couple of Chicago entertainers viewing the body of John Dillinger in the morgue—in their swimsuits. They were there courtesy of J. Edgar Hoover, director of the FBI, who so exulted in

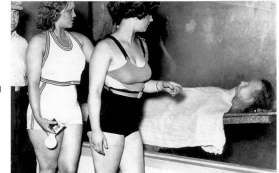

his agents' gunning down of Dillinger that he kept his sightless, sardonic death mask on display for thirty-eight years, a scream of vengeance we can still hear today when we look at the picture.

Death, wrote Al Alvarez, is a kind of pornography at once exciting and unreal. Such images share time with us, and they will share it with those who come after us. Luc Sante has written vividly of his

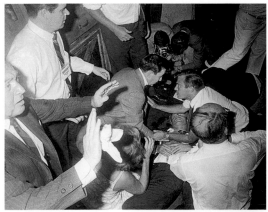

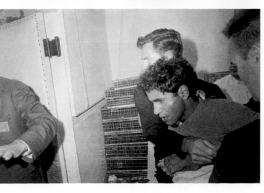

sensations in discovering an archive of quotidian death in abandoned police photo files from 1914–1918. "In looking at these bodies, cold for three quarters of a century, it is difficult to avoid a sense that we are violating them afresh, that we are breaking a taboo as old as the practice of shutting the eyes of cadavers and weighing down their lids." One wants to turn away even from the photograph of a man who did us all such harm, Lee Harvey Oswald, lying stitched up on the autopsy table. The feeling of reproach is intense when we are invited to look at the head of President John Kennedy lying on the autopsy table in Dallas. The passage of time may be argued to sanctify the intrusion on a hero at rest: it's "history." But these lines are difficult to draw. Different considerations apply, I believe, to books, to newspapers open to families, to courtrooms. When I was editing *The Sunday Times* of London, I would not have published Oswald, still less Kennedy, but I did publish, as news, Robert Kennedy dying on the floor of that California hotel. And

I would have had no scruples publishing the photograph on page 17 of Sirhan Sirhan being apprehended, although English "fair trial" law would not have allowed him to be identified as the assassin. Photographs like that of the dying Kennedy do distress people, yet sometimes they have to be seen. I had no hesitation, either, in printing photographs of corpses at My Lai; they were evidence of a crime otherwise hard to believe. In the1920s and 1930s, it would have served the United States better if editors had been less squeamish about printing photographs of lynchings and immolations in the South.

Moral certainty may not be given to us in these matters, but as a newspaper editor I had four tests for a photograph that would undoubtedly offend: Is the event of such social or historic significance

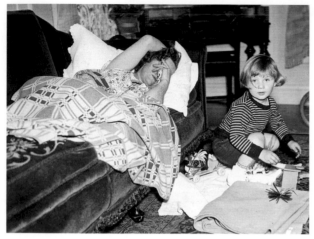

that the shock is justified? Is objectionable detail necessary for a proper understanding of the event? Does the subject freely consent? Is the photograph expressive of humanity? My rough rule then was that if at least one of these questions could be answered in the affirmative, then publication to a wide audience was justified. According to these tests, a contemporary newspaper would not have published the photograph of Mrs. Anna Hauptmann, prostrated with grief in her Bronx living room on the day after her husband's execution in a Trenton prison for the kidnapping and murder of the Lindbergh baby. It was a cruel intrusion.

The compelling nature of the great gallery of tabloid images from the 1920s to the 1950s has as much to do with style and technique as with content. It lies in the melodrama provided by numerous news photographers using the wide-angle four-by-five Speed Graphic. The camera's magnesium powder flash presented foreground figures harshly lit against a dark background redolent of film noir. The flash heightened the sense of rawness, of menace on the streets and in the precinct houses and at the crime scene, and we're glad we're seeing it through someone else's eyes. For many years in the 1930s and 1940s in New York they were notably the eyes of Arthur Fellig. He was an Austrian immigrant who developed a fine sense for melodrama in black-and-white photography while working as a young man in the darkroom at the Acme news service. His biographer Louis Stettner suggests that he earned his later nickname, Weegee, derived from "Ouija board," because he often seemed to know beforehand where the scene of a crime might be—a legend he was happy to foster. He did seem always on the spot for the late-night street fracas, the arrest of a peeping Tom, the stickup at a delicatessen, the bookings at police precincts, the suicide jump; in his year as a freelance photographer he might cover six stories a day. This had less to do with metaphysics than with electronics. Like his competitors, Weegee lived in one of the "shacks" behind police headquarters in Manhattan, where reporters would hang out monitoring the short-wave police radio. But for the news tips they gave him, he was also adept at cultivating friendships with bar owners, nightclub bouncers, and

hatcheck girls, with cops and street-corner stool pigeons. Weegee was the Damon Runyon of photography. It was his genius to turn away from some grisly scene to photograph the spectators as well, transfixed in the windows of a tenement building, in the mean street gawking at the corpse from the edge of the police line, or right there in the melee of the cops' arrival on the crime scene. His photograph *Their First Murder* is the classic of this genre. The astonishment, gratification, despair, and excitement on people's faces against the dark silhouette of the city were an endorsement of his work—although he has his critics. John Coplans wrote: "His photographs are morally dubious. . . . Often he is deliberately spying. . . . People shocked, in terror, convulsed with pain, or blown out of their minds were his special targets."

Crime photographers and their editors, then and now, inevitably invite the rebuke that they are exploitative voyeurs—doing it for the money. Because our attitudes to their work are ambiguous, they risk being denounced for giving us what we secretly want. Confronted by troubling images, we find excuses for looking but protesting. In 2000, the Italian photographer Oliviero Toscani and *Talk* magazine were criticized for some striking portraits of men on death row published as part of a U.S. advertising campaign for the clothing company Benetton, known for its shocking use of news photographs. "Commercialism" was the cry in various newspapers—but was it any more commercial than seeking circulation by splashing crime and disaster on the front page? Or by publishing photographs from the paparazzi who chased Lady Diana, Princess of Wales, to her death?

Nobody will argue much about the most common crime photograph: the mug shot. There is a very clear public purpose in printing those classic portraits, full frontal and profile. We want to identify them in our minds, to put them away, and we inescapably look into their faces for clues to criminality. Behind every crime, a criminal. What kind of person robs, assaults, and kills? Is there a criminal type? In the old dime-store thrillers, we read that the villain's eyes were closely set, or that he had a lowered brow or simian features. The U.S. attorney general A. Mitchell Palmer, who deported hundreds of aliens in the Red Scare of 1919–1920, justified his actions to a congressional committee with an eloquent exposition of the connection between looks and depravity. "Out of the sly and crafty eyes of many of them leap cupidity, cruelty, insanity and crime; from their lopsided faces, sloping brows and misshapen features may be recognized the unmistakable criminal type." They were Palmer's words, but in the idiom of J. Edgar Hoover, the nativist director of the FBI. We may be more sophisticated these days, yet it is a shock, deeply troubling to our sense of security, when we see a photograph of a serial killer, a Ted Bundy, say, and find we are looking at an apparently normal, attractive person. Lewis Payne, one of the conspirators in the plot to kill Abraham Lincoln, was a matinee idol. Perhaps this dysfunction of image and moral sense explains—but does not justify—the temptation for an editor to choose the least appealing photograph of an accused person, even to doctor it digitally. For its

O. J. Simpson cover, *Time* appropriated the police mug shot, but didn't use the image straight. The magazine's art staff scanned it into a computer and digitally darkened Simpson's skin for a scary photo

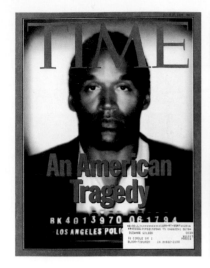 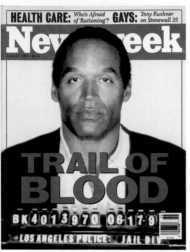

illustration. Wheezes such as this undermine the credibility of photography. *Time* argued that it had created an icon of tragedy and that its headline, "An American Tragedy," was sympathetic. True. *Newsweek* used the same mug shot, untouched, but its headline running across Simpson's shirtfront was pejorative: "Trail of Blood." Word and picture together create what Wilson Hicks called the "third effect." Words may reinforce, challenge, or mock the image.

We have to forget the illusion that the face alone can warn us of danger: would you have given a lift to George Cvek? What is more vital is the correct identification of a person. How good are witnesses at remembering faces, picking out the right person from a lineup or a collection of mug shots? Having stood in a lineup for the purposes of Court TV's documentary *Shots in the Dark*, I can say it is an unsettling experience. And then there is the problem of aliases and disguises that fool the camera.

Toward the end of the nineteenth century, the Frenchman Alphonse Bertillon, chief of criminal identification for the Paris police, sought to supplant photographs of likenesses with measurements of faces. He used steel calipers and compasses to measure heads, ears, hands, fingers: eleven physical attributes in all, as demonstrated in the photographs on page 21. He calculated that the probability for

two people to have precisely the same eleven measurements was one in 4 million. The French police were skeptical, but they gave it a try. In three years the Bertillon system firmly identified eight hundred suspects. Soon police forces everywhere were using Bertillon's calipers and compasses. In 1903, a new prisoner, Will West, arrived at Leavenworth prison in Kansas. When the clerk checked him with Bertillon's instruments, he was sure he had measured this man before. West denied having previously been in Leavenworth. The prison official insisted. Some-

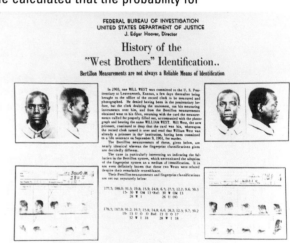

time later, while checking through the records, he felt vindicated: there in a file were the exact same measurements—and they were for a William West. But the records showed that William West was already in the prison, serving a life sentence for murder. There were two Wests. When they were brought to the warden's office, nobody could tell them apart. Neither Bertillon nor photography could distinguish between them. Only a few years later did the system come along that enabled police to tell

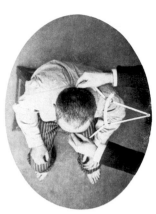

Will from William: fingerprint identification as developed at Scotland Yard. The odds against two individuals' having the same fingerprints are 67 billion to one. And for the new DNA analysis, the odds are infinite. Yet the Bertillon system has developed a second life, as we shall see.

Luc Sante found that the police images he surveyed would not leave him alone. Long dead, they lived in the eternal present of his mind, coming back to him in disconcerting detail. It is a familiar phenomenon. Our minds have an extraordinary capacity to recall a still image, and crime images, being particularly vivid, have a habit of lingering. Nobody can rerun a movie in his mind, but a single photographic image can be recalled years later. We have whole galleries of them in our heads, the image defining history. Lincoln's murder: the conspirators on the gallows. Prohibition: the St. Valentine's Day massacre in Chicago. The Mafia: the godfather Carmine Galante lying in the back of a Brooklyn restaurant on July 12, 1979, with a bullet through his left eye, featured on the front page of the *New York Post* under the simple shocker "Greed!" Son of Sam: David Berkowitz escorted blinking into the precinct house. Or think of Jack Ruby lunging forward in the police station in Dallas and shooting Lee Harvey Oswald in the stomach. Millions of us watched a murder as it happened, saw the pain, saw the police officers immobilized by shock, heard the chaos. The television pictures of that were sensational. We were stunned by the swiftness in the making of history, the finality of it. We wanted to reach out and stop the action. Yet if you recall that moving image, you'll find that you freeze on the single still, the isolated moment preserved forever by the photographer at the scene of the crime. That single image is indelibly part of our collective memory. It is the symbol for a thousand questions from the assassination of the president and the rubbing out of his killer. Images like these don't answer any of the questions. They do enable us to carry whole worlds in our head. A grim photograph in *The American Century* of a double lynching in Marion, Indiana, epitomizes the terror endured by blacks in the South—and the attitude of the spectators having fun at the scene of the crime.

It is hard to shake from our minds the single image that changed the life of Patricia Campbell Hearst, the kidnapped heiress who joined her kidnappers, the Symbionese Liberation Army, in a deadly bank raid. It's the image of "Tania," the gun-toting SLA terrorist caught on surveillance camera during the raid. Which is the real Patty Hearst? The grim-faced Tania on the 1976 *Time* magazine cover slashed with the single word "Apprehended?" Or the appealing "Patty" on the cover a few months later, the Berkeley coed who was held against her will, forced to do what she did? Most of us have etched in our minds the picture of Tania with gun—as if she were holding up the bank all by herself. But that's a cropped picture. The original full surveillance picture of the scene tells a rather different story. As she complained, "They've edited it so that you can't see that the guns are pointing [at me]." If she made a false move, she was exposed to gunfire from her kidnappers. Hearst was pardoned in 2001 by the outgoing President Clinton; her case is notable for reminding us how easy it is for a series of distortions to congeal into a prejudice.

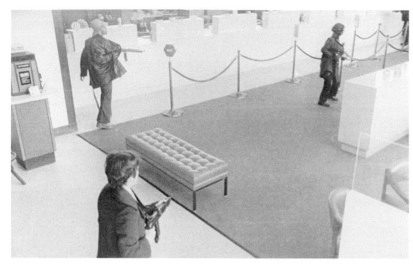

You have certainly been photographed as Patty-Tania was. Video surveillance cameras are everywhere these days—in stores, in elevators, at ATMs. New Yorkers cheered when a hidden camera filmed a bad guy in the act of holding up a livery cab driver: day after day, the drivers were being hunted down by robbers, attacked, shot, and murdered for their earnings. The burly robber aiming a black nine-millimeter handgun at the driver thought he had beaten the system. He ripped out the camera. But the videotape was running in the trunk, and still pictures were soon released. Three weeks after the images had appeared in the media, a stunned Raymond Williams was arrested at a subway station and charged with two counts of robbery and illegal possession of a gun. It was difficult to argue with the photographic evidence. It's cheering when the camera stays ahead. A man who set out to rob a Radio Shack in Arkansas, evidently having forgotten a disguise, pulled a plastic bag over his head. In his rush to get on with things, he didn't realize he would not be able to see through the improvised hood. He tripped over television sets, then crawled to an exit and came back with an eyehole in his plastic helmet. This time he left with $1.6 million of goods. A clean getaway for Stumblebum? Not quite. The camera has that unforgiving eye for detail. Cops remarked that he was wearing a security guard's uniform—and there, pinned to his uniform, was his name tag.

Millions of us have videocameras, and in recording our ordinary daily lives we may well by

chance film the extraordinary, as Abraham Zapruder did when he made a home movie of President Kennedy's visit to Dallas. Crime may lurch into our frame before we realize it, or we may respond to an emergency, as the Los Angeles plumbing supply store manager George Holliday did when he sprang out of bed to film a nightmarish scene in the street, where Rodney King was being unmercifully beaten by policemen. Without Holliday, the event, and its unforgettable images, would never have entered public consciousness. Who will be the next Zapruder, the next Holliday?

We are all being watched, pretty well most of the time. Hidden cameras around the world shoot millions of feet of film every day. The pictures can help catch bank robbers, looters, vandals; track the movement of victims; provide crucial clues to a mystery. The District Attorney's Office in Manhattan proved Mafia corruption in the painters' union by concealing a small videocamera in the chandelier hanging above the table where the loot from protection rackets was divided. That was relatively simple. It may take thousands of man-hours to scan video that is less specifically directed at a particular crime. In 1999, crude improvised time bombs packed with large quantities of nails were left, concealed in sports bags, in crowded areas of London. Two people died, more than a hundred were injured when the bombs detonated. The Metropolitan Police took 1,600 statements from witnesses, detained and released three men. The break in the case came from the unresting eye of a surveillance camera. Detectives seized 1,097 tapes with 26,000 hours of recording from a number of sites. They spent 4,000 hours reviewing them before coming across the pinprick image of a man carrying a sports bag similar to those used in the outrages. And there in another picture was the same man without the bag. The enhanced images, released to the media, led to the identification of the nail bomber, one David Copeland, by a fellow worker. Copeland was arrested before he could bomb again. Yet the surveillance video can help establish innocence as well. The Manhattan District Attorney's Office was not quite convinced by the eccentric homeless man who said he had attacked a woman on a city street with a brick. The man, who was known for carrying his life's possessions in a milk crate, was a habitual loiterer in an electronics store. People from the DA's Office looked at film from the store's surveillance cameras, and saw that the crate-carrier was clearly there before, during, and after the time of the brick attack a mile away. He had "confessed" apparently because he thought doing so would help him out of trouble.

Of course, hidden cameras limit the privacy of the innocent as well as the criminally guilty. They can photograph any of us when we would rather stay incognito—for some perfectly civilized reason, you understand. The technology is relentlessly on our tail in a way that George Orwell could never have imagined. Big Brother with a Ph.D. in computer science has developed what's called biometric surveillance, in which "face recognition" software turns faces caught on film into strings of numbers and compares those numbers with other strings of numbers that represent other faces. It is not a beauty contest. The idea is for the computer to compare your face with the thousands of mug shots

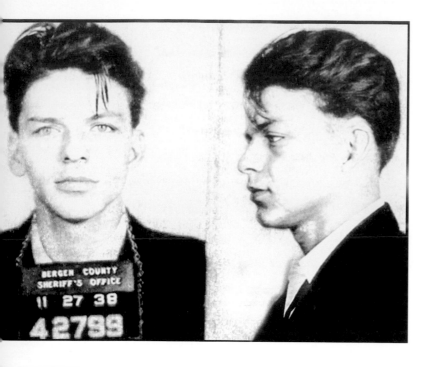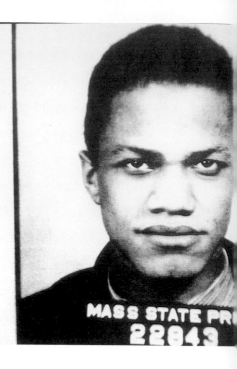
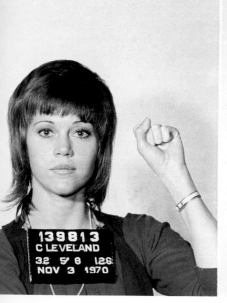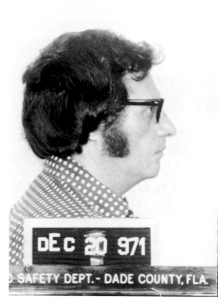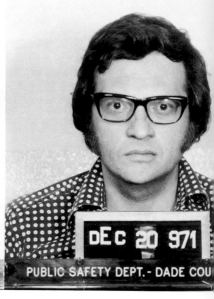
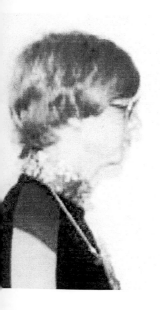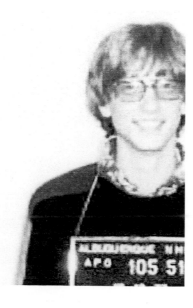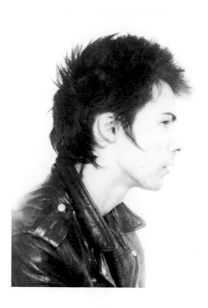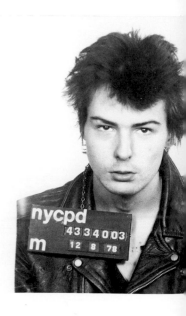

in state and federal files. What counts is not your sweet smile, but 128 elements: the size of your left earlobe, the distance between your eyes, the slope of your nose, the shape of your lips, the angle of your cheekbones. Bertillon lives! If you were one of the more than 70,000 spectators at the Super Bowl in January 2001, your face has already been scanned, converted, and compared with the faces of bad guys. The FaceTrac software at the Super Bowl made nineteen positive IDs of petty criminals. They were left alone—this time.

There are imperfections to smooth out in the varieties of digital face recognition systems, so that we don't stumble over the biometric equivalents of Will West and William West, but the technique can become an astounding tool for stopping crime before it happens. Two detectives walking the casino floor at the Atlantic City Hilton spotted someone known as a thief and card cheat. They checked his name against the Wanted lists. He was clear. But one of the detectives was not satisfied. He went to his office, called up the man's mug shot on a computer, and hit Search. The face recognition technology flashed on the screen several mug shots—under different aliases—and for two of those aliases there were warrants for the man's arrest for theft. The same technology led to the arrest of another suspicious character using a phony name at the Trump Marina casino, also in Atlantic City. In the shopping area of London's East End borough of Newham, a face recognition system connected to three hundred security cameras keeps a round-the-clock watch for any one of scores of known thugs. Computer identification rings an alarm in a monitoring room. Crime is down thirty percent. The police suspect this may be because the thugs have gotten used to the system and moved elsewhere—which means that biometric surveillance will spread, too, as other communities look to Big Digital Brother to protect them.

It is all very heartening to law-abiding citizens. But how do you feel about the prospect that some authority is checking your identity wherever you go, whoever it is you are with, whatever you do? We are on the eve of the day when every moment of our lives is evidence. Privacy is dying. Is it a cheap price to pay for peace of mind about criminals—or will the crime camera, recorder of so much drama, creator of so much mental turmoil, yet make paranoids of us all? The unspeakable demon aroused by crime photography remains what it always has been: that it might so easily be you or I who is the subject caught in the lens. We are willing observers now, but at some point in the unknowable future, we may ourselves become unwilling participants.

Facing page: Celebrity mug shots (clockwise from top left): Frank Sinatra, arrested for seduction under false promise of marriage; Malcolm X, for breaking and entering; Larry King, for grand larceny; Sid Vicious, for murder of his girlfriend; Bill Gates, for drunk driving; and Jane Fonda, for drug possession and assault on a police officer.

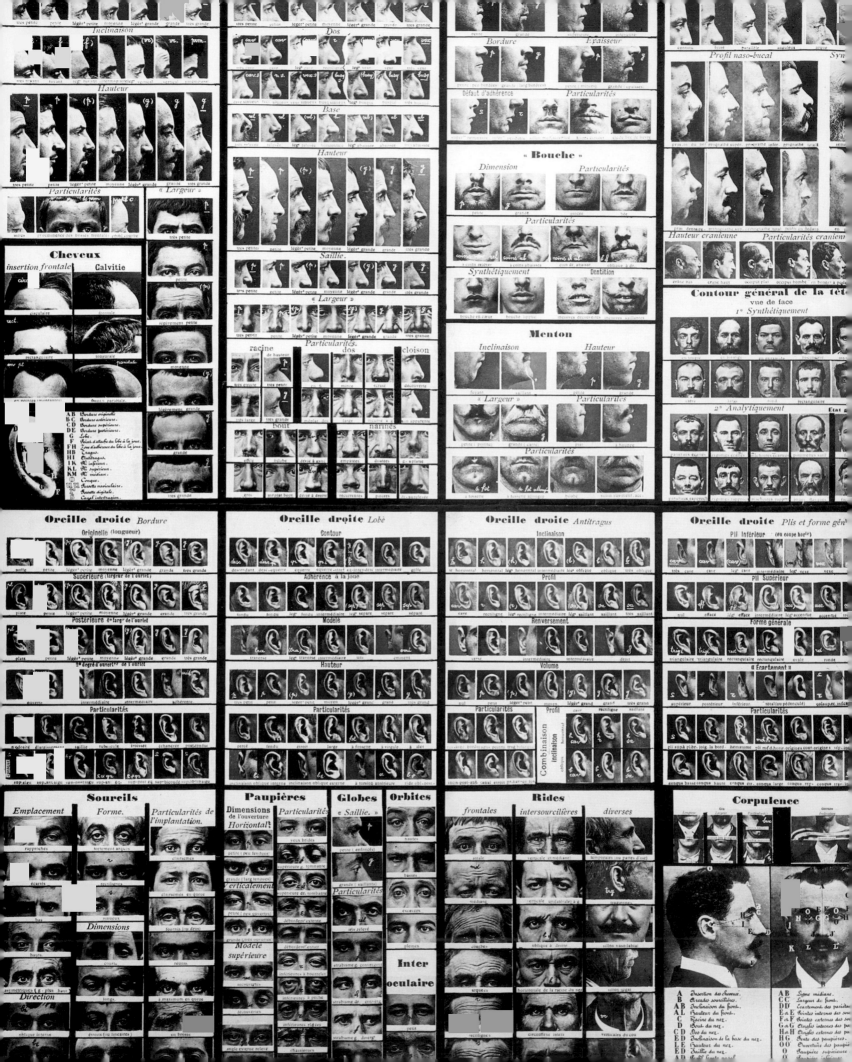

The invention of photography . . . is no less significant for criminology than the invention of the printing press is for literature. Photography made it possible for the first time to preserve permanent and unmistakable traces of a human being.
—Walter Benjamin, *Baudelaire*

The first criminals to confront the camera, in the early 1840s, had quite a fright. You can see it in their expressions in the earliest extant daguerreotypes. They were steeled for the routine grilling, but now they were told to sit down in front of a mysterious machine, not draw a breath, keep perfectly still. Was this some diabolical device to consign wrongdoers, inert, to perdition? Certainly it did not help that the camera and lens together resembled a small cannon.

It was recognized early that this new magic would influence police investigations. The first recorded use of the camera in detective work was in 1841, two years after the announcement of photography. There was a problem with Louis-Jacques-Mandé Daguerre's process as a tool for police work, however, for it reversed images: the villain identified in the flesh by the parting of his hair on the right was shown in the image with the parting on the left. Still, crime and mystery writers were quick to endorse it. Edgar Allan Poe called it "the most important, and perhaps the most extraordinary triumph of modern science." Like Sir Arthur Conan Doyle, Poe used the camera and photography as clues and props in his stories. In *The House of the Seven Gables,* Nathaniel Hawthorne has his protagonist, Holgrave, work for a time as a daguerreotypist.

There was, from the beginning, a dissonance about the ultimate virtue of the camera, between those who deemed it primarily a tool of documentation and those who considered it an eye into the soul. Hawthorne was fascinated by the "secret character" in camera portraits and explored the idea that the camera lens can see truth where the human cannot. A contemporary, Sir Francis Galton, father of eugenics and deviser of a system of classifying and describing the unique minutiae of fingerprints, maintained the existence of a "criminal type," one that could be illustrated photographically. Galton made composites—images superimposed one over another—to illustrate the physical traits of the typical criminal. The line of thought had originated with Johann Caspar Lavater, who in the late 1770s argued that the "original language of Nature, written on the face of Man" could be deciphered by a "physiognomic science." Phrenology, developed in the early nineteenth century by the Viennese physician Franz Josef Gall, sought to prove a correspondence between the topography of the skull and localized brain functions. Allan Sekula, in his essay "The Body and the Archive" (in Richard Bolton's *The Contest of Meaning: Critical Histories of Photography*), explains that physiognomy and phrenology caught on because they were methods for "quickly assessing the character of

strangers in the dangerous and congested spaces of the nineteenth-century city. . . . In the United States in the 1840s, newspaper advertisements for jobs frequently requested that applicants submit a phrenological analysis."

The camera as detector of character has not fulfilled those early hopes, but it has more than fulfilled its potential as a documenter of fact. Although it is deficient at diagnosis, it is supreme at the description that can be crucial in crime work. The inventor of positive-negative photography, William Henry Fox Talbot, underlined this virtue in *The Pencil of Nature* (1844–1846), the first book to be published with photographs. "The eye of the camera would see plainly where the human eye would see nothing but darkness," he wrote, encouraging viewers to give photographs more than a cursory glance. He recommended taking a magnifying glass to a print, because it would often disclose "a multitude of minute details, which were previously unobserved and unsuspected. It frequently happens moreover—and this is one of the charms of photography—that the operator himself discovers on examination, perhaps long afterwards, that he has depicted many things he had no notion of at the time. Sometimes inscriptions and dates are found upon the buildings[,] or printed placards, most irrelevant, are discovered upon their walls; sometimes a distant dial-plate is seen, and upon it—unconsciously recorded—the hour at which the picture was taken." Harold Evans writes in his essay about how just such a photograph of a clock face can, more than eighty years later, establish the innocence of an accused man. Talbot was prophetic. Among the marvelous and imaginative possibilities he foresaw for his invention was its use in court cases to prove ownership of property. He recommended keeping a photographic inventory of precious possessions, for "should a thief afterwards purloin the treasures—if the mute testimony of the picture were to be produced against him in court—it would certainly be evidence of a novel kind; but what the judge and jury might say . . . is a matter which I leave to the speculation of those who possess legal acumen." This is the first published mention of "evidence photography" as it relates to crime.

Allan Pinkerton seized on the essential element of the photograph as a means of identification. He came to the United States from Scotland in 1850, priding himself on employing modern means of tracking criminals, and assembled one of the largest collections of criminal photographs in the country and used them to apprehend suspects. Throughout the nineteenth century, police departments in the United States and Europe built up photographic inventories, but with no consistent pattern or method. Thomas Byrnes, New York City's police inspector and chief of detectives from 1880 to 1895, was a pioneer in this regard. There were, according to information cited by the historian Arthur Schlesinger, Jr., some 30,000 professional thieves and 2,000 gambling dens in the city in the early 1870s. Byrnes compiled a rogues' gallery of thieves, burglars, forgers, murderers, pickpockets, con men, bank robbers, and swindlers, and published their photographs in his massive 1886 volume *Professional Criminals of America.* He explained his objective in the preface:

Aware of the fact that there is nothing that professional criminals fear so much as identifica-
tion and exposure, it is my belief that if men and women who make a practice of preying
upon society were known to others besides detectives and frequenters of the courts, a
check, if not a complete stop, would be put to their exploits. While the photographs . . . are
kept in police albums, many offenders are still able to operate successfully. But with their
likenesses within reach of all, their vocation would soon become risky and unprofitable.

Byrnes's book is arranged by "professions" and designed as an illustrated directory, for laypeople and law enforcers alike. If, for example, you worked in a hotel, you would study the faces and working methods in the "Hotel" section, and when you recognized a professional burglar walking into your lobby, you quickly escorted him out. Byrnes produced pocket versions for his detectives to carry with them on patrol. And it wasn't just the police or businessmen who needed to see photographs of criminals, he contended; if photographs were to be of use in fighting crime, as many people as possible should see them.

Sensible, yes, but in the early days of crime photography, the most bizarre notions arose. People understood neither the chemistry nor the optics of the new medium. They considered photography, as Talbot wrote, "a little bit of magic realized—of natural magic." Some believed that the retina contained a light-sensitive substance similar to a photographic emulsion and retained, at death, the last image the eye had seen. This fantastical notion reverses every precept of crime scene photography. The victim does not need to be photographed to help find clues to the murderer. The victim is the camera eye, and the perpetrator has been "captured" the moment he commits his violation. A lawyer arguing a case in 1871 maintained:

Every object seen with the natural eye is only seen because photographed on the retina. In
life the impression is transitory; it is only when death is at hand that it remains permanently
fixed on the retina. . . . Take the case of the murder committed on the highway: on the eye of
the victim is fixed the perfect likeness of a human face. . . . We submit that the eye of the
dead man would furnish the best evidence that the accused was there when the deed was
committed, for it would bear a fact, needing no effort of memory to preserve it. . . . [It is] the
handwriting of nature, preserved by nature's camera. (Quoted in André A. Moenssens, "The
Origin of Legal Photography," *Finger Print and Identification Magazine,* January 1962)

Some police did peer into the eyes of the deceased for clues, and some attempted to photograph those eyes that had "photographed" their assailants. The results, where they exist, are indecipherable. These digressions aside, crime photography would progress, and come of age, at the end of the nineteenth century, thanks to a brilliant Frenchman.

The name of this father of forensic photography, creator of the standard mug shot, and the inspiration behind some of today's most sophisticated surveillance systems, is Alphonse Bertillon. He was supposed to be "Alfred," but when his distinguished doctor father went to register the name of his newborn son, he couldn't recall what he and his wife had agreed on. It was 1853, there were no telephones, and all that he could remember were the first two letters. When a clerk suggested "Alphonse," the good doctor acceded.

Alphonse Bertillon came from a family of great thinkers with poor memories. His lasting contribution to forensics was a simple rule: Record it. Don't rely on memory to catch a thief. Don't rely on memory, period.

In 1879, at age twenty-five, Bertillon was considered the black sheep of a renowned family of scientists. Because of ill health, military service, and academic setbacks, he didn't have a university degree. Alphonse finally found employment, through his father's intervention, at the prefecture of police. He was responsible for copying forms and registering suspects brought into the station. Day after day he wrote the words "average" and "ordinary" for height and jotted down whatever name an offender chose to use for the occasion. It became clear to the young man that the police needed a better system. But when he broached the subject, his superiors declared that they had their own quite adequate method of identification.

Until 1832 in France, criminals could by law be branded with a red-hot iron—even for minor offenses. The practice was suspended around 1809, only to be replaced by a more corrupt, if less brutal, method. A payment of five francs was offered to police officers for each offender they recognized as having previously been in jail. The law enforcers often split the money with the lawbreakers, who agreed to say that they had been in trouble once or twice before.

The Paris police had no interest in a "system," a concept that had, in those days, radical overtones, but Bertillon, after eight months of filling out endless forms, did. He cut up photographs and arranged them by body part—noses, ears, eyes. His biographer Henry F. T. Rhodes described him as the kind of young man who, when walking through Paris, saw "not the street, but perhaps long lines of noses, ears, and mouths." Bertillon had a revelation: If he could standardize the measurement of sufficient parts of the body, he could identify any individual and recognize him should he be brought again into police custody. (Fingerprinting would not be widely used until the early twentieth century. Bertillon's system had a statistical accuracy rating of one in 4 million; fingerprints are accurate one in

67 billion; DNA, if read correctly, is absolute.) Bertillon's plan was to record exact measurements on catalogue cards in a manner that would allow for easy retrieval. The goal: No mistaken identities. He told his boss. Whether the following dialogue, offered by Rhodes, between the prefect and young Bertillon actually took place or not, it is at least charming:

> "Bertillon, I believe you are a clerk of the twentieth grade and on the staff eight months, eh? And you have ideas, it seems. Your report reads like a practical joke."

> "If you will allow me to explain, sir . . ."

> "So you think our system of records can be improved by your method. Of course, I don't understand what your method is; but I doubt it. We have used the method we have for a long time, and have considerable experience. It works very well."

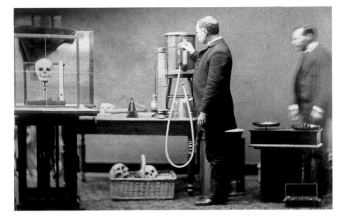

> "If you will excuse me, sir, it doesn't work well; it doesn't work at all. I know. I have to fill in the forms."

> "M. Bertillon . . . you are a young man in a junior position in this department, and with no experience of it. You have no scientific qualifications, and you produce an incomprehensible report which you cannot explain. I warn you that if I am troubled again I shall take a serious view of it." (Rhodes, *Alphonse Bertillon: Father of Scientific Detection*)

The prefect sent a letter to Bertillon's father, president of the Society of Anthropology, suggesting his son might be mad. Louis-Adolphe, after reading his son's proposal, concluded that Alphonse wasn't crazy; he was brilliant. He was going to prove that "every man and woman born into this world is a unique specimen." Behind the doors of the Paris prefecture, he would start an intellectual and scientific revolution. His indexing system, to be called anthropometry, or "Bertillonage," involved:

> Measuring and recording on standard-size cards the length and breadth of the head; the dimensions of the right ear; the length from each elbow to the tip of the corresponding middle finger; the length of the middle and ring fingers; the length of the left foot; height without shoes; the length of the trunk; and the span of the outstretched arms from the tip of one middle finger to the other.

> Writing a physical description of the subject, including eye color, birthmarks, scars, tattoos.

> Photographing, full face and right side, under consistent lighting, to reveal maximum detail of complexion and other facial characteristics. Suspects were to sit in a stationary chair placed a given distance from a camera with standard lens and focal length, their head against a head rest. Standardization was vital to allow precise registry of a face and thus facilitate comparison of photographs taken over a period of time.

> Establishing a retrieval system based on the measurements.

Mug shots, the most familiar of Bertillon's contributions, he called *portraits parlés*—"speaking likenesses." He wrote that unless the pose and the lighting conditions were consistent, the resulting photographs were lies, useless. The portraits had to be taken with a specially calibrated camera so that, as Ronald Thomas explains in *Detective Fiction and the Rise of Forensic Science,* "the shape of identifying features like the ear and nose could be properly gauged against standard diagrams." Whereas most detectives were happy if the picture merely resembled the individual in question, Bertillon was concerned with details. In the rare instance when measurements proved inconclusive, a photograph taken under set conditions, and filed with the vital statistics, was invaluable in identifying and recognizing recidivist criminals.

Thousands of photographs were in police files in the 1880s when Bertillon became involved in forensics. The problem, as he described in 1891, was that "the collection of criminal portraits has already attained a size so considerable that it has become physically impossible to discover among them the likeness of an individual who has assumed a false name. It goes for nothing that in the past ten years the Paris police have collected more than 100,000 photographs. [Is] it practicable," he asked, "to compare successively each of these with each one of the 100 individuals who are arrested daily in Paris?"

In 1882, a new chief of police, more sympathetic to Bertillon than his previous supervisor, gave him two assistants and three months to prove himself. Bertillon began to make the system of processing suspected criminals logical and simple enough that even untrained workers could complete the measurements in about seven minutes. The photography would take a little longer. And critical to the enterprise, trained specialists had to be able to retrieve the information in five minutes. To accomplish this degree of efficiency, Bertillon devised a method of classification similar to that used in botany or zoology. Once his system was operative, he could boast identifying 4,564 recidivists of the 100,000 males and 20,000 females he processed between 1883 and 1893. He defeated the criminal's age-old ploys of disguise, false names, alibis, and multiple biographies.

A story in Rhodes's biography sheds light not only on Bertillon's methodology, but on his character as well. It is all the more revealing of the contrast between his approach and that of the typical French policeman toward prisoners. On March 27, 1892, the anarchist and murderer Koenigstein, better known as Ravachol, was arrested and brought to headquarters. He was bruised and bleeding, and his clothes were torn. He refused to be photographed.

"Why?" Bertillon asked him. "I have to do this. It is part of my duty."

Ravachol, who had just been roughed up by the police, was surprised by Bertillon's gentle manner. Yet he persisted. "I won't be photographed now," he said.

"And why not now?"

"My face is not a very pretty sight, is it?"

"You are right. We will put it off. After all, what I want is a true likeness."

Bertillon's work was revolutionary. He is credited with restructuring police practices around the world and effectively challenging the "diagnostic" school of crime photography, which held that physiognomy and phrenology could serve to distinguish criminals from "normal" people. Bertillon's objective was to prove that each human being is an individual, not a type.

In the early days of photography, when exposures were long, a dead body was far simpler to capture than a living, breathing, *moving* person. From the outset of the medium, there was a tradition for post-mortem pictures. People, often children, died before the camera could immortalize them while they breathed, and a reflection of the dead and departed was preferred to no likeness at all. Death, and photographs of the dead lying peacefully as if asleep, were accepted by the Victorians without squeamishness.

 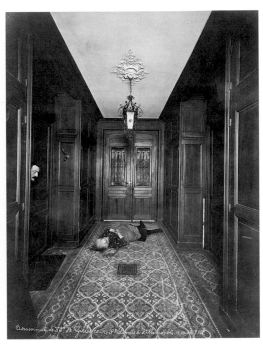

Corpses, photographed coldly with the police camera, were not like the cased or framed memorial portraits. Crime scene photographs in the nineteenth century initiated a new genre of realism that still raises ethical and aesthetic questions for artists, journalists, and viewers, though not for police photographers. If the police are called, the crime scene must be photographed with precision and thoroughness. The earliest examples of the genre in this book are the police pictures of Lizzie Borden's murdered parents (page 86). The images shocked the jury when the prosecutor presented them in court in 1893, and they shock us today. Now, perhaps, it is not so much the brutality of the scene that shocks, as the fact that the camera actually recorded this infamous scene in the past and we can contemplate it so many years later. Beyond their shock and historical value, the pictures hold limited forensic information.

Crime scene photography was as chaotic a business as police portraiture had been, until Bertillon put his, and everyone else's, house in order. Camera lenses were sharp in the nineteenth century, and the large plate cameras recorded all manner of detail. Yet for the most part, crime scenes held on to their secrets, until standards were established for camera angles, perspective, subjects, scale, and most crucial, lighting. If the murder weapon was near the body, but in shadow,

it often wasn't visible on the negative. Bertillon introduced a measuring scale for photographing crime scenes and a three-pronged approach for photographing dead victims: first, record the entire victim's body from overhead (look carefully and you often see the tripod legs in early crime scene pictures); sec-

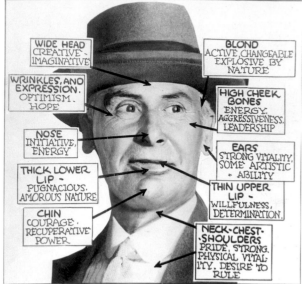

ond, photograph the body within its surroundings, and use a scale to indicate the dimensions of the room and the sizes of the objects in it; third, take a closer, ground-level side view. In 1902, Bertillon started photographing fingerprints found at crime scenes.

Every defense attorney knows that testimonies may be inaccurate and that even signed confessions don't prove guilt. But evidence photographs, taken under strict conditions, continue to serve as faithful witnesses in court. In order for their pictures to be admissible as evidence, police photographers must follow certain rules:

Do not disturb the crime scene. Investigators and jurors must view the setting precisely as it appeared when first encountered after the crime. Courts have disallowed evidence photographs that included investigators' scales and labels. The first set of pictures must contain no additions to the scene. There must be overviews of it undisturbed. Then, and only then, can objects blocking a clear view be moved and measuring sticks and numbers added. It is best, if the photographer has an assistant, to show that person making any changes. This will indicate to a jury exactly what was done and why.

Photograph everything that may be important. Blood, signs of struggle, surrounding objects, liquor, a murder weapon—anything that could bear on the crime must be photographed. A person being held

for questioning must be photographed with any scratches, bruises, or other marks that may signify a struggle. A man was once identified by teeth marks on an apple found at a crime scene. Ted Bundy was identified by teeth marks on a victim's buttocks. The apple decays, the photograph doesn't. The body is buried, the court case proceeds.

Black-and-white film is used for evidence photographs of footprints, tire impressions, and the like when contrast and detail are important. Crime scenes are photographed in color. Blood is evidence and emotional artillery for prosecuting attorneys.

No camera is more important to police than the fingerprint camera. Smaller police departments without fingerprint cameras use thirty-five-millimeter single-lens-reflex cameras with macro lens or close-up attachments and black-and-white film. Digital cameras and computer software for enhancing fingerprints and making comparisons are common in larger police units.

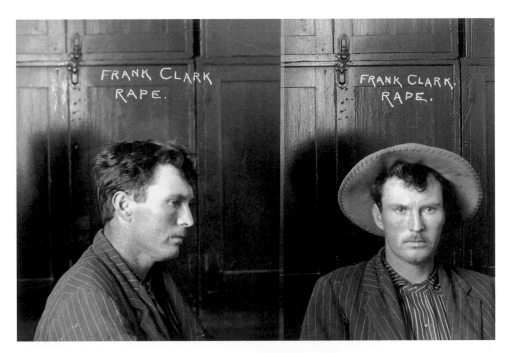

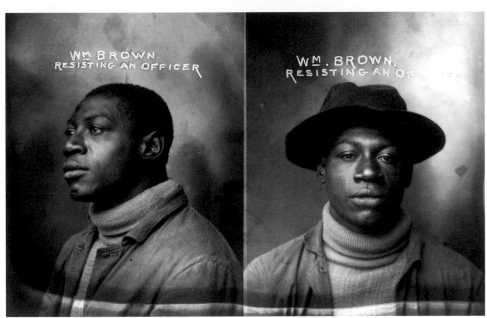

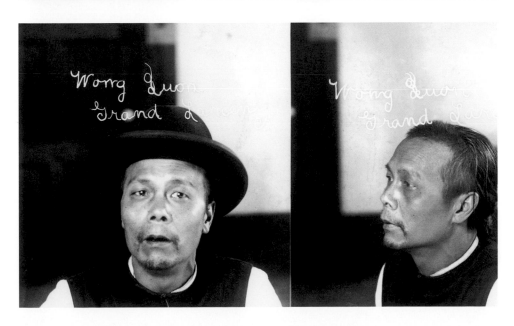

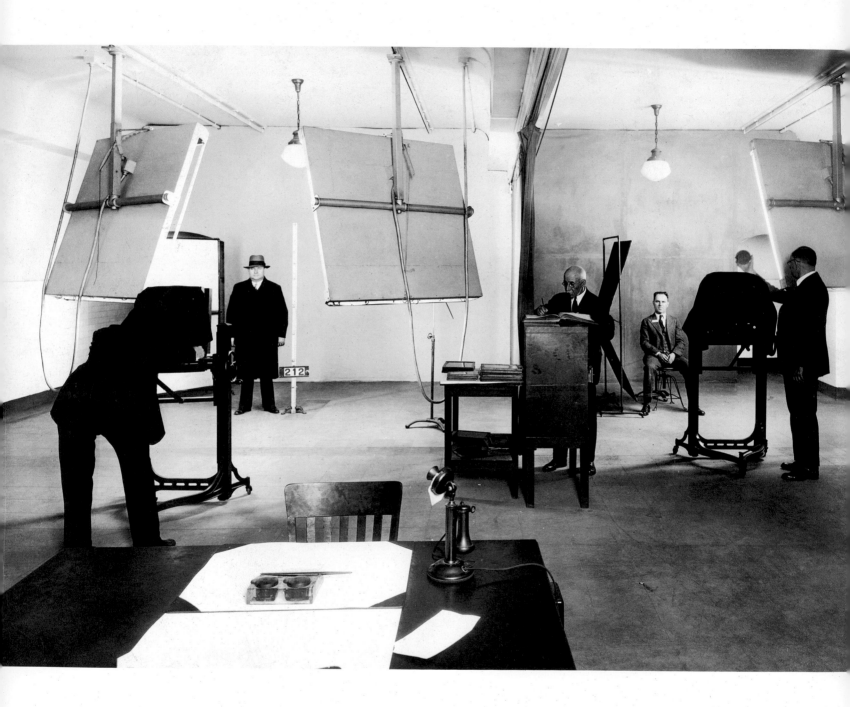

Make a complete set of pictures, for a complete view. The photographer must move around the scene to cover the entire area. Each important object—and most important, a dead body—must be photographed in three ways, in accordance with Bertillon's method: overview, mid-range, and close-up.

Photography is an accepted means of documenting crime scenes, but a flat measuring tool must be included. This is achieved through photogrammetry, the science of measuring with photography. Generally, the higher the camera over the victim, the more accurate the measurements. Heavy tripods once supported bulky cameras; now police photographers use ladders, rubber grips, long booms, and other devices, as well traditional tripods, to position or attach their cameras.

Many police precincts use videotape to supplement still pictures at crime scenes. In addition to conveniently panning 360 degrees, the camera can be positioned exactly where a person stood and show how he or she may have moved through the scene of the crime.

Keep in mind camera angles. Relationships of size and distance may be distorted by poor judgment of camera position. The lens is in this regard not a perfect witness. Tire marks may look longer or shorter in the viewfinder than they are in real life. Evidence photographers normally shoot from eye level, the viewpoint people are most accustomed to for experiencing visual information. If an object is large, for instance a house, it should be photographed from every angle.

Record all relevant data. The forensic photographer must document the content of each photograph, and when and where it was taken. A marked-up photograph may be ruled inadmissible in court, so markings should be made on a transparent overlay. Sometimes a sketch map is prepared in order that the court can see where each picture was taken.

Follow proper procedures with digital, video, and other new technologies. Digital images, which can be smoothly manipulated, raise questions of admissibility in court. Alterations may go undetected: one person's head may be placed on another person's body. If proper methods are followed, however, digital and video pictures are acceptable courtroom evidence.

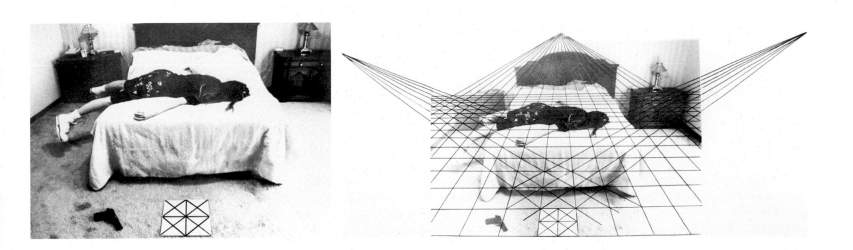

The principal requirements to admit any photograph as evidence in a court proceeding are relevance and authenticity. The party entering an original photograph must prove it is an exact representation of the scene. This means calling as a witness someone who can testify that the photograph accurately portrays the scene as viewed by that witness. A digital image stored in a computer is considered an original, as is any exact printout.

In order that the authenticity of a digital photograph or video not be challenged, standard operating procedure applies: The photographer must be able to provide information about the date the camera was used, about the chain of custody and image security, and about any image enhancement. An original digital image must be preserved on a hard drive or CD; image security hardware may be used. Digital images should be stored in their original formats, not compressed. If images are stored on a computer work station to which several individuals have access, the image files must be "reader-only" for all but evidence and photography lab staff. If an image is to be analyzed or enhanced, the old image file or videotape should be preserved.

Surveillance cameras are everywhere, to protect and to apprehend. Although we may think of them as eyes in the sky, watching for crime, they also may attest to a person's innocence, as when they identify his whereabouts at a certain time. Harold Evans in his introduction describes some of the latest advances in technology and raises questions about privacy in a world where, as *The New York Times* recently headlined, "software can turn dimples into digits."

Computer files have replaced file cabinets as storage units for mug shots, and cameras with sophisticated microchips have the ability to scan, take measurements, and identify faces at staggering speeds. The measurements they take are many of the same ones that Bertillon depended on more than a century ago. But unlike the suspect seated or standing uncomfortably before the camera, we aren't necessarily aware of the camera recording our face and vital physical statistics and storing the information for—and here's the rub—retrieval by parties unknown. Old-time mug shots are still taken, mostly with video or digital cameras. A suspect's picture enters a computer system along with a physical description and arrest information. This information is then made available nationwide, and can be categorized and located by race, age, height, weight, presence and nature of tattoos, facial hair, and even type of glasses worn.

"Bertillonage," fingerprinting, and DNA analysis are only as reliable as the people who use them. Police work has really only one mission: Apprehend the guilty, let the innocent live protected and free. Photography, the "mirror with a memory" and "pencil of nature," may have its failings, but over the decades it has proved itself a willing and able aid to police work, and a reliable witness in the fight against crime.

(above) Viewing of mug shots in a police station, New York City, circa 1905.

Page 26. A guide to interpreting mug shots, circa 1890.

Page 27. Lemercier, daguerreotype of a prisoner, Brussels, 1844.

Page 30. Photographing of a subject with the Bertillon system, 1907.

Page 31. Police laboratory experiment to measure brain volume.

Page 33. Alphonse Bertillon, crime scene photographs, Paris, circa 1900.

Page 34 (left). A guide to physiognomy, circa 1940.

Page 34 (right). "The Bashful Model," from *The Graphic*, November 8, 1873.

Page 35. Between 1900 and 1908, Clara Sheldon Smith took mug shots of some five hundred accused criminals in her Sacramento Valley, California, portrait studio. The Marysville Police Department, which commissioned the work, paid her an average of $9.50 per month.

Page 36. Two suspects being photographed at a police station, circa 1927.

Page 37. Method currently used by police to photograph and measure a crime scene, 1998.

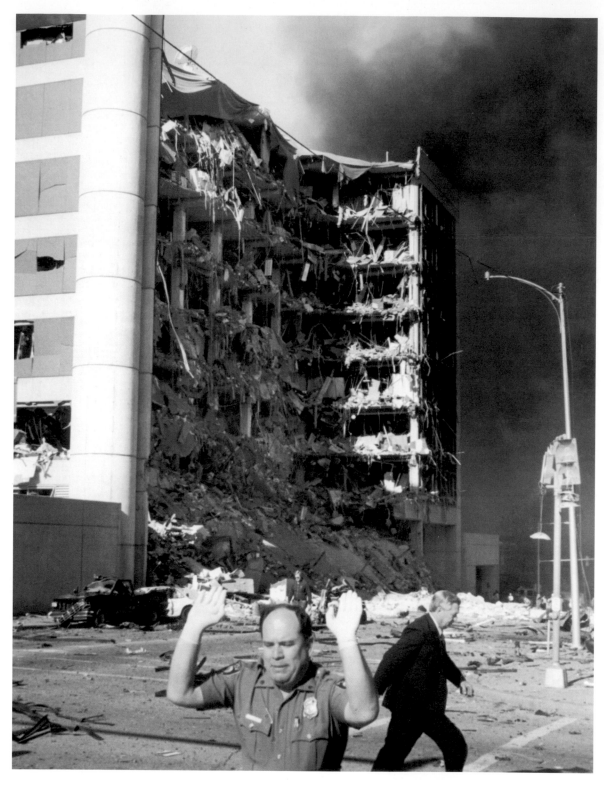

Moments after a massive explosion in Oklahoma City on April 19, 1995, the scene is surreal. A black cloud, not of nature's making but of man's, hovers over the Alfred P. Murrah Federal Building, in which hundreds—dead, maimed, mutilated, stunned—are trapped in the rubble and horror. The picture is witness to the worst act of terrorism ever to take place in the United States. The number of the dead, 168, must be multiplied many times over to reflect the true number of casualties. Mothers and fathers who lost children, sons and daughters who lost parents, sisters and brothers who lost siblings, and the grief goes on. The sorrow reaches out past the heartland to every corner of the country.

On June 10, 2001, the day before Timothy McVeigh was executed by lethal injection for his terrorist act, his attorneys issued a statement. Their client, they said, was sorry for those who suffered but he did not regret detonating the bomb. At 8:14 a.m. the next day, at the federal penitentiary in Terre Haute, Indiana, McVeigh was pronounced dead. Ten survivors and victims' representatives, ten members of the news media, and four individuals selected by McVeigh himself witnessed the first federal execution in the United States in thirty-eight years. No members of McVeigh's family were present. In Oklahoma City, via closed-circuit television, 232 survivors and victims' relatives watched him die.

Our responses to violence are as complex as the subject itself. Many respond to violence with a mixture of horror, revulsion, outrage, fascination, arousal, and valorization.
—James Gilligan, *Violence: Our Deadly Epidemic and Its Causes*

We are all wildly ambivalent about crime photography. We want to look, and we want to look away. Our response to many images of violence is the same as it is to a terrifying scene in a movie: we cover our eyes but leave our fingers just a little apart. The police photographer has no option; he must take his regulation overviews and close-ups. The newspaper photographer and the TV camera-man have more latitude with camera angles and subject matter. We, the conflicted public, expect them there, at the scene of the crime, as our surrogate observers.

The ancients and Shakespeare believed in the power of tragedy to reveal truth; in the later part of the nineteenth century, people started to trust the power of the new medium of photography. "The nineteenth century," writes William Ivins, Jr., in *Prints and Visual Communications*, "began by believing that what was reasonable was true and . . . would end up by believing that what it saw a photograph of was true." Today, fact and fiction collide in photographs, and often it is hard to know what is real and what is not.

The photographs in this chapter are from real crime scenes—unmediated, with an ugly, uncensored face. Pleasant pictures are easier to look at, of course, but perhaps Freud was right: we must face our demons as well as our deities. We look at landscape photography and lose ourselves in another place. We view historical images and arrive at a deeper understanding of the past. In portraits, we see men and women whose accomplishments we admire or detest, or who simply are our neighbors here on earth. We look at photojournalism to be informed, intellectually and emotion-ally, about people around the world—and too often, about their plight. Beautiful photographs exist to give sensual pleasure, while snapshots are taken, for the most part, to provide fond memories later. We have no road map, no background, for viewing many of the photographs in this chapter.

We come upon them alone. We bring our own personal history, our fears and fascinations. "Don't look," our mothers told us if there was something brutish in the world, "you will have bad dreams." I have had more nightmares about accidentally or intentionally murdering someone than I have had about being the corpse on the ground. I look at the victims in some photographs for cold comfort: they reassure me that I could never do that to another human being. In his article "The Pornography of Death" (published in 1955 and quoted in Barbara Norfleet's *Looking at Death*), Geoffrey Gorer concluded that death had replaced sex as the taboo subject in Western society. Even pornography may elicit a communal giggle; we feel more guilt looking at death than we do looking at forbidden flesh.

The world, however, does not become a kinder, gentler place because we hide what is not kind and gentle. The crime scene pictures here have been brought out of the closet and into our

crime Scenes

consciousness. These are difficult to look at because they demand so much of the viewer. And as with death itself, we must face the significance of these images alone. Police pictures are pure evidence, and in their starkness we recoil. Photographs by Weegee, Stephen Shames, Donna Ferrato, Andrew Savulich, Alex Tehrani, and Mark Peterson, although oppressive, are easier to reconcile because they have been filtered through another person's sensibility and art.

Death is a member of the family, the distant relative who shows up unwelcome and unrecognized. Yet its otherworldliness intrigues us and, since time immemorial, makes us want to know more. The following photographs are not like nineteenth-century postmortem pictures that suggest death as one long sleep. These are about flesh and blood and brutality.

Old cliché: A picture is worth a thousand words. New cliché: One real crime scene photograph is worth a thousand Hollywood images. Sharon Tate, movie actress, was strangled, eight months pregnant—no make-believe. The young women in Harvey Glatman's photographs were really raped and murdered. The fifteen-year-old in Stephen Shames's chilling picture is truly being shot up with heroin by an adult. Some mother's daughter was killed and dumped, like garbage, in an L.A. slum. The image of the bare-breasted woman hung like a slab of meat is not a tableau by Cindy Sherman, it is bitter reality.

Until one looks at death, it is doubtful whether life can be viewed with due respect. An image of violence is also, by its very contrast, a celebration of peaceful life. The act of looking assures that we have not reached the great finality. Life makes us unique. In death, we are all the same.

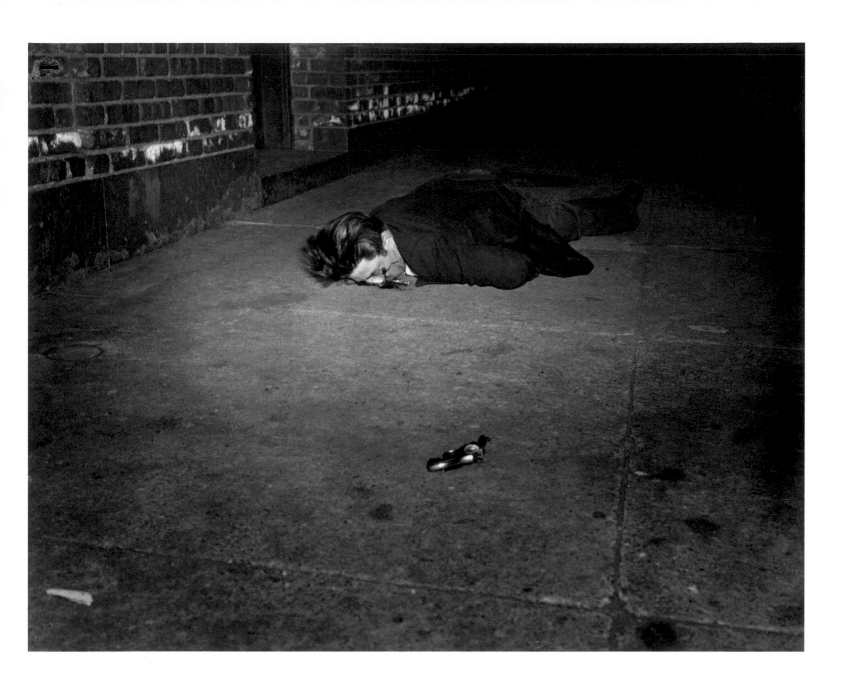

In a classic photograph by Weegee, the body of a gunman lies facedown on a New York City sidewalk on February 3, 1942, after he was shot dead by an off-duty cop.

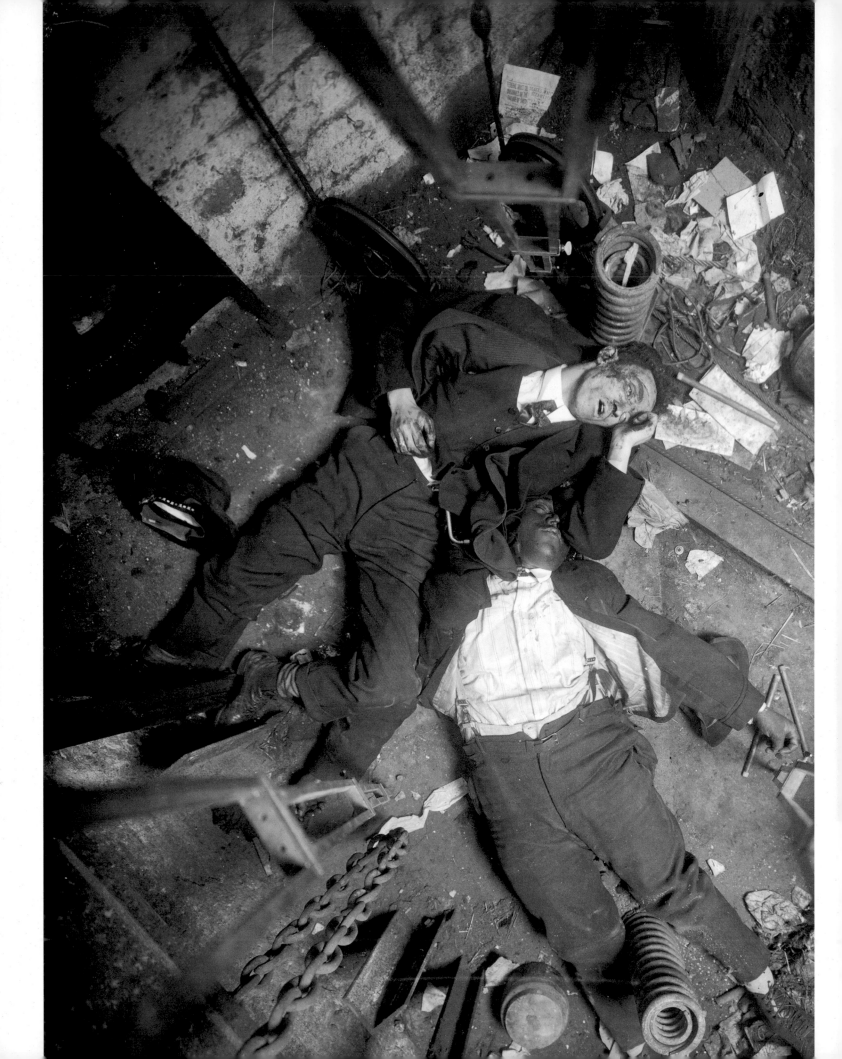

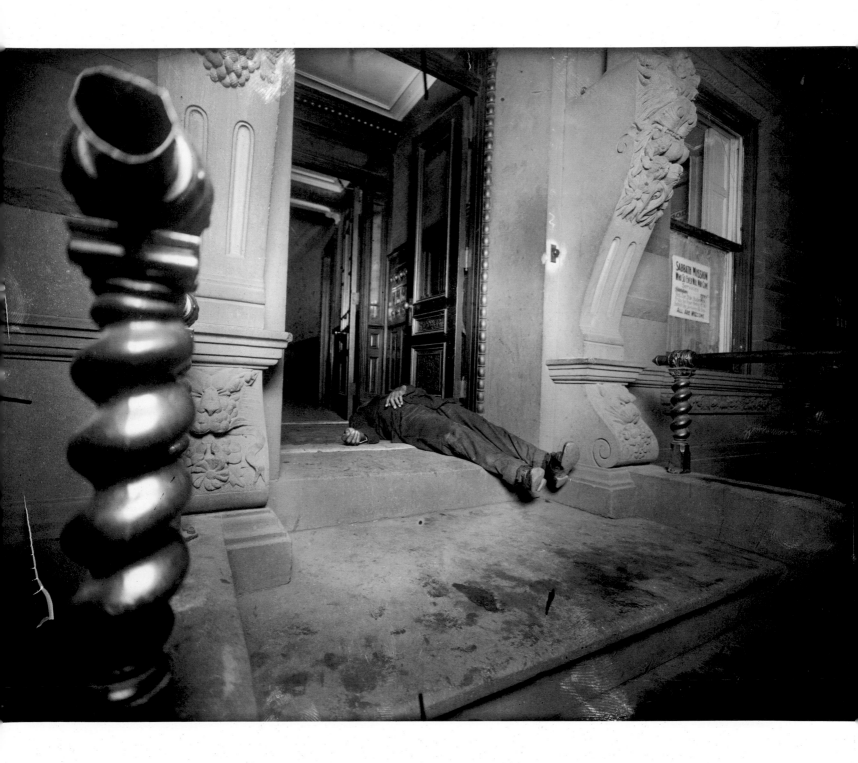

A total of 222 homicides were recorded in New York City in 1915. The eight-by-ten-inch glass-plate negative used in early police cameras captured precisely every coil, chain, scrap of newspaper, and drop of blood left at crime scenes. Police photographers were required to make images of murder victims from above; the legs of the photographers' tripods can be seen in the pictures on pages 44, 46, and 47.

(above) It is not known why the well-dressed John Rogers was shot on West 134th Street in Manhattan on October 21, 1916. The extraordinary scene, shrouded in mystery, was taken by a New York City Police Department photographer.

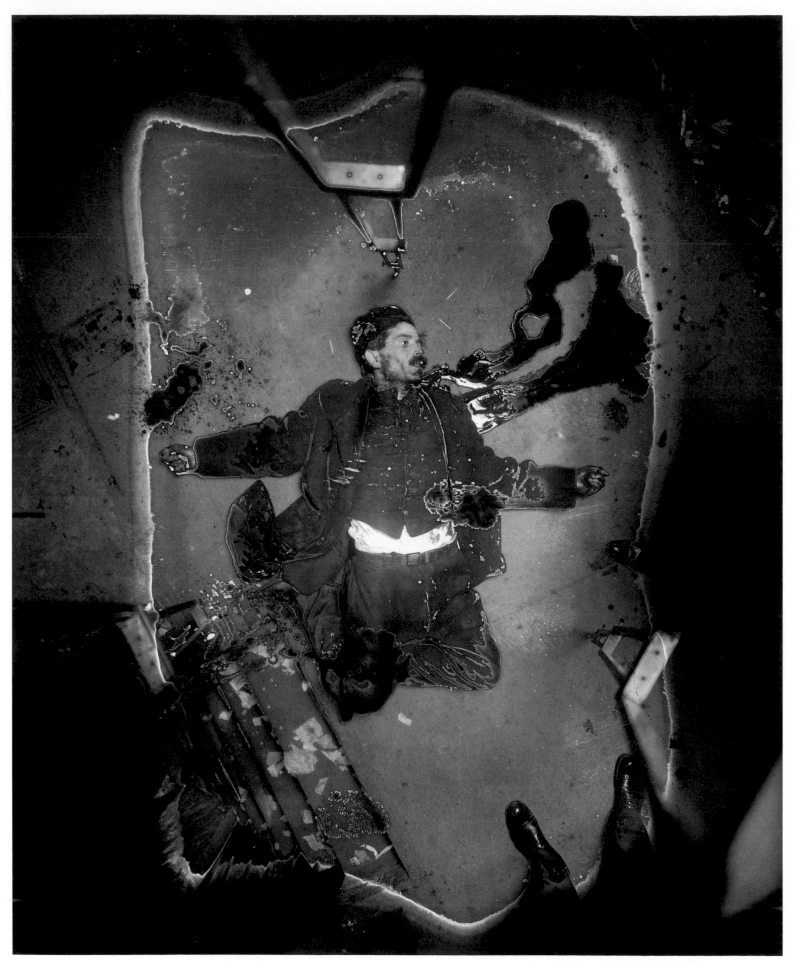

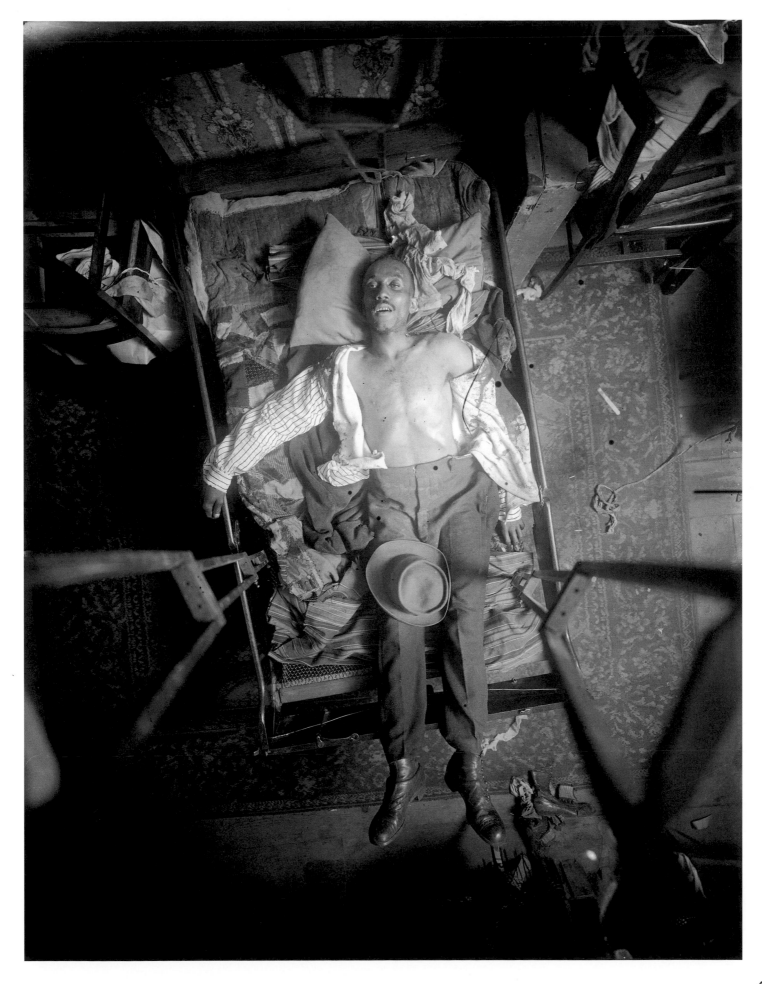

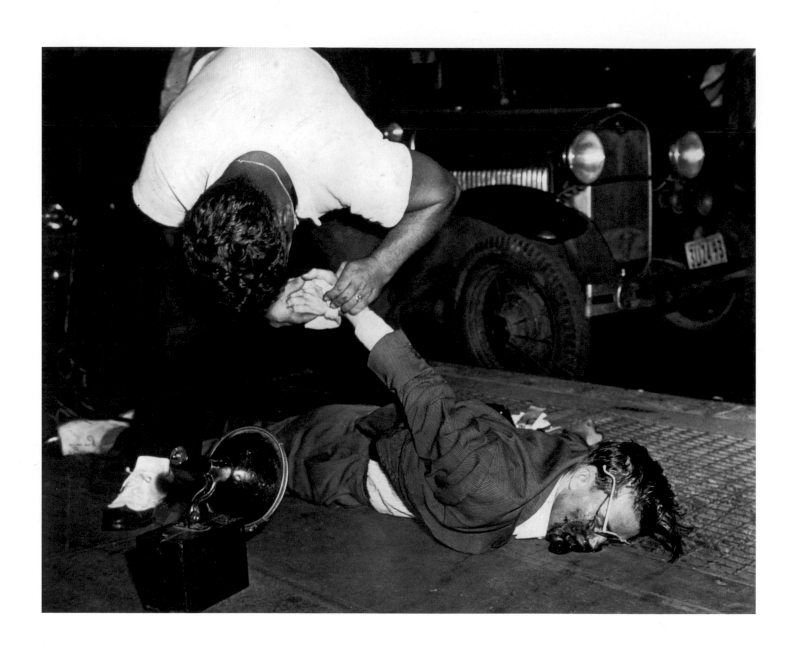

Roy Bennett, twenty-seven years old, had come from Texas by bus and immediately tried his hand at big-city crime. His first attempt at a stickup was his last: detectives shot him dead as he tried to escape on August 11, 1941. Weegee was on the scene with his camera and recorded Bennett's body being fingerprinted by police.

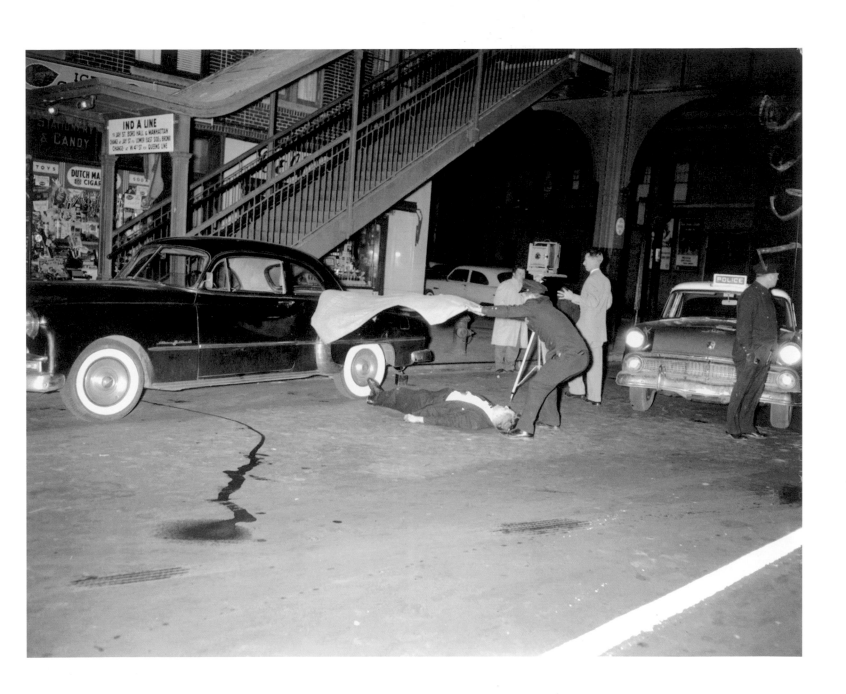

Police detective William F. Christman, a thirty-eight-year-old father of five,
was shot by twenty-five-year-old George Robert Thomson after an argument
over a World Series baseball game on October 9, 1956, in Queens.

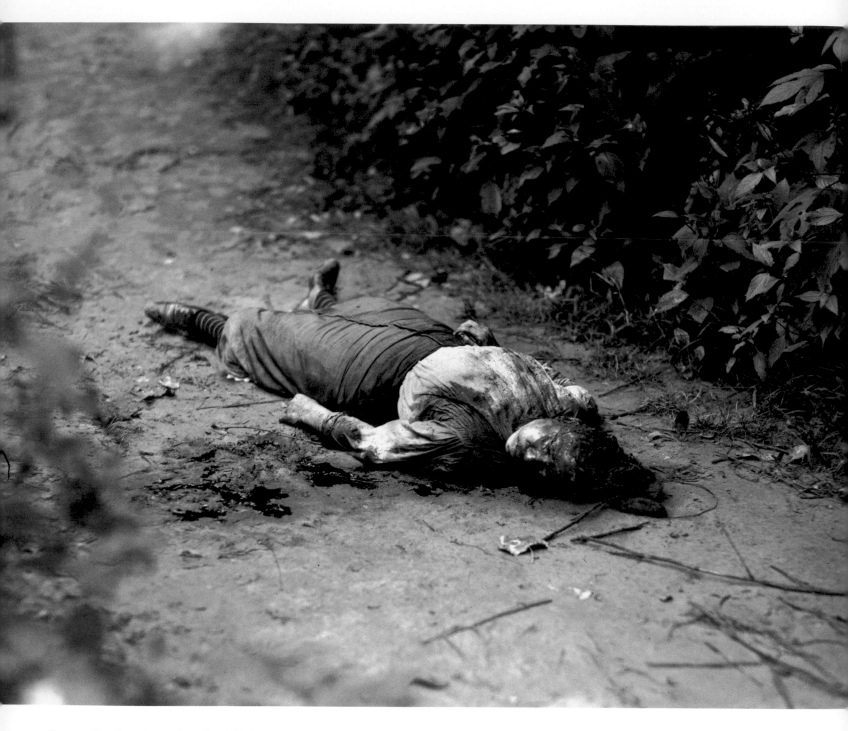

Spuyten Duyvil, at the northern tip of Manhattan, has been the site of crimes and unsettling discoveries throughout New York City history. This woman's body was found there on August 10, 1913; nothing further is known about her.

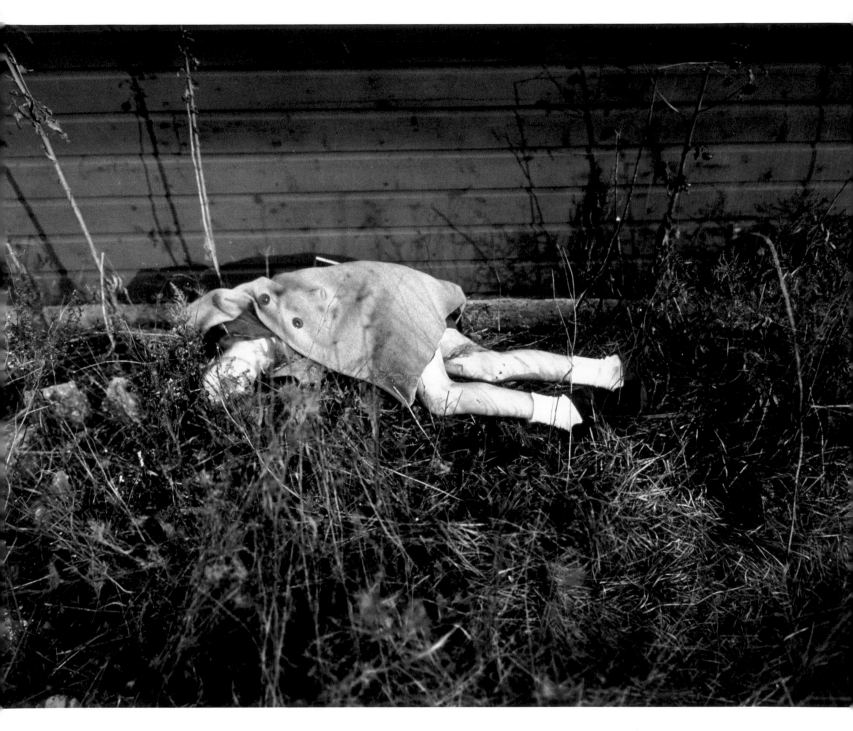

Susan Scanga was only sixteen in 1945 when she was found dead in a junk-yard at the foot of Huron Street in the Greenpoint section of Brooklyn. During the day she worked in an apparel shop; at night she attended business school. A bullet had been fired at close range to her head. She had not been beaten or raped.

On the wall near her body was written: "Nick." The police assumed the victim had scratched her assailant's name before she died. After questioning friends and relatives of Susan's, they issued an eight-state alarm for the arrest of her fifteen-year-old boyfriend, Nicholas Fomkin.

Nick and his friend Leonard Runkoski, sixteen, found themselves near Mobile, Alabama, four days after the murder. They had taken a bus to Philadelphia and hitched a ride south with an army lieutenant. Then they called Brooklyn police and asked for money to return home. Mobile authori-ties took them into custody until New York policemen arrived to retrieve them.

Nick Fomkin had been dating Susan for about seven months. On the night of November 20, while heading for a pool hall after drinking beer with friends at his home, he bumped into Susan. She was walking with a boy, a friend of both of theirs. According to Nick's testimony, he playfully put a gun to her head and said, "If you ever went out with any other guy . . ." and the gun went off. He panicked and threw the gun in a creek. He had traded his fish knife for his friend Leonard's gun.

Nick had written his own name on the wall. He evidently dragged his victim to a familiar haunt, inadvertently implicating himself in the crime by leaving her below the graffito. On December 6, Nick Fomkin pleaded not guilty to second-degree murder. He was remanded and on the following day pleaded guilty to first-degree manslaughter.

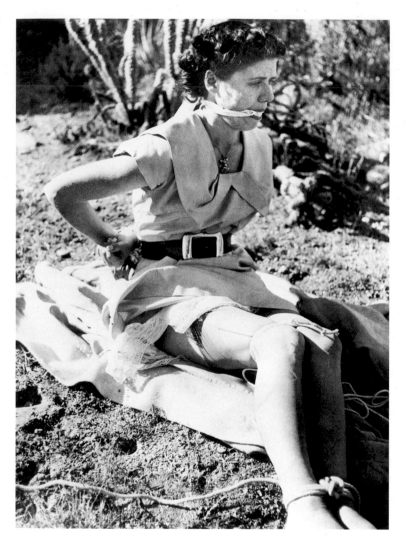 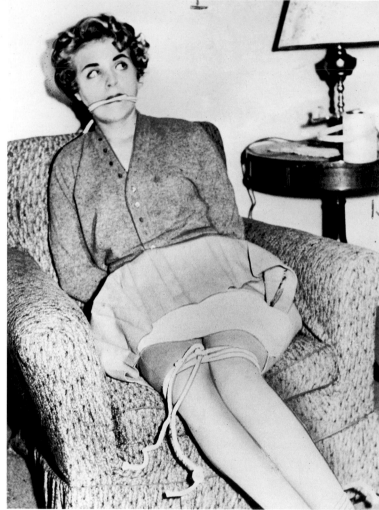

You are looking at two young women as photographed by their murderer, Harvey Murray Glatman. Photography was a hobby he took up after being released from prison in 1951. It was apparent, during his six-year incarceration for robbery, that Glatman had severe mental problems.

In Los Angeles in 1957, posing as a professional glamour photographer, Glatman advertised for a model. Finding would-be models and actresses was no problem, and on August 1, nineteen-year-old Judy Dull (right) arrived for a photo shoot. Once in his "studio," she was tied up, photographed, raped, and killed. Glatman buried her body in the desert.

Shirley Ann Bridgeford (left) was a twenty-four-year-old divorcée Glatman met through a lonely-hearts club. On their first date, he took her to the desert, raped her, tied her up, and shot her with his camera—and then with his gun.

Glatman's third victim had advertised her services as a model. He abducted her from her home, drove her to the desert, and spent the day alternately photographing her in the nude and raping her, before putting an end to her misery. His fourth victim, after being repeatedly raped and photographed, managed to grab his gun and hold him captive until help arrived. Glatman was convicted of murder in November 1958. He refused to appeal his sentence, and died in the gas chamber at San Quentin on August 18, 1959.

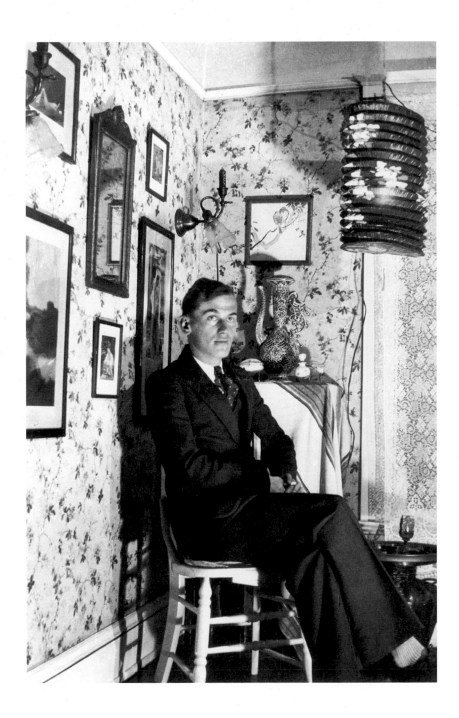

The Cleveland police felt that if they could identify the surroundings in the photograph, they might learn the identity of Edward Andrassy's murderer. They suspected the murderer may have been the photographer. Andrassy's headless and mutilated body was found beside that of another dead man in Cleveland's notorious Kingsbury Run section on September 23, 1935. The "Mad Torso Murderer" claimed eleven victims, and although Eliot Ness led the investigation, the murderer was never apprehended.

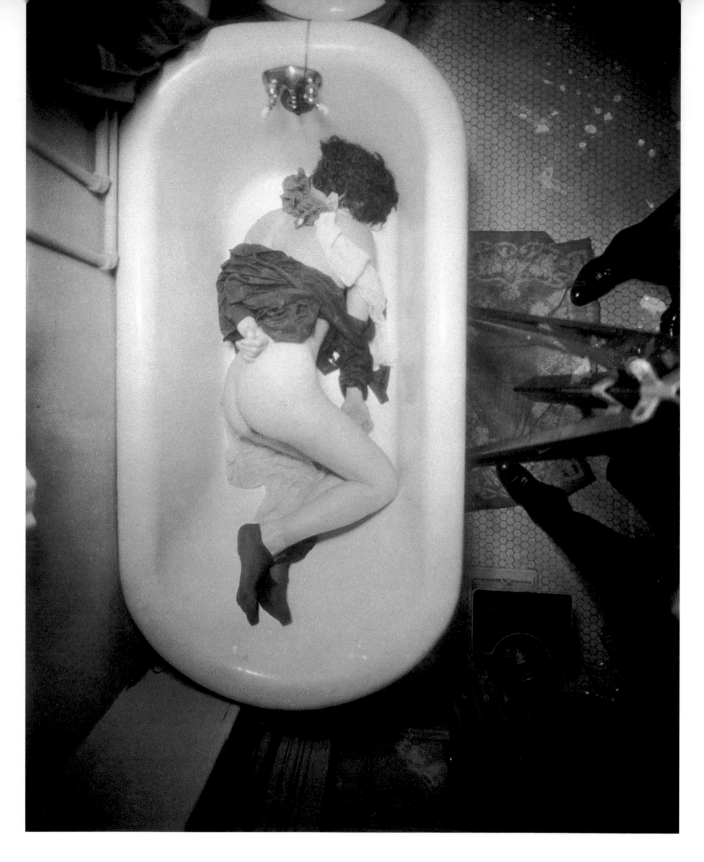

The murder took place on April 10, 1936, at a fashionable Manhattan address, 22 Beekman Place. The victim was a writer, thirty-four years old, married to an NBC executive. The story of the murder appeared on the front page of *The New York Times.* The police found no sign of forced entry, but evidently there had been a struggle: the woman's clothes were torn off, and her own pajamas were used to strangle her. She seemed to have been killed in the bedroom, then deposited in the bathtub. There was no mention of rape, but this was 1936 and the paper was the *Times*.

Twelve days later, a suspect was arrested: an ex-con who had upholstered a chair for the victim and who with another man "discovered" the body when they delivered a couch to the apartment later on the day of the murder. John Fiorenza, twenty-four years old, was found guilty of first-degree murder and sentenced to death.

The book *Crimes of Gender: Violence Against Women* by Gary E. McCuen, published in 1994, cites the following statistics: In the United States, violent crimes against women account for more injuries and deaths to them than do auto accidents and household accidents combined. Thirty percent of women murdered in this country are killed by their husbands or boyfriends. Four women a day are murdered as a result of domestic disputes. Murder is the second leading cause of death among young women in the United States.

The pictures above are downloaded from a website, lasecrets.com/MurderInc.htm, and the address could not be more apt. Secrets emanating from the anonymous streets and tawdry rooms of Los Angeles. The photographs are found on the Web, but who took them, who put them into cyberspace is unclear. The Web is an equivocal temptress: seduction and repulsion at the click of a mouse.

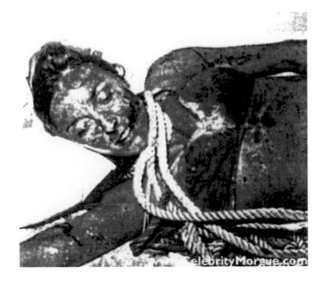

On August 9, 1969, members of Charles Manson's "family" stabbed to death Sharon Tate and killed four others who happened to be at her house. Tate, an actress and the wife of film director Roman Polanski, was eight months pregnant.

In the introduction to Donna Ferrato's book *Living with the Enemy,* Stacey Kabat likens Ferrato to "a combat photographer. Her territory is this singular war in which both sides occupy the same ground, this civil war in which women strive for democracy and freedom while men fight to preserve the old regime. In this devastating war the battlefield and the home front are one and the same. And there are no winners."

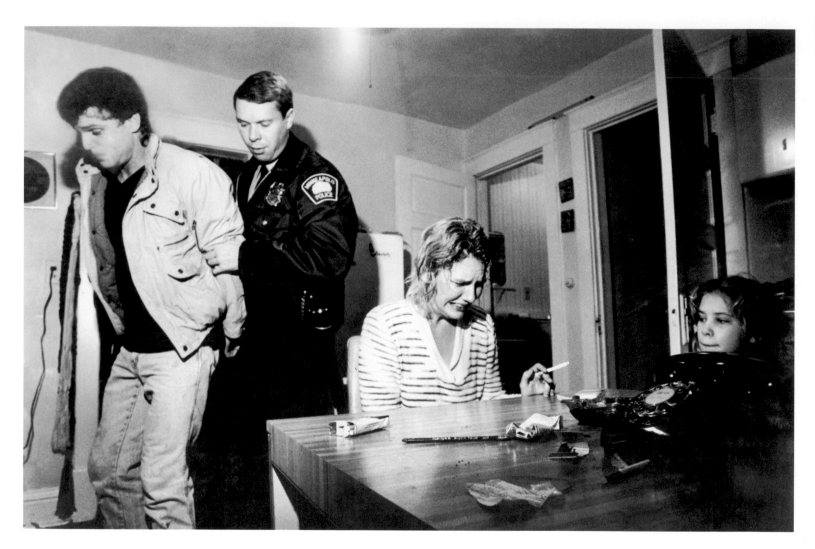

"He fights all the time, but it was never this bad before," Karen sobbed as her boyfriend was arrested. Her children had been awakened when the boyfriend threw Karen against the bathtub, knocking her unconscious. Later Karen told a battered-women's advocate in the hospital emergency room that she didn't want to press charges. The boyfriend was released from jail the following morning.

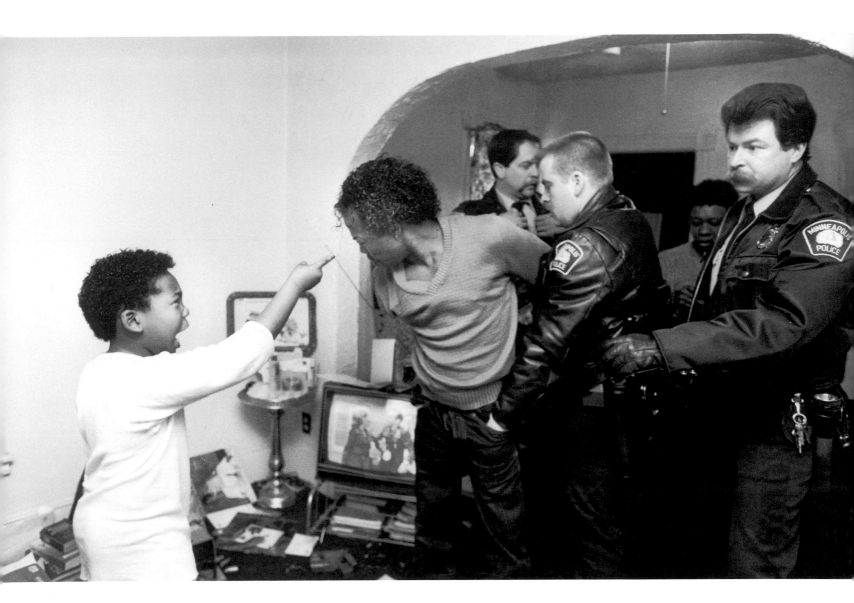

"I hate you! Never come back to my house," an eight-year-old screamed at his father as police arrested the man for attacking his wife.

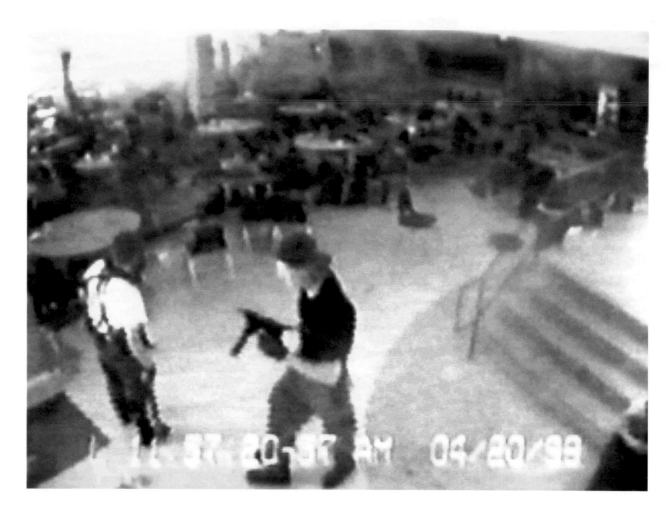

On Hitler's birthday in 1999, Eric Harris and Dylan Klebold set out on a "suicide mission" at their Colorado high school. They killed thirteen of their fellow students and one teacher, and wounded twenty-three others before turning their guns on themselves.

The year before, on May 20, 1998, in Springfield, Oregon, another high school student, Kip Kinkel, killed his parents at home, and the next day walked into his school and sprayed students with fifty rounds from a semiautomatic rifle, killing two and wounding twenty-five. A note found in his house after his arrest reveals the state of mind of a young person on the brink:

It's not their [his parents'] fault or the fault of any person, organization, or television show. My head just doesn't work right. God damn these VOICES inside my head. I want to die. I want to be gone. But I have to kill people. I don't know why. I am so sorry! Why did God do this to me? I have never been happy. I wish I made my mother proud. I am nothing! I tried so hard to find happiness. But you know me I hate everything. I have no other choice. What have I become? I am so sorry.

The site could be a McDonald's anywhere across the nation; this one is in San Ysidro, California. The year is 1984.

James Oliver Huberty was ordinary in many ways: He was married with two children. He worked as a mortician, a welder, and a security guard, although he had had difficulty keeping a job over the past year. He owned guns to defend his home and family.

Around four in the afternoon on July 18, Huberty headed for the door of his apartment with a twelve-gauge pump shotgun, a Browning nine-millimeter, a semiautomatic pistol, an Uzi carbine, and a bag of ammunition. When his wife asked him where he was off to, he told her he was "going to hunt humans."

Huberty went to a nearby McDonald's, tuned his transistor radio to a pop music station, and opened fire. Two hundred forty-five rounds and seventy-five minutes later, he had shot forty people, twenty-one of whom would die; four others had hidden themselves, and five had escaped. A police sharpshooter brought Huberty down.

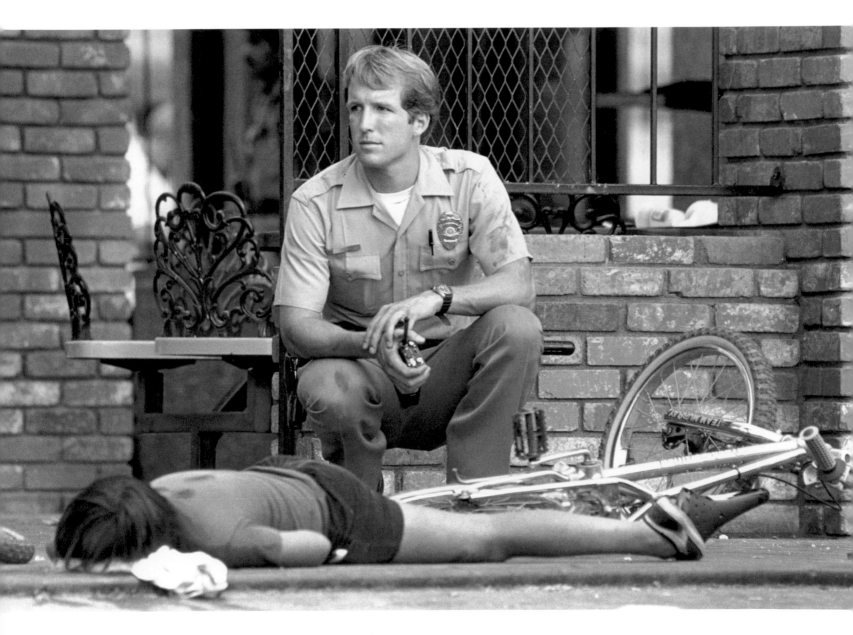

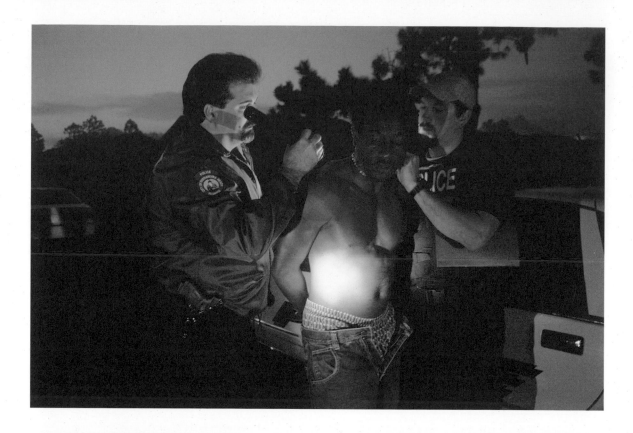

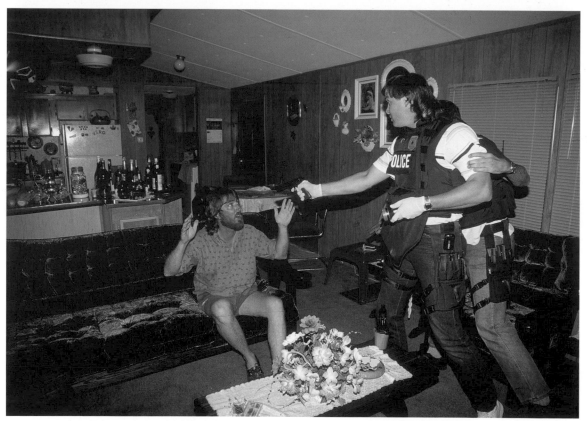

(top) This is one of forty-three arrests made by a mobile enforcement team, or MET, in the cocaine-infested town of Fernandina Beach, Florida, in an on-going operation that lasted from September 1999 through early 2000 and cost half a million dollars. METs, undercover units within the Drug Enforcement Administration, typically enter communities where there is a drug problem that local officials cannot handle, then negotiate as many drug deals as they can over a three-to-four-month period, and, in a single massive roundup at the end of that period, arrest as many dealers as possible.

(bottom) A drug enforcement team in Houston barges into the house of a suspected crack dealer to make an arrest.

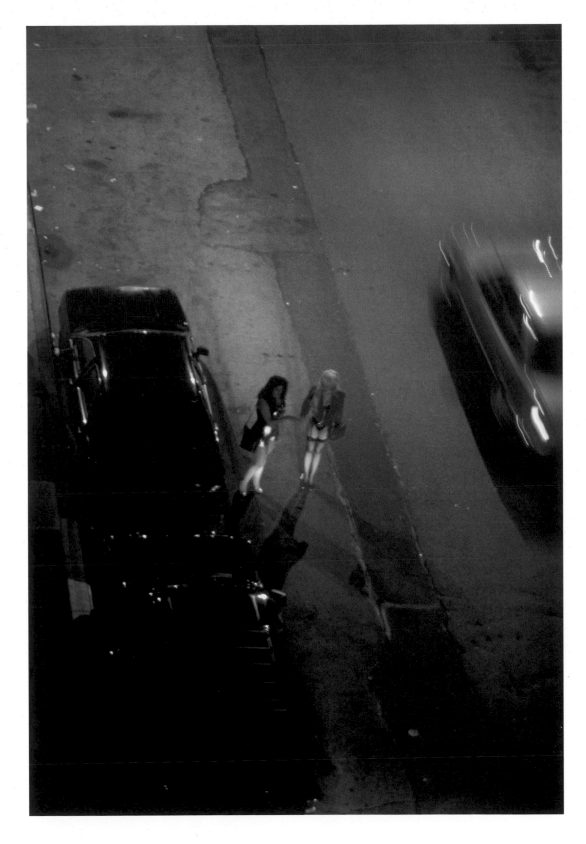

The rights of women are central in the ongoing debate about whether or not prostitution should be decriminalized. Wendy Chapkis, a professor of sociology and women's studies and the author of *Live Sex Acts: Women Performing Erotic Labor*, feels that keeping prostitution illegal exacerbates prostitutes' problems by isolating the women from the law and leaving them vulnerable to abusive pimps and johns. "In a profession where women traditionally are not treated well, aren't empowered, and should be able to go to the police for protection and assistance," she writes, "we make the police an extra obstacle, a threat." The "working girls" themselves are conflicted, however: she has interviewed street prostitutes (such as the two New Yorkers in the photograph) "who feel powerful and in control and are making a lot of money," and has met "many high-class call girls who hate their jobs." Since 1975, sex workers have formed support groups to have their business recognized as an industry, not a crime.

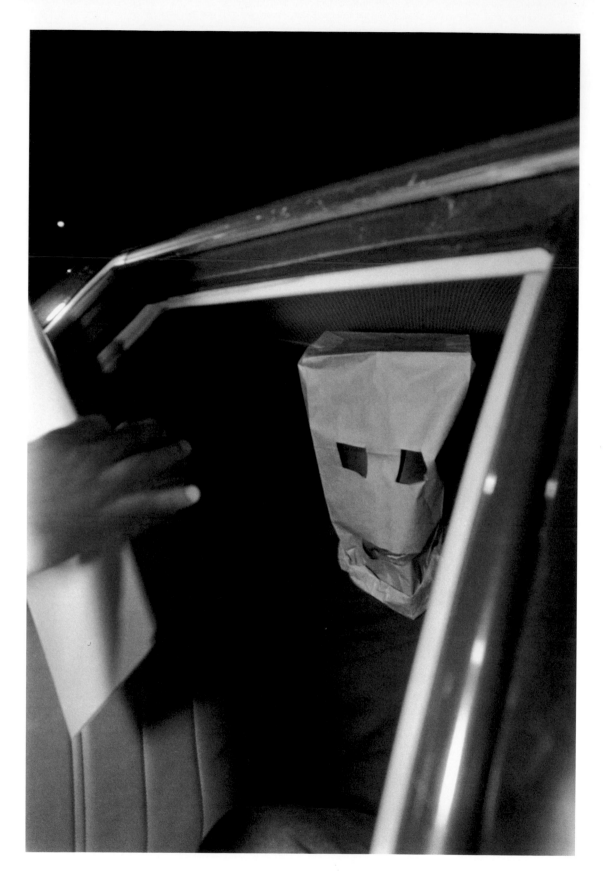

The East Side Rapist, the one who began attacking and terrifying women in New York City in the 1980s, is still at large. He has been indicted, though, on the basis of his DNA. If he is ever arrested in the United States, he can be charged with rape.

This photograph shows another rape suspect on his way from a police station to Central Booking in 1985. The paper bag that the police have put over his head means that his face won't appear in the next day's paper or on the evening news. Victims are often asked to identify their assailant in police lineups, and keeping a suspect's features concealed helps with fairness and accuracy in identification.

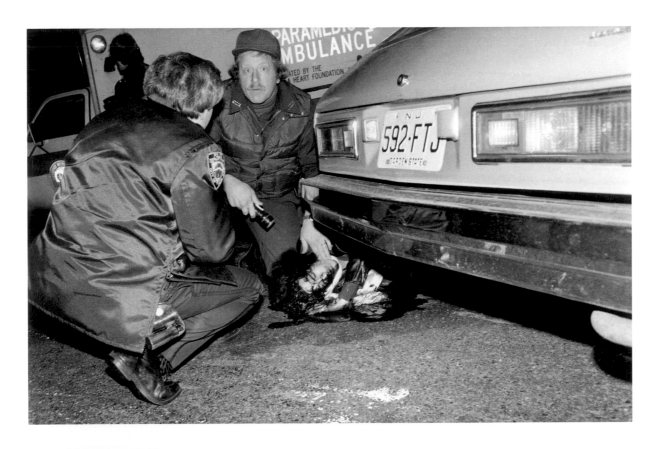

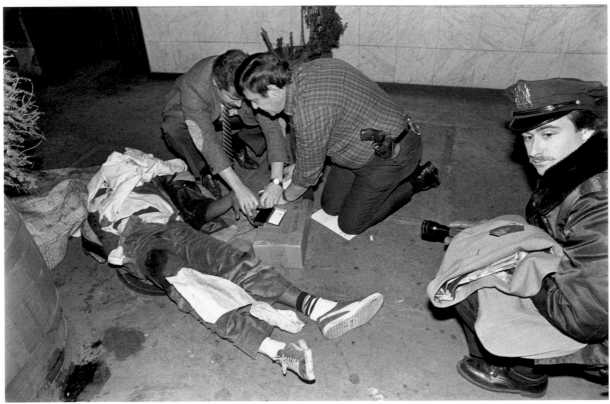

"Simple" crimes, with unanticipated consequences. (top) A car thief lies fatally injured after a high-speed chase by police in 1981. (bottom) Homicide detectives take fingerprints of a man shot dead by police after he shot an off-duty policeman during an attempt to rob him on a midtown Manhattan street in 1982.

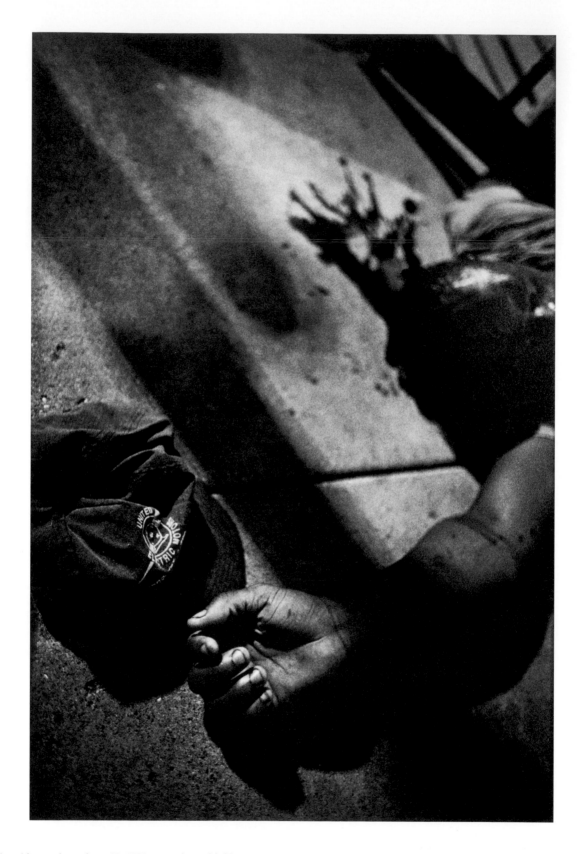

The man lying dead on his porch on June 13, 1992, was shot with his own rifle after threatening his girlfriend once too often. When the police arrived yet again at the house in Houston, they had little sympathy for the victim. Texas has a long tradition of supporting the right to bear arms, and a woman who defends herself against a violent partner there has a good chance of being let off. The woman in this case was not prosecuted.

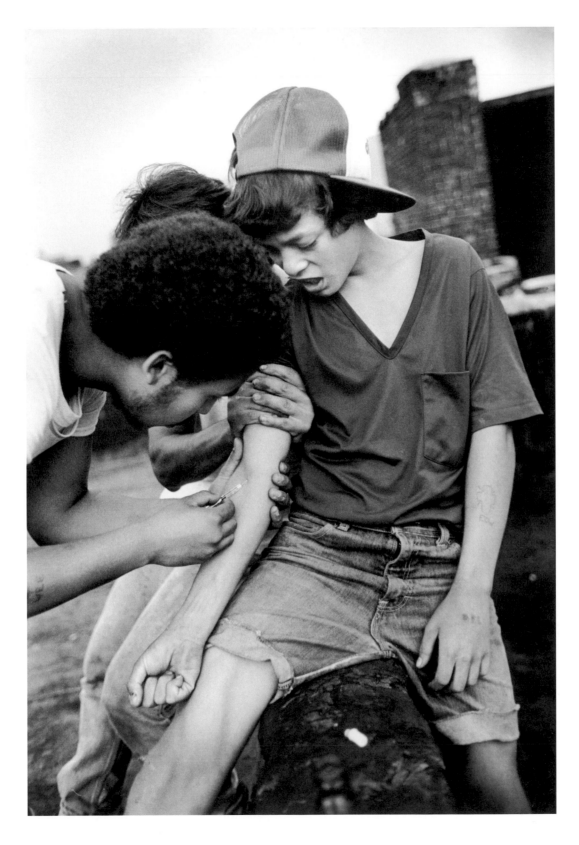

A "friend" with a very small *f* helps fifteen-year-old Delfin shoot up on a rooftop in the Bronx in 1982. Delfin was already addicted to heroin. When the photographer Stephen Shames's book *Outside the Dream: Child Poverty in America* was published nine years later, Delfin was in prison serving a life sentence for murder.

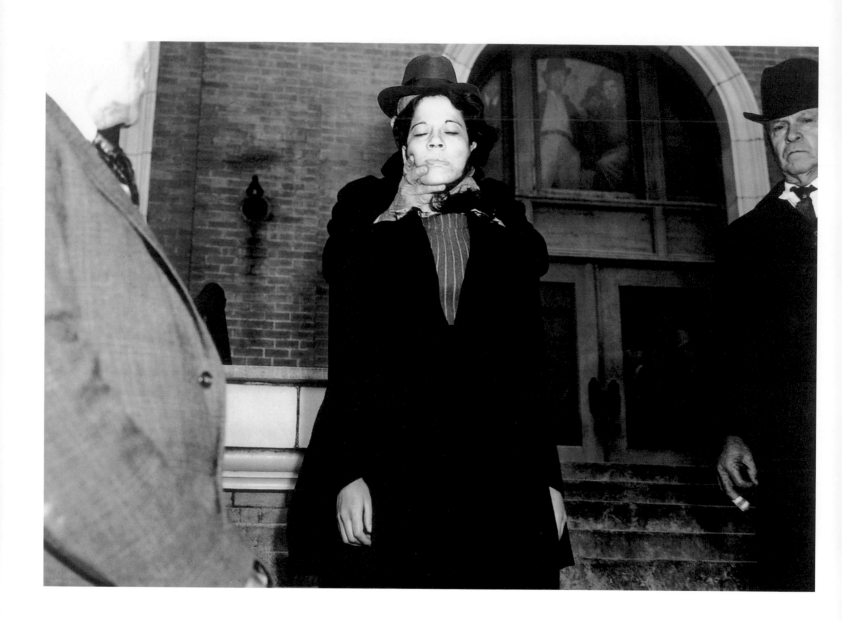

This is the face of a murderer. Mrs. Annie Beatrice Henry, photographed on February 21, 1940, killed a Good Samaritan in cold blood. Joseph Calloway had seen Henry and a companion walking wearily along a road near Lake Charles, Louisiana. He offered them a ride, and in return they forced him into a field, stripped him of his clothes, and shot him as he begged for his life. Henry, who pulled the trigger, wanted money for her murderer husband's appeal. She was executed in Louisiana on November 28, 1942.

Their faces are unfathomable—gentle and cruel, innocent and hardened, unquestioning and perplexed. They may have lived a life of crime or committed one single devastating violent act. They are mothers and fathers, sons and lovers. We look at their faces to search their souls. "Through the eyes," Michelangelo wrote in 1533, "the heart is seen in the face." The viewer's eyes, through the camera's eye, search the killer's eyes for clues. Why did this person murder? How could he take someone else's life? Might he again stop another's heartbeat? Has he no heart himself, no soul?

The father of serial killer Jeffrey Dahmer thought his son might have been born without a conscience. The Reverend Hans Schmidt looks remorseful in his photograph. Women who kill in self-defense have the look of victims, not perpetrators. Compare the faces of Juanita Thomas, who killed her repeatedly violent boyfriend, and Nannie Doss, who used rat poison to murder four husbands. What category of murderer is the nineteen-year-old father who lives with his four children and teenage wife in one room and stops the crying of his newborn daughter with two fatal slaps to the face? What are the forces—within and without—that make someone snap, become a killer?

We look at the faces in this chapter, as well, to see if we recognize ourselves. Could we possibly, by accident or will, take another person's life? Freud said that people with character or personality disorders act out in their behavior the fantasies that normal people act out in their unconscious minds. Few portraits in this chapter instill fear, but no one would want to be left in a room with the "Butcher of Clarksburg." Mug shots imply criminality, so John Wayne Gacy looks guilty; yet his victims thought him jovial and kind. And look at Richard Hickock and Perry Smith, and Gary Gilmore, whose lives and deaths were the inspiration for bestselling books by Truman Capote and Norman Mailer, respectively. They are not the heroic figures of literature. Their photographs show them as they were—boys who became young men who went wrong. Ted Bundy, whose good looks and charm deceived enough people, is pictured not dapper and dandy, but dead. Nowhere do the eyes as gateway to the heart unsettle as they do in the photograph of Charles Manson on page 78. In them we see not a media performer but evil incarnate.

In his book *Violence,* James Gilligan writes: "The 'pornography of violence'—the sensationalizing of violence—is a means by which we distance ourselves from it, perhaps render it less frightening and more manageable by reducing it to the dimensions of titillation and entertainment." The photographs in this chapter try to make the subject of murder more complex, more resonant to our human condition, and to bring it closer to, not further from, our consciousness.

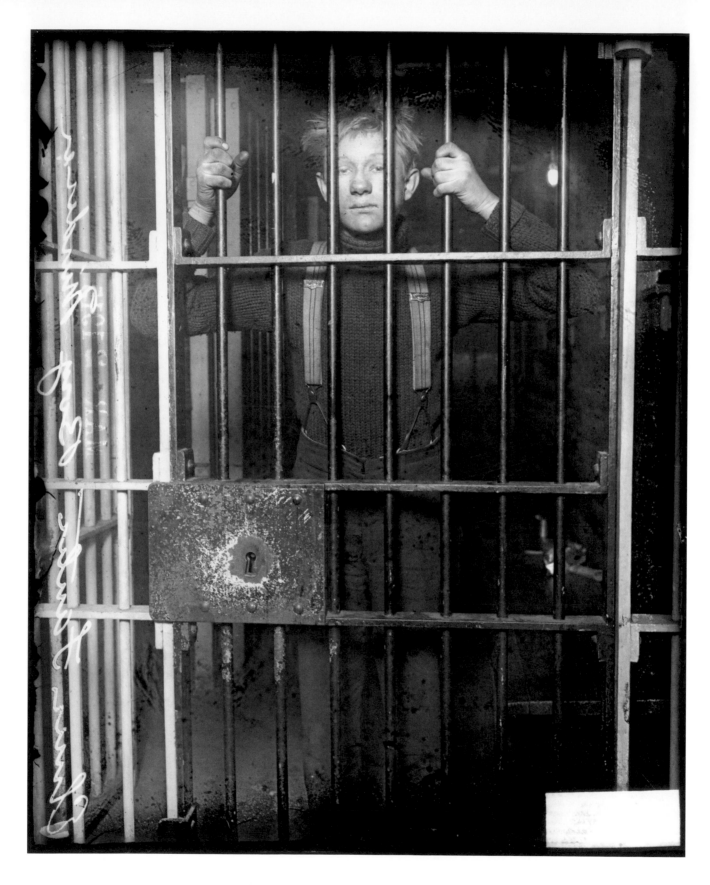

Elmer Fanter, sixteen, with two accomplices, sixteen-year-old Charles Miller and nineteen-year-old Otto Mann, attempted to hold up Mrs. Diana Hoffmann's delicatessen-confectionery in Chicago on a February morning in 1915. A fifty-three-year-old tailor named August Jantzen came to Mrs. Hoffmann's aid, and Fanter shot and killed him.

In this photograph, Fanter waits for a grand jury hearing. He looks lost and confused, as, of course, he is. He and his friends saw no violent movies and were not subjected to inappropriate scenes on television, and those hands clenching the bars of the prison door never moved a mouse in a violent video game.

In September 1913, a young woman's dismembered body, part of which was wrapped in a pillowcase, was found along the Hudson River. The county physician of the area of New Jersey where the pillowcase had washed ashore ascertained that the victim had given birth prematurely not long before she was murdered. The coroner observed that whoever had dismembered the body knew what he or she was doing.

The pillowcase bore distinctive markings, and the police were able to trace it to a particular store. The shopkeeper recalled the customer who had bought the pillowcase, and directed the police to the Reverend Hans Schmidt.

Schmidt, thirty-two, had served at St. Boniface Catholic Church in New York City before assuming his current appointment as assistant pastor at St. Joseph's on West 125th Street. The police found him there, in the rectory. They had learned that he also rented an apartment, where, however, he did not live, and insisted on being taken there. In the apartment they found bloodstains, a bloody knife, and a saw. Schmidt broke down and confessed to the murder of Anna Aumuller. The motive he gave: "I loved her."

Aumuller was a twenty-one-year-old German immigrant who worked as a servant at St. Boniface. On February 26, 1913, she and Schmidt obtained a marriage license, and Schmidt himself performed the wedding ceremony. He set Anna up in the rented apartment.

Authorities investigated whether Schmidt really was a priest (he was, trained in Germany). When questioned, he admitted a shady past, involving counterfeiting and posing as a physician after receiving some surgical training. There was no mention of a botched abortion in Aumuller's case, but that appeared to have been her fate.

On December 7, Schmidt was put on trial for murder. He pleaded not guilty on grounds of insanity. The trial ended on December 30 with a hung jury. He was retried the next month, and again used the insanity defense. This time Schmidt was convicted of first-degree murder and sent to Sing Sing to await execution on March 23, 1914.

At first Schmidt accepted the verdict. Then he changed his mind, and appeals, stays, and new explanations ensued. Finally, on February 12, 1916, Schmidt went to his death, declaring that his insanity plea had been meant to protect people whose help he had solicited; he was, he said, "morally responsible," but was being executed only for the crime of lying. He was the first Catholic priest to be executed in the United States.

(below) Rena Morrow, twenty-three, was accused of murdering her retired inventor husband on the morning of December 28, 1911, in Chicago. Charles Morrow was found on his back porch with two bullet wounds, one to the heart and one to the head. Mrs. Morrow said it was suicide; her stepson Dr. Arthur Webster Morrow claimed otherwise—she had even threatened and shot at him before. Imagining a suicide in which the individual shoots himself first through the chest and then through the head is difficult, but such a feat is not impossible. A jury acquitted Mrs. Morrow in July 1912, the year this picture was taken; she pledged to sue her stepson for libel in his attempt to gain control over his father's property.

(above) Ethel Parker, alias Frankie Ford, and also known as the "Vampire Woman," sits for the camera on September 6, 1912. She was connected to an Illinois vice ring. A "morphine maniac," according to the press, Parker was accused of murdering two people while under the influence of the drug.

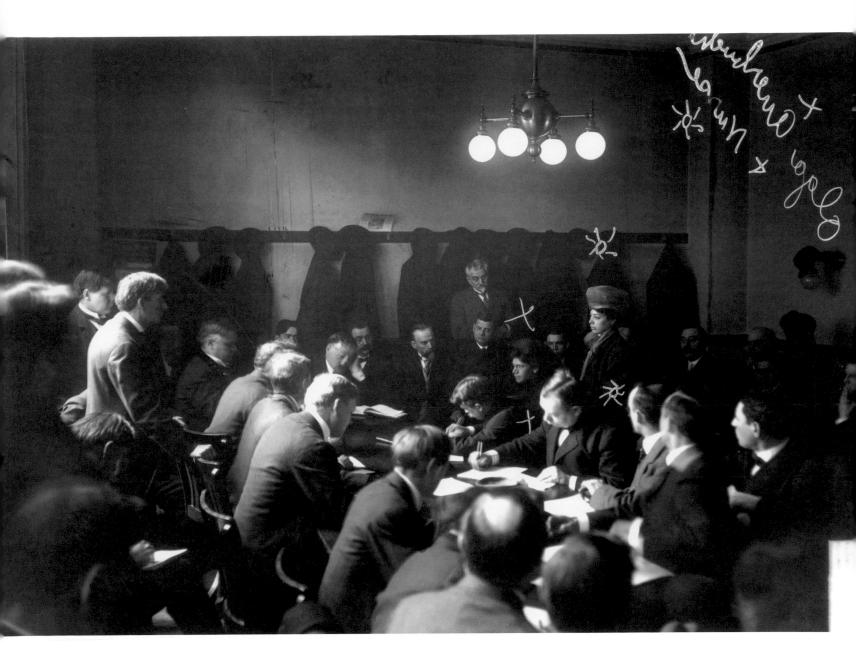

Olga Averbuch, Russian immigrant, stands to testify at the inquest for her brother Lazarus (aka Jeremiah/Henry/Jeremy). The only other woman in the room, seated beside her, is identified as a nurse.

On the morning of March 2, 1908, Lazarus Averbuch attempted to assassinate the Chicago chief of police, George M. Shippy. Averbuch appeared at Shippy's home, 31 Lincoln Court, stabbed the chief in the right side, wounded his driver in the wrist, and shot Shippy's nineteen-year-old son, Harry, in the right lung. Harry was seriously injured, and not expected to survive, but he did. Chief Shippy was able to pull his gun and shoot Averbuch, who died.

A few weeks before the attack, it was believed, Averbuch had participated in the "Hoboes' Parade" organized by Ben Reitman, a famed anarchist. The police had been denounced for halting the parade and clubbing marchers. The Chicago *Daily News* suggested that their handling of the march had enraged Averbuch.

The Averbuch family had survived a massacre of Jews in Russia in 1905 and fled to Austria before immigrating to the United States. Olga did not attend anarchist events in Chicago, but according to a newspaper report, police were investigating "social settlement workers" and friends of hers after the attempt on Shippy's life. A coroner's jury eventually ruled the police chief's shooting of Lazarus justifiable homicide.

The *Daily News* ran a large profile portrait of Averbuch after the attack, with the caption "The Anarchist Type," and on the picture the numerals 1 through 5, indicating his features that purportedly reflected anarchist political leanings: "low forehead, large mouth, receding chin, prominent cheekbones, and large simian ears."

On March 8, 1943, after carefully bathing her two-week-old baby, Mrs. Rosary Shellfo, twenty-two, laid the infant facedown on her kitchen breadboard and hacked off his head. She had, her sister-in-law related, a morbid obsession that something was wrong with the child. Shellfo told police simply, "I don't know why I killed my baby."

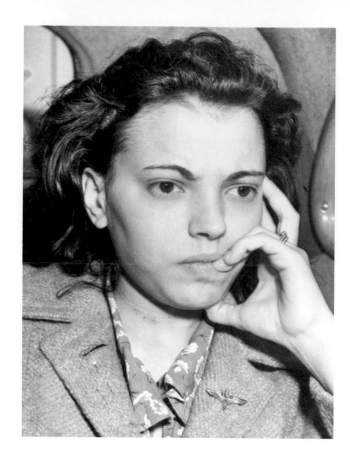

Detective D. L. Sund of the Los Angeles Police Department examines the body of the Shellfo baby in the kitchen where his mother murdered him.

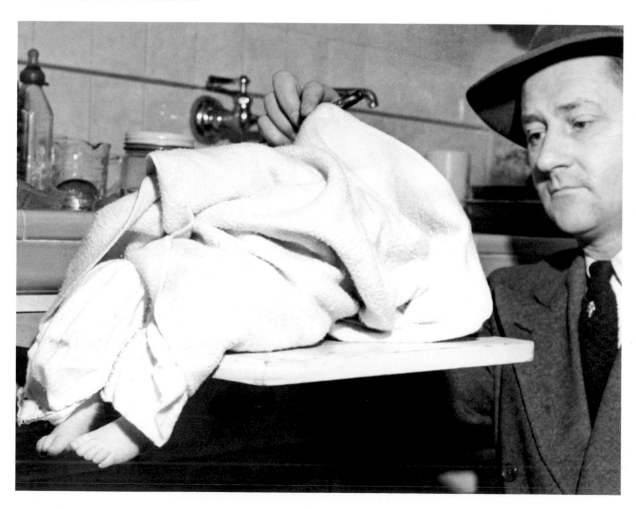

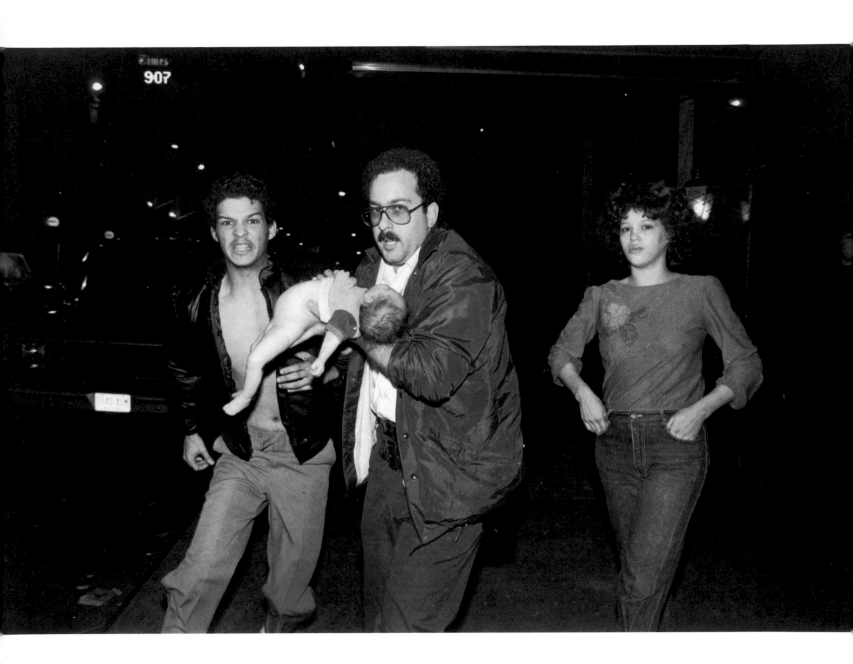

A medical technician carries infant Jasmin Correa to an ambulance as her father Joaquin, who was charged with her death, and mother Marisol follow. The Correa family, nineteen-year-old parents and their four children, lived in a single room at a New York City welfare hotel. On November 23, 1983, the crying of the youngest child, twenty-five-day-old Jasmin, provoked the anger of her father, who was trying to sleep. Her mother took her into the bathroom, quieted her, and then returned and placed her on the king-size bed. When Jasmin began crying again, Joaquin hit her twice. Frightened, the parents called the police with an invented story; when the emergency rescue official arrived, it was already too late.

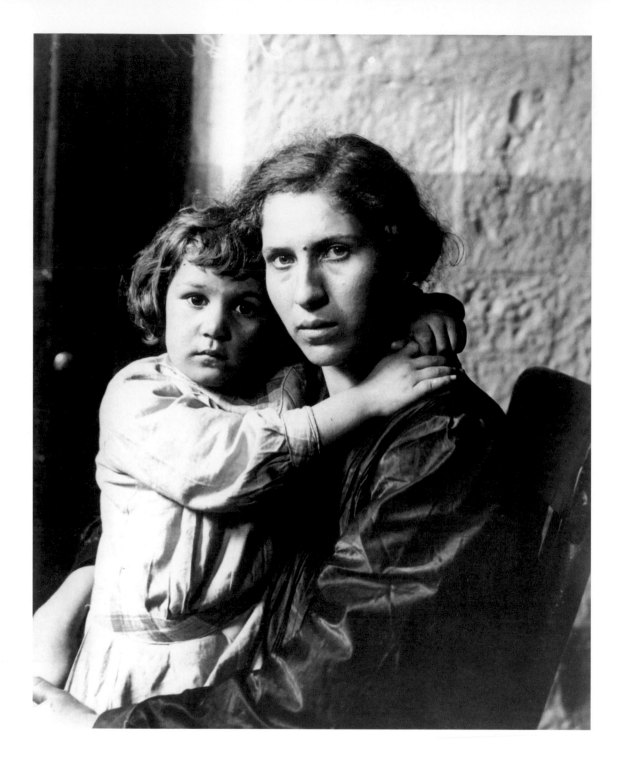

The body of Peter Musso, age thirty-two, was found on April 30, 1912, murdered in his blazing bed. He had been shot three times. His wife, Antonia, and daughter, Catherine, had disappeared. Two days later they were located at the home of Mrs. Musso's aunt. Antonia Musso confessed to the murder but claimed self-defense.

Antonia Musso was brought to trial in February 1913 (after the picture above was taken). Three recent cases involving wives accused of killing their husbands, Florence Bernstein, Rena Morrow, and Jane Quinn, had resulted in acquittals. The Chicago *Daily News* reported that Mrs. Musso was optimistic about the outcome of her trial. When she began her testimony, however, she broke down crying and court had to be adjourned. The headline the next day, running across seven columns, read: "Woman Faints Telling Murder Story." On the witness stand, Musso stated that her husband

believed she was having an affair with their landlord, a former alderman, but refused to allow them to move to another building. The night of April 29, she testified, "I started to wash the dishes, and he said: 'You don't need to wash the dishes. You won't eat from them any more.' He then went to a closet and got a revolver. 'See this? I am going to kill you with this to-night.' . . . He said I would have to tell him the truth. I told him what he accused me of was not true. He asked me where his razor was . . . and when we went to bed that night he said: 'I'm going to kill you with this; a gun makes too much noise.' . . . I cried. . . . He wouldn't let me out of the bedroom. I didn't take my clothes off, because if he went to sleep I was going to get my baby and run away." Women in the courtroom wept in sympathy.

The state wanted Musso found guilty and hanged. On February 28, 1913, after a half-hour deliberation, the jury returned a verdict of not guilty.

Lana Turner looks more vulnerable than in any of her films as she fetches her thirteen-year-old daughter from a police station in downtown Los Angeles in April 1957 after the girl was picked up wandering on Skid Row. One year later, on April 4, 1958, Turner was arguing loudly with her boyfriend, the small-time hood Johnny Stompanato, in the bedroom of her Beverly Hills home. When Cheryl heard her mother being threatened, she took a butcher knife from the kitchen and ran upstairs. Whether she stabbed Stompanato or he ran into the knife is unknown; he died in the room.

After hearing tearful testimony by Turner, and deliberating for an hour, a coroner's jury ruled Stompanato's death a justifiable homicide. Rumors, never proven, lingered that Cheryl and Stompanato had been lovers, and that Turner killed Stompanato and let her underage daughter take the rap. Cheryl Crane was made a ward of the court and placed in her grandmother's custody. Stompanato's gangster boss, the infamous Mickey Cohen, reportedly commented: "It's the first time I ever saw a man convicted of his own murder."

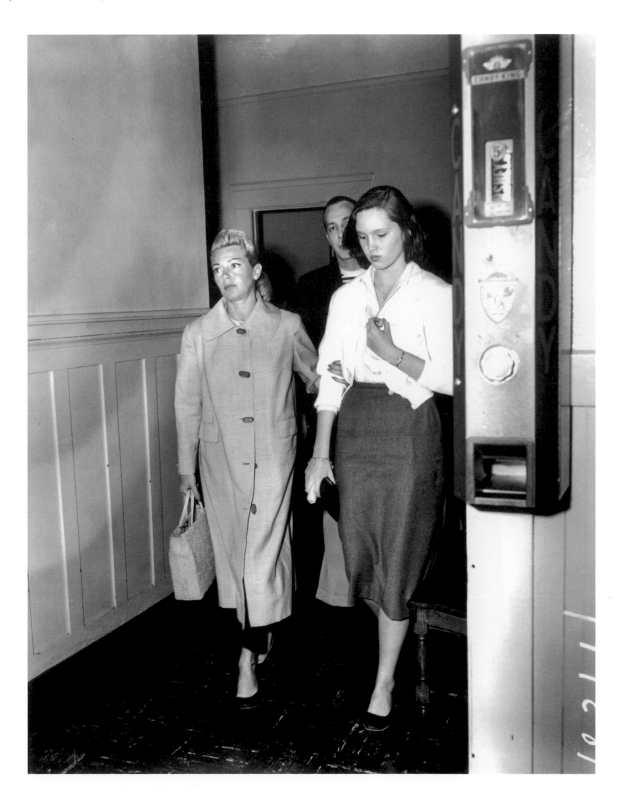

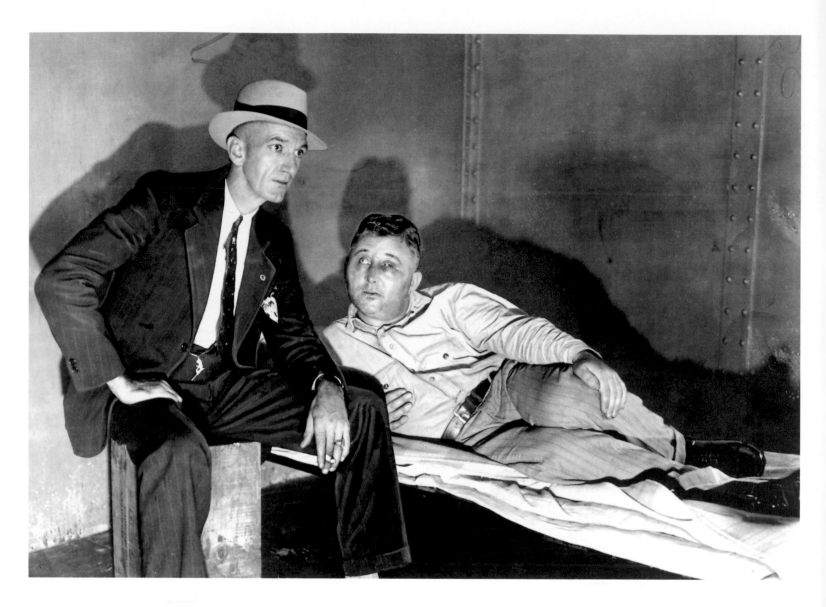

Herman Drenth, known as the "Butcher of Clarksburg," describes the grisly details of his murders to a detective in his cell on September 1, 1931.

Harry Powers was one of the names used by Drenth, who is believed to have killed some fifty women in the windowless concrete torture chamber he built at his home in Quiet Dell, West Virginia. When Drenth was finally confronted by police with evidence of five murders, he confessed but added, "You've got me now on five, what good would fifty more do?"

During the late 1920s, Drenth was addicted to reading newspaper classifieds of single women and widows seeking a husband. He responded to scores of these advertisements, courted the women, and if necessary, married them to reap financial benefit. And he seems to have murdered them for his pleasure: Drenth admitted to police that he received intense sexual gratification when torturing his victims.

In 1931, using the name Cornelius O. Pierson, Drenth married Asta Eicher, a widow from Park Ridge, Illinois, and killed her on their "honeymoon." He then collected her three children from a friend of hers who had been looking after them. The children were never seen again. The friend, suspicious of Pierson, especially when a check he had written bounced, reported him to the police.

Later the same month, Drenth killed Mrs. Dorothy Lemke of Northboro, Massachusetts. Police searching her home after her disappearance found a letter from a "Pierson," the return address a post office box number in Clarksburg, West Virginia. They kept the post office under surveillance, and when Drenth came for his mail, he was detained. A trail of blood and a pervasive stench led police to the five corpses in a drainage ditch beside the bunker Drenth called his "garage." He was hanged on March 18, 1932.

On November 9, 1935, during a high-speed chase, Edward Metelski (left) virtually decapitated a pursuing state trooper with shotgun blasts. Metelski was arrested and jailed, and later escaped with another convict, Paul Semenkewitz (right). The hunt for them was one of the biggest in New Jersey history. The photograph was taken in Newark, after they had been captured and had spent some time in police custody. Metelski died in the electric chair on August 4, 1936.

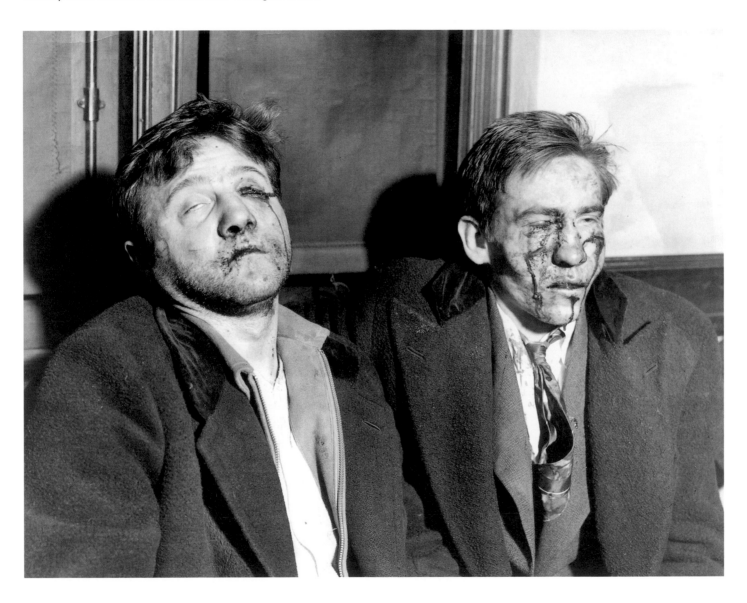

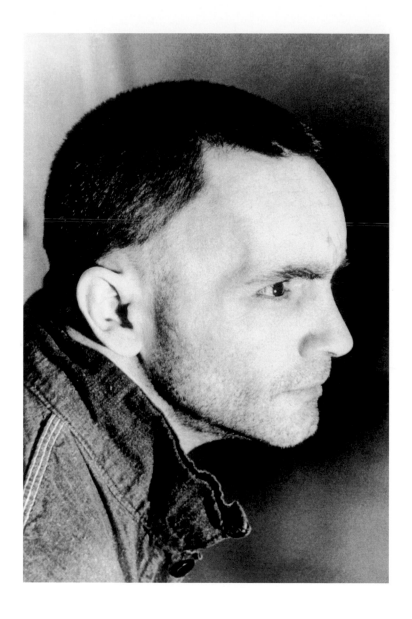

Charles Manson's followers would do anything for him, he said, even murder. In the early-morning hours of August 9, 1969, under orders from Manson, four of his followers—Susan Atkins, Patricia Krenwinkel, Linda Kasabian, and Charles "Tex" Watson—entered the home of Roman Polanski and his wife, the actress Sharon Tate. The drugged murderers stabbed Tate, eight months pregnant, sixteen times, killing her and her baby. Her friend the coffee heiress Abigail Folger, Folger's boyfriend Voytek Frykowski, the hairstylist Jay Sebring, and a young man, Stephen Parent, who was visiting the caretaker, were also shot, stabbed, and bludgeoned to death. Two days later, Manson, disgusted with the job his "family" had done, was determined to show the correct way to realize "Helter Skelter," his plan to destabilize the nation and launch a race war.

He led a larger death squad, now including Leslie Van Houten, to the randomly chosen suburban home of Leno and Rosemary LaBianca, who were then murdered.

Linda Kasabian received immunity from prosecution because of her testimony against her fellow "family" members. The others were convicted and sentenced to die in the gas chamber, but their sentences were transmuted to life imprisonment when California abolished the death penalty in February 1972. All have been denied parole.

Charles Manson is in protective housing at Corcoran State Prison. He receives more mail than any other prisoner in the United States. Susan Atkins, who is in the California Institute for Women at Frontera, married a Harvard Law School graduate—her second marriage since she went to prison. Patricia Krenwinkel and Leslie Van Houten are in the California Institute for Women at Frontera. Charles "Tex" Watson became a minister in prison and fathered four children. His wife and children live near Mule Creek State Prison, where he is held.

Of all the convicted murderers in the United States who have confessed their crimes, Henry Lee Lucas, who died of a heart attack on March 12, 2001, was one of the least likely to die of natural causes. He had been on death row in Texas since 1984, but in 1998 (when this picture was taken), then governor George Bush commuted his sentence to life imprisonment, four days before he was to receive a lethal injection. Bush allowed 152 people to be executed during his tenure as governor; the serial killer Henry Lee Lucas was the only one to enjoy a reprieve.

Lucas killed the two women most central in his life: his mother and his fifteen-year-old girlfriend. He served four years in prison and six in a state mental hospital for bludgeoning to death his mother, who, according to Lucas, treated him like "the dog of the family; I was beaten; I was made to do things that no human being would want to do." Lucas was diagnosed as psychopathic, sadistic, and sexually deviant. He asked not to be let out of the hospital, saying he would kill again.

Lucas suffered dizziness and blackouts from the savage beatings his mother had given him as a child, and had experienced brain damage to the areas controlling emotion and behavior. His perpetual squint resulted from his brother's stabbing him in the left eye.

In 1983, while in custody for gun possession, Lucas described murders he had committed; on day eleven of his arrest there were seventy-seven, and the toll soon more than doubled, to 156. Law enforcement officials from forty states asked him about thousands of unsolved murders, and he admitted to as many as six hundred. In 1999 he told the *Houston Chronicle:* "I made the police look stupid. I was out to wreck Texas law enforcement."

The murder case for which Lucas was sentenced to death, ironically, was one for which there was adequate proof of his innocence. He had, of course, confessed to it, but then, in typical fashion, he retracted his confession. No one knows exactly how many murders Henry Lee Lucas did commit; estimates now range from three to twelve.

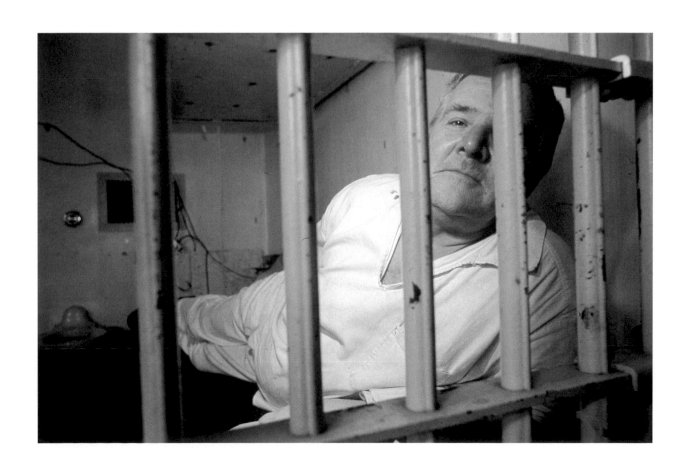

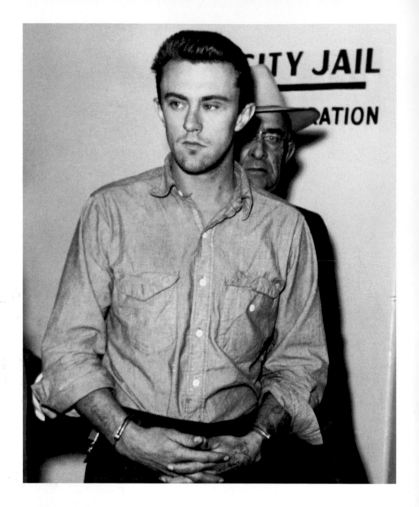

Richard Eugene Hickock (top) and Perry Edward Smith (bottom) are taken from jail in Las Vegas on January 4, 1960, and returned to Kansas for trial.

The prosecuting attorney at the trial challenged the twelve men and women not to be "a pack of chicken-hearted jurors" who would refuse to do their duty. Their duty, as he saw it, was to condemn Perry Smith and Richard Hickock to death for the murders of the Clutter family: mother, father, and two teenage children. The jury did their duty, and Smith and Hickock were hanged—four appeals and five years after their conviction.

Hickock had heard from a prison cellmate about a farmer in Holcomb, Kansas, who might have a safe in his house with a lot of money. Neither Hickock nor Smith alone could have done the deed, but together they were an incendiary device. Their plan was to rob the family and kill any witnesses. On November 15, 1959, they carried it out, against four well-loved people. Smith later confessed, "I didn't want to harm the man [Herbert Clutter]. I thought he was a very nice gentleman. . . . I thought so right up to the moment I cut his throat." In the end, Smith and Hickock found only forty-two dollars in the house.

Truman Capote read about the crime and began writing about it while the suspects were still at large. He befriended the two young men after they were apprehended, speaking with them up to the time of their hanging on April 14, 1965. Capote's book on the case was published as *In Cold Blood,* and the writer became an advocate against the death penalty and for mandatory life sentences for murder. He also opposed the 1966 Supreme Court *Miranda* ruling. Capote believed that had Smith and Hickock been advised of their rights to remain silent, obtain legal counsel, and have an attorney present, they would never have confessed to the murders.

The case illustrated the failure of the M'Naghten test, which states that a defendant is sane if he has sufficient mental capacity to know and understand that what he is doing is wrong when he commits a crime. The one psychiatrist who testified at trial was hamstrung by M'Naghten and could never voice an opinion on the defendants' mental capacity.

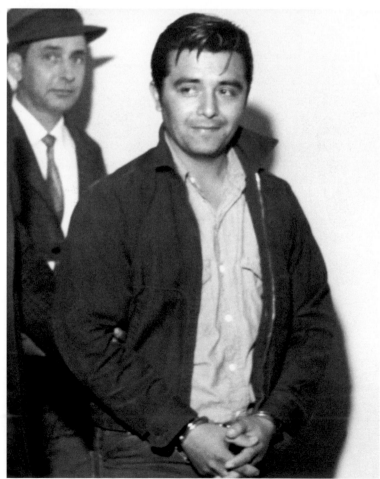

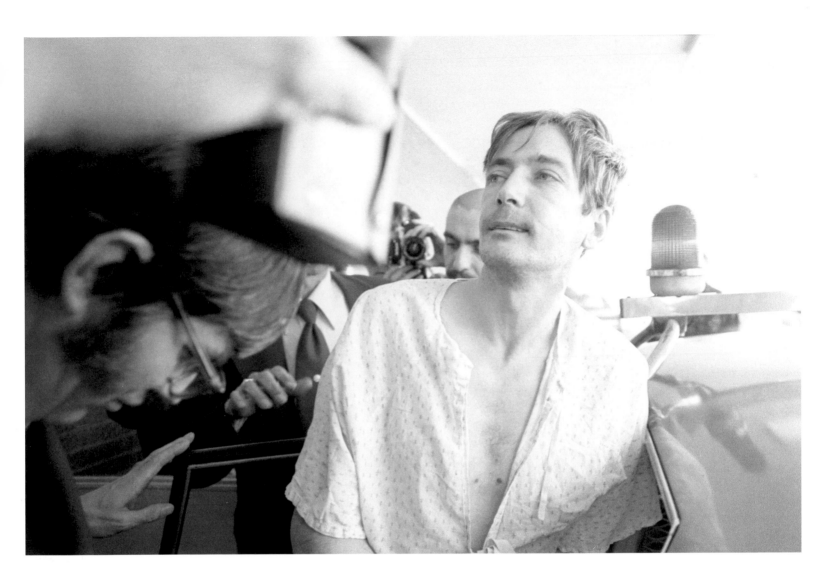

On January 17, 1977, Gary Mark Gilmore was strapped into a chair at Utah State Prison. A white circle was pinned on his shirt. Five marksmen took aim at the circle. His said: "Let's do it." Gilmore had chosen death by firing squad. He wanted to die.

The trial lasted only two days. The defense counsel had no defense. Gary Gilmore, who had spent more than half of his thirty-five years in jail, killed and robbed two men only three months after he was paroled.

The ACLU and the NAACP Legal Defense League mounted a campaign to save Gilmore's life. Norman Mailer, fascinated by the man, the case, and his wish to be executed, wrote a 1,072-page book, *The Executioner's Song*. The book quotes poignantly from Gilmore's letters to his girlfriend:

Nothing in my experience, prepared me for the kind of honest open love you gave me. I'm so used to bullshit and hostility, deceit and pettiness, evil and hatred. Those things are my natural habitat. They have shaped me. I look at the world through eyes that suspect, doubt, fear, hate, cheat, mock, are selfish and vain. All things unacceptable, I see them as natural and have even come to accept them as such. I look around the ugly vile cell and know that I truly belong in a place this dank and dirty. . . .

Once you asked me if I was the devil, remember? I'm not. The devil would be far more clever than I, would operate on a much larger scale and of course would feel no remorse. So I'm not Beelzebub. And I know the devil can't feel love. But I might be further from God than I am from the devil. . . . What do I do now? I don't know. Hang myself?. . . Hope that the state executes me? That's more acceptable and easier than suicide. . . . What do I do, rot in prison? Grow . . . old and bitter and eventually work this around in my mind to where it reads that I'm just an innocent victim of society's bullshit? What do I do? Spend a life in prison searching for the God I've wanted to know for such a long time? . . . Eat my heart out for the wondrous love you gave me that I threw away . . . ?

John Wayne Gacy was a member of the Junior Chamber of Commerce. As "Pogo the Clown," he often entertained local children. But this ostensible good citizen, twice married, had served ten years at a correctional facility in Waterloo, Iowa, for sex crimes and violence against young men. After his release, he was arrested for trying to rape a teenage boy and forcing a man to have sex at gunpoint.

Gacy was a serial killer. One potential victim, after being chloroformed in Gacy's car, then driven unconscious to a house where he was whipped and raped, was uncharacteristically dumped alive in Chicago's Lincoln Park. None of the other young men lured by Gacy was so fortunate. When police finally followed the trail that led to Gacy's suburban home, they recognized a foul smell. Seven bodies in varying states of decomposition were discovered in the crawl space under the house, and eight more were dug out of lime pits in the garden and under the garage. Still others were dredged out of the Des Plaines River. Gacy admitted to murdering thirty-two young men—before, during, or after sex. He pleaded insanity at his trial in 1980, and was executed by lethal injection on May 10, 1994.

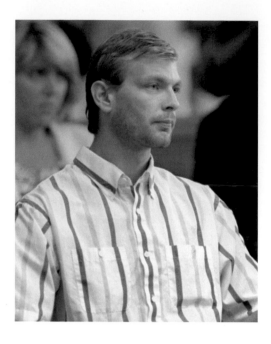

Even his father, Dr. Lionel Dahmer, conceded that "there was something missing in Jeff . . . a 'conscience' . . . that had either died or . . . never been alive in the first place." The jury that heard the 1991 case against Jeffrey Dahmer, for the murders of fifteen young men, rejected his plea of guilty by reason of insanity and sentenced him to life imprisonment. A fellow inmate with his own ideas murdered Dahmer months after he began his sentence. Dahmer's crimes were among the vilest, most nauseating in American history. "[Keeping] skulls in locker, cannibalism, sexual urges, drilling [into live human heads] . . . necrophilia . . . trying to create a shrine [out of body parts], lobotomies, defleshing, calling taxidermists, going to graveyards. . . . This is Jeffrey Dahmer," his attorney intoned. "[He is] a runaway train on a track of madness."

"He wasn't a runaway train," countered the prosecutor. "He was the engineer!" When he was captured, Dahmer, well spoken, handsome, blond, seductive, had been a murderer for thirteen years, almost half his life.

He was unique even among serial killers. James Fox, dean of the College of Criminal Justice at Northeastern University, writes: "The difference [between Dahmer and other serial killers] is that most serial killers stop once the victim dies. Everything is leading up to that. They tie them up; they like to hear them scream and beg for their lives. . . . [For Dahmer] everything is postmortem . . . all of his 'fun' began after the victims died." Aside from violating the dead and the living, Dahmer photographed his acts of mutilation and sexual transgression so that he would have mementos of his interaction with his victims.

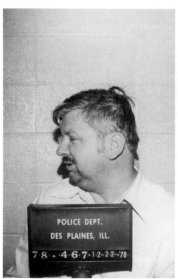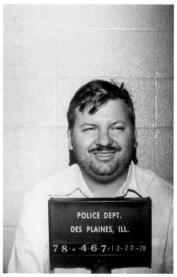

After stalking Gianni Versace for days, Andrew Phillip Cunanan, young man of many disguises, sneaked up behind him outside his palatial home in South Beach, Florida, and shot the famous designer at point-blank range. Then he vanished. Authorities speculated that he might be dressed as a woman to escape detection. The computer-generated images above show what Cunanan might have looked like as a blonde and as a brunette. Cunanan ended his own life days after his most famous killing, shooting himself on a moored houseboat where he had been hiding from an intense manhunt.

Before the murder that made international headlines, Cunanan had killed two acquaintances in Minnesota. He had gone to them for help with emotional problems, and their rejection of him seems to have lit a fuse. He then drove to Chicago, where he killed a prominent real estate developer, who somewhat resembled a former lover. Cunanan exchanged the red Jeep stolen from his first victim for his third victim's dark green Lexus, drove this car to a Civil War cemetery south of Philadelphia, where he shot the caretaker and exchanged the Lexus for a pickup truck. He then drove—via Manhattan—to Miami. He arrived there in early July 1997, with apparently no other reason than to kill Gianni Versace, whom he adored.

He was good-looking, personable, articulate, and attractive to women. Theodore Bundy shattered popular notions of what a psychotic serial killer should look like. In *Great American Trials,* Colin Evans observes that "he was not wild-eyed, dirty or dissolute; on the contrary he was incredibly charming. And in a society where such a premium is placed on appearance, he remains a reminder that things are often not what they seem, and nothing is unthinkable."

Ted Bundy killed young women, typically those who wore their hair long, and parted in the middle. Even when police departments in different locations suspected the same law student, they could not pin anything on him. The testimony of one potential murder victim, who escaped being bludgeoned after being lured into his Volkswagen, led to Bundy's first sentence in 1976, one to fifteen years for kidnapping.

Bundy was a double escape artist: he could escape people's suspicions, and he could physically escape his captors' grip. In June 1977, while being extradited to Colorado on a murder charge, he jumped out a second-floor window in a courthouse library and ran to a river to hide his trail. Eight days later he was captured by police, only to escape again by carving a hole in the ceiling of his cell and crawling through.

This time, Bundy went on a murderous rampage. He violently attacked five and killed two female students in their sorority house at Florida State University in Tallahassee. He attacked again and killed a twelve-year-old girl. Finally, the police caught him. Finally, he was tried for murder. Finally, his smile could not eclipse forensic photographs showing his bite marks on the buttocks of one of his victims, or where he had bitten off a nipple. Finally, he did not escape. Bundy was executed in Florida's electric chair on January 24, 1989. The FBI estimates he killed thirty-six women; prosecutors calculated at least fifty.

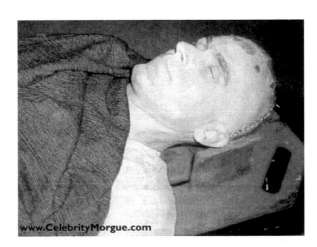

Nannie Doss (above), the "Giggling Granny," killed four husbands with rat poison—one in Alabama, one in North Carolina, one in Kansas, and the last in Oklahoma. She was alleged to have killed her mother, two of her four daughters, a mother-in-law, a number of grandchildren, and other family members in a variety of ways, but mostly with her special recipe of prunes and arsenic.

The first suspicious deaths took place in 1927, when two of her daughters, fine at breakfast, were dead by lunchtime. Charley Braggs, her first husband, bolted, taking his eldest daughter with him. He had made it policy never to eat or drink anything his wife handed him when she was in a foul mood. Braggs returned a year later, girlfriend by his side, and Nannie, furious at her man, left seething. He was "the one who got away"; Nannie's next four husbands were not so lucky. She was arrested after the autopsy on her last husband, Samuel Doss, revealed that he had been poisoned and after police in Tulsa confirmed that his three predecessors had died in the same way. After a lengthy cross-examination, Nannie Doss admitted that she had dropped poison into Sam's coffee because "he wouldn't let me watch my favorite programs on the television and he made me sleep without the fan on the hottest nights. He was a miser and . . . well, what's a woman to do under those conditions." In May 1955 she was sentenced to life imprisonment.

Juanita Thomas was afraid that her boyfriend would stab her with the scissors he held while forcing her to have sex. She reached for a butcher knife that was in the bedroom—she hid it anywhere in the house except the kitchen—and stabbed him repeatedly in the chest, in self-defense, according to her testimony, not with the will to kill.

The man she loved and feared had killed his mother's boyfriend with a butcher knife (although he was acquitted of the charge) and had repeatedly been violent toward her. "Silly as it sounds," Thomas told Carol Jacobsen, a documentary film maker, "when you really love a person you keep thinking he is going to change." But once the beatings start, she added, they never really stop. Juanita Thomas is serving a life sentence for murder.

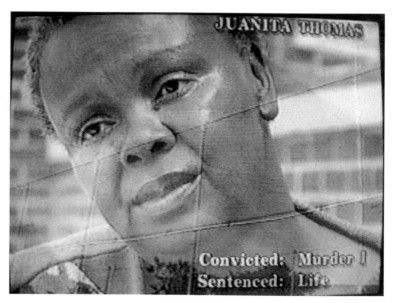

JUANITA THOMAS

Convicted: Murder 1
Sentenced: Life

This twenty-year-old at the Tennessee Prison for Women in Nashville was on death row when Jane Evelyn Atwood photographed her in 1996. Because she was awaiting an appeal, there was no interview. Atwood, in whose book *Too Much Time: Women in Prison* this picture appears, knew only that she had murdered a colleague with the aid of a man who, like her, was a "Satan worshipper." The young woman told authorities that a "supernatural force" had told her to kill.

Mary Riley (left) sits in her quarters with cellmate Marjorie Braggs at the Louisiana Correctional Institute for Women, Saint Gabriel. The prospect of going nowhere until the end of their days has had a sobering effect on these two convicted murderers. It is important, they explain, to coexist as harmoniously as possible in the space allotted them. Race differences are overshadowed by the reality that, as Riley says, "these six numbers that we have make everyone of us equal."

Lizzie Borden

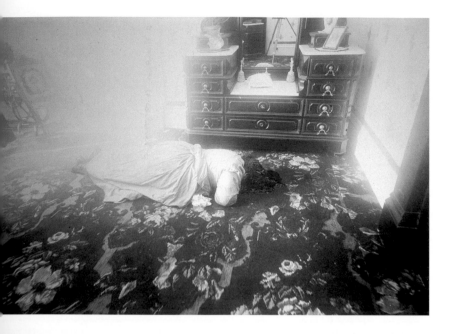
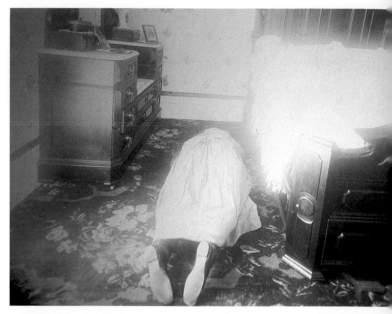
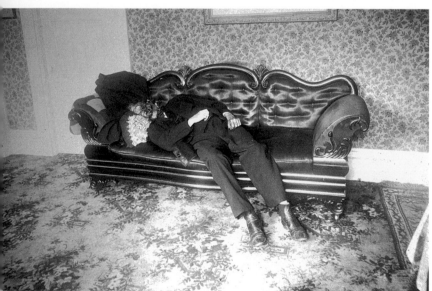
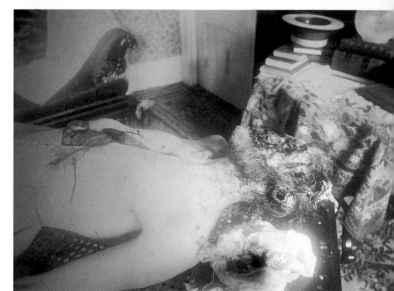

If the good people of Fall River, Massachusetts, had not acquitted Lizzie Borden in 1893 of the double murder of her father and stepmother, they would have had to admit that any one of them— churchgoing, charitable, well bred—could be a killer. Better to have the fiend a foreigner than a friend.

Lizzie, although acquitted of the gruesome murders, was nevertheless condemned forever by a children's rhyme. No, she didn't give her mother forty whacks and her father forty-one. The actual numbers were considerably lower, but even so, her parents were "hacked to pieces," as the Boston *Daily Herald* headlined. The edition sold out in minutes.

This chapter opens with images of the bodies of the Bordens and ends with images of the slain Nicole Brown Simpson. Though separated by a century, the Borden and Simpson cases have a number of similarities. Each was the most sensational murder trial of its day; each defendant possessed the financial resources to hire the best defense team available; both court cases became public spectacles and media events, and in both the police investigation was criticized by the defense; stereotypes (of gender, of race) were used to raise passions and prejudices; and each criminal trial ended in a disputed acquittal. And blood, volumes of it, ineradicably stains the crime scene in both sets of forensic photographs.

A defense attorney addressed one jury:

They [the prosecutors] either got to produce the weapon which did the deed . . . or else have to account in some reasonable way for its disappearance. . . . Direct evidence is the testimony of persons who have seen, heard or felt the thing or things about which they are testifying . . . [and there] is not one particle of direct evidence in this case.

The attorney was representing Lizzie Borden.

The New York Times editorialized:

It is many a year since a criminal case in this country has excited such universal interest and been the subject of so much discussion. . . . It has all the fascination of a mystery about which there may be a thousand theories and upon which opinions may differ as variously as the idiosyncrasies of those who form them. There is little absolute evidence. . . . [Much depends on one's] general view of human nature. There seems little prospect that the mystery will be cleared up by the trial. . . . The verdict, if there shall be a verdict, will make little difference. Unless there is to be some disclosure of which there is yet no sign. The whole case is a tangle of probabilities and improbabilities, with little . . . certain except that a man and wife were murdered . . . [and] the officers of the law were unable to find any evidence that the crime was perpetrated by anyone outside of the family.

It was *The New York Times* in 1892.

Stories like those of Lizzie Borden and O. J. Simpson become media circuses because the press understands that each of us, at least since adolescence, has been trying to master the art of judging people, recognizing good from evil, learning how not to be tricked, how not to come to harm, and above all, whom to trust. Reading the stories is not enough. We want pictures to help us understand the individuals involved.

What makes a case sensational? Personality, perversity, passion, prejudice, and sometimes plain stupidity (especially if someone involved is supposedly intelligent)—any or all, especially if a murder occurs, are reason enough for the public to stay engaged. Will Rogers commented on tabloid readers: "If they saw a half-page picture of a pretty woman, they felt that she was either a murderess or a movie divorcée; if it was a full-page, she might be both." Murder is at the center of the following cases; celebrities feature in a few.

Nathan Leopold, Jr., and Richard Loeb ignited only because, like two sticks, they rubbed together. Richard Hickock and Perry Smith (see the previous chapter) individually might not have butchered a family, but together they combusted. Every newspaper in the country sensationalized the case of the wealthy, handsome, educated Leopold and Loeb; Hickock and Smith might have gone unnoticed and unsung if one brilliant storyteller, Truman Capote, had not dramatized the lives of these two lost souls and one fine family.

The case of William Heirens, blasted day after day in Chicago newspapers in the late 1940s, is whimpering on-line. Heirens is still in jail for murders he says he did not commit, and growing numbers of people believe he is innocent. Rarely are stories of attempts to free someone from prison as sensational as those of attempts to see someone convicted (an exception is the case of Mumia Abu Jamal). Heirens believes he was a scapegoat of the police, found guilty by the press before he was tried in a court of law.

Photographs relating to two particular cases illustrate the difference between tabloid journalism and police documentation. All the pictures of Salvador Agron, "The Capeman," and Antonio Luis Hernandez, "The Umbrella Man," are news photos, which appeared in the press with startling headlines and rapid-fire reports. Captions told readers what to see: "Two Faces of Murder" was how the New York *Daily News* titled an image of the teenagers on its front page. Agron, grinning, was described as a "self-styled Dracula." With microphones pushed in his face and newsmen all around, the sixteen-year-old blurted, "I felt like it," when asked why he committed the murder. Those words alone were sufficient to create a sensation.

John List murdered his entire family. That part is known. The police photographs of the crime scene were never published, however. They are reproduced here with the story of the case, but without captions to prompt the viewer. Each viewer enters the death chamber on his own. The case

was sensational because List vanished and remained hidden for so long, yet the actual photographs are somber, as are most evidence photographs. Reproducing such images perhaps helps lay a case to rest.

Sensational cases sell. But they turn criminals into celebrities and make entertainment out of violence. Samuel Johnson, the eighteenth-century savant, got this one wrong, when, in the preface to his *Shakespeare*, he commented: "The delight of tragedy proceeds from our consciousness of fiction; if we thought murders and treasons real, they would please no more."

Leopold and Loeb

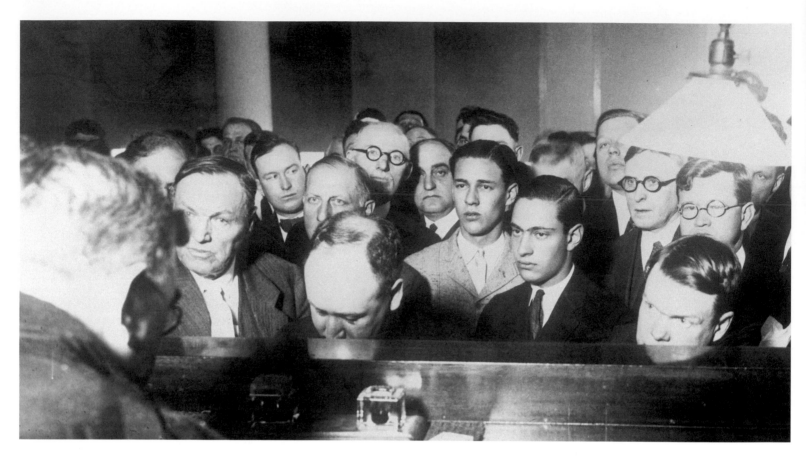

Nathan Leopold, Jr. (right of center), and Richard Loeb (in light suit) appear
in court with their lawyer Clarence Darrow (on left) in June 1924.

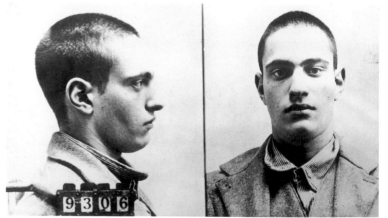

The first pictures released of Richard Loeb (#9305) and Nathan Leopold, Jr.
(#9306), after they arrived at Joliet prison on October 18, 1924.

They were brilliant, handsome, wealthy—and murderers. The trial of Nathan F. Leopold, Jr. (left in the picture above), and Richard Loeb mesmerized the nation for most of the summer of 1924. Millions of first- and second-generation Americans who aspired to the education, fortune, and lifestyle of these two young men could not understand why they would kill. These privileged teenagers appeared to have everything except a moral conscience.

"Dickie" Loeb, at eighteen, had already graduated from the University of Michigan and was studying at the University of Chicago. "Babe" Leopold, a year older, Phi Beta Kappa, was a law student. They wanted to carry out a "perfect murder," and at this, for the first time in their young lives, they would fail dismally. The body of their victim, fourteen-year-old Bobby Franks, was found within twenty-four hours of the murder, surrounded by enough clues to lead the police directly to the pair.

The brilliant and compassionate Clarence Darrow was hired as an attorney by the young men's millionaire parents. He wanted to save their lives, not defend their innocence, and had them plead guilty so that a judge, not a jury, would decide their fate. "If these boys hang," Darrow told the judge, "you must do it. There can be no division of responsibility here. . . . It must be by your deliberate, cool, premeditated act." Darrow went on to deliver a most eloquent denunciation of the death penalty. Conceding that his clients were "not fit to be at large," and uncertain about "how much salvage there is in these two boys," he nonetheless "would be the last person on earth to close the door of hope to any human being that lives."

Darrow saved their lives. During that hot summer of 1924, not only were two teenagers judged, but so were questions of capital punishment and personal redemption. Leopold and Loeb each received a sentence of life imprisonment plus ninety-nine years for kidnapping. They were placed in the Illinois State Prison at Joliet, where twelve years later, Loeb was slashed to death in an argument. Governor Adlai Stevenson reduced Leopold's sentence in gratitude for his assistance in testing malaria treatments during World War II. Released from prison in 1958, he was permitted to serve his parole in Puerto Rico, away from media attention. There he worked in hospitals and church missions, married, earned a master's degree, and taught mathematics. He died in 1971.

The Lindbergh Kidnapping

The most famous kidnapping in U.S. history occurred on March 1, 1932, during the heart of the Depression. It resulted in what has been called the "trial of the century"—and was, in the words of H. L. Mencken, who was present at the trial, "the biggest story since the Resurrection." Even more than five decades later, the widow of the man convicted and sentenced to death for the abduction and murder of the Lindbergh baby was still trying to have the case reopened. Why has it never been fully laid to rest?

Bruno Hauptmann, an immigrant German carpenter, was convicted on circumstantial evidence drawn from novel types of scientific crime detection. There had been no reliable witness to the crime, and no fingerprints were found in the nursery of the Lindbergh home, or on the ladder used for the abduction, or on the ransom notes. But expert witnesses concluded that Hauptmann had written the orthographically deficient letters demanding a $50,000 ransom and that the wood of the ladder used in the kidnapping matched wood found in Hauptmann's attic. Money paid as ransom was discovered in his garage, and the name, address, and telephone number of the "go-between" were written inside his bedroom closet. Hauptmann was caught in 1934 when he used a ten-dollar gold certificate that had been part of the payment.

The trial, for all concerned, was a circus. Thousands of sightseers, seven hundred reporters, and hundreds of radio and telephone operators descended on the small town of Flemington, New Jersey. On Sundays, the flood reached 60,000, with people roaming the streets and trying to enter the courthouse. The Hearst New York *Journal* hired a top lawyer to defend Hauptmann and paid all the legal fees; the paper was to have an exclusive on Mrs. Hauptmann's story.

Already before the trial, papers tried for scoops, and photographers were part of the frenzy. Journalists are said to have broken into the funeral home in Trenton where the child's body was awaiting burial. But even among tabloid journalists there was a degree of decorum. The New York *American* sent Sammy Schulman to Trenton to photograph Lindbergh at the funeral home. "When he came out," Schulman recounted, "I put my camera to my eye and looked through my finder. . . . Then I put the camera down without making the shot."

Charles Lindbergh disliked the parasitic press and had deplored their attention already before the kidnapping. After his son's funeral he requested a moratorium on pictures. Cameramen generally honored it—for a while. In November 1934, Dick Sarno of International News Syndicate secretly took a snapshot of Anne Morrow Lindbergh and her son Jon leaving his nursery school. In usual tabloid fashion, the picture ran on the front page, its caption informing readers that the boy was born on August 16, 1932, "while his mother still wept over the murder of her first-born."

Sarno again had a scoop on February 13, 1935, the day the jury announced the verdict in the case against Hauptmann. No cameras were allowed in the courtroom, so Sarno sneaked in a small one and, from the first row of the balcony, made a single one-second exposure of the foreman delivering the verdict of guilty.

Until her death in the 1990s, Anna Hauptmann claimed that her husband was "framed, always framed." Her many attempts to clear his name failed. But Charles Lindbergh, Sr., American hero, had heard the voice of the kidnapper and confirmed in court that Hauptmann's "was the voice I heard that night."

The decomposed body of Charles Lindbergh, Jr., was found just two miles from the family home on May 12, 1932. The baby's skull was fractured. Charles Lindbergh, Sr., identified the remains from a birth defect on one of his son's toes.

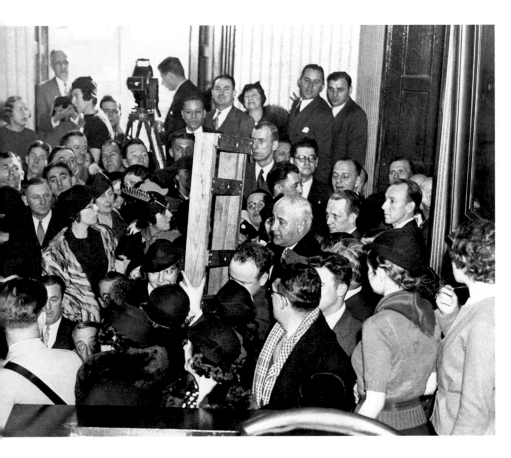

On January 25, 1935, the kidnap ladder was brought into the crowded Hunterdon County Courthouse, in Flemington, New Jersey. Shortly thereafter, Bruno Richard Hauptmann, alleged Lindbergh kidnapper, resumed testifying. He steadfastly denied the state's charges.

Hauptmann, accused of the kidnap and murder of Charles Lindbergh, Jr., poses for mug shots at police headquarters in New York City on September 21, 1934.

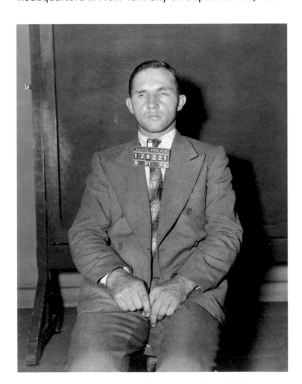

William Heirens

Some say he did, some say he didn't commit three brutal murders in 1945 and 1946, when he was in his teens. William Heirens, now in his seventies, is still in jail, serving three consecutive life sentences without possibility of parole. His claim of innocence has gained widespread support, yet a substantial body of evidence points to his guilt. The case is far from clear.

Hysteria surrounded the murders of two women and a six-year-old girl in Chicago. Fear was high and pressure was on the police to apprehend a killer. Heirens, an admitted petty burglar and a student at the University of Chicago, was caught breaking into a house. After he pulled a gun on a policeman and had three terra-cotta pots dropped on his head, he was taken into custody. At the police station, the case of William Heirens becomes confused. How strong were the strong-arm tactics of authorities? A previous suspect, a man without a record, was so severely hurt during two days of questioning that he had to be hospitalized for ten days. (He was awarded $20,000 in a lawsuit filed against the police department.) Did the injury to Heirens's head disorient him and impair his ability to defend himself during the early period of questioning—for six days of which he had no legal representation?

Heirens ultimately did confess to the murders. This was two decades before the Miranda rule gave the accused basic rights. Years later, Heirens reflected: "They had a boy without any rights to stop them from painting just what they pleased. . . . The police and prosecution made statements that they were convinced of my guilt—something the law doesn't even allow. . . . I didn't have the money to hire my own fingerprint expert to make an independent examination. . . . The newspapers . . . printed everything the prosecutor told them and when the prosecutor ran out of words the press fabricated their own."

This, indeed, was one of the most shocking aspects of the Heirens case: newspapers convicted this youth with the big questioning eyes before he was even tried. A *Chicago Tribune* reporter wrote his own detailed account of Heirens's "full confession" before the young man had made it. Other papers picked up the story, and the fiction was soon accepted as fact.

Heirens's attorneys were told by the prosecutor that their client's burglary convictions were enough to earn him life imprisonment. Rather than face a "messy trial" and have the state condemn a boy not yet eighteen, Heirens should plead guilty to the murders and thus be saved from the electric chair. "Before I walked into the courtroom," Heirens recalled, "my counsel told me to just enter a plea of guilty and keep my mouth shut."

No eyewitness identified Heirens as the man at the crime scenes. Handwriting experts differed on whether or not two examples of writing left behind by the murderer were written by the same person and whether or not the handwriting was Heirens's. Fingerprints first were not and then were found at the crime scenes, and the fingerprints that were analyzed may not have been read properly.

ABC's *PrimeTime Live* conducted its own investigation in 1996. Among those interviewed was an FBI handwriting analyst who stated that Heirens did not write either of two key pieces of evidence used in his conviction. It was also revealed that a convicted child molester had confessed to the girl's murder from prison years before.

William Heirens has been in prison since 1946. He may be guilty. He may be innocent.

These photographs show Heirens being escorted by Cook County jail guards after his arrest; behind bars; and being administered a "sanity test" by Dr. Seymour N. Stein while Sheriff Michael Mulcahy observes.

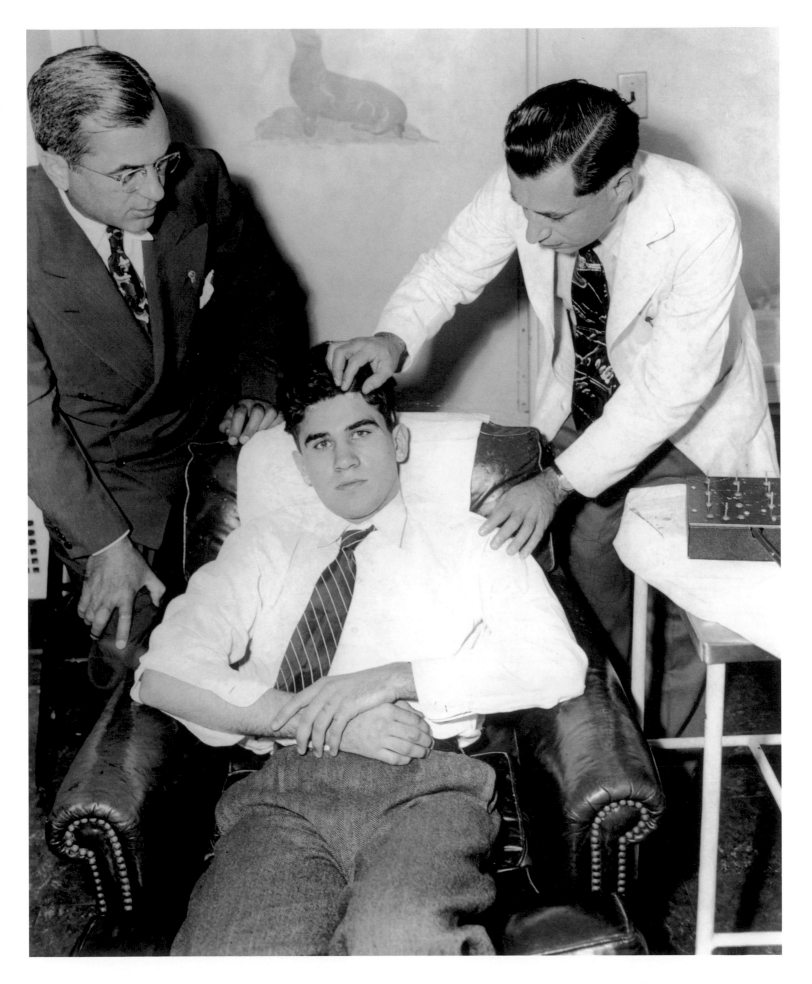

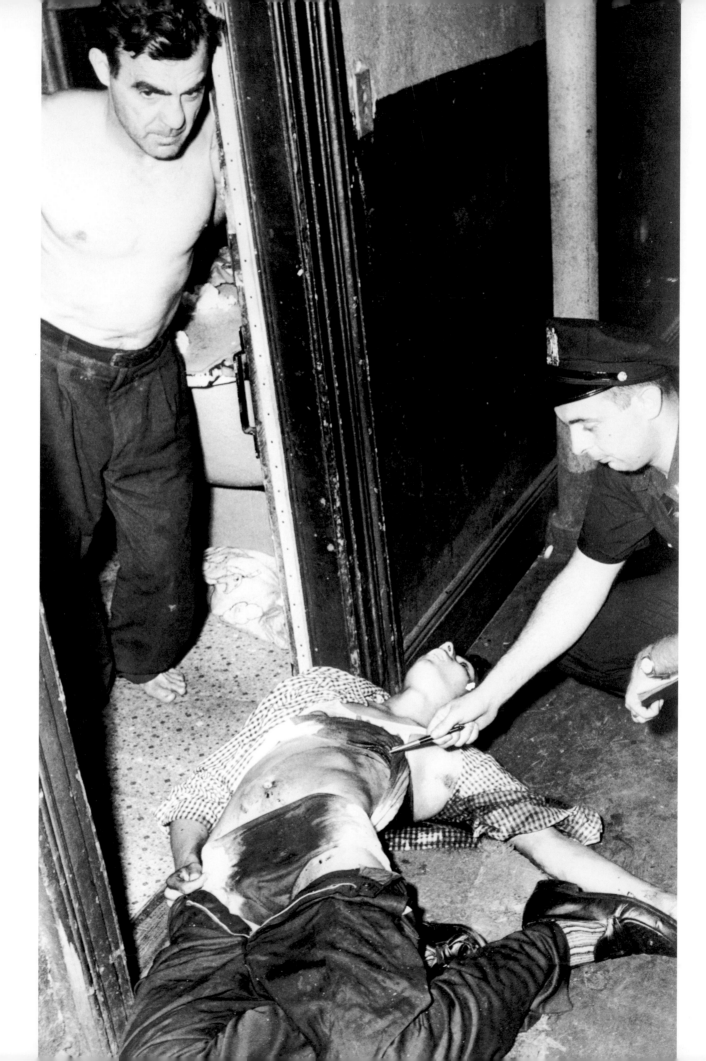

The Capeman

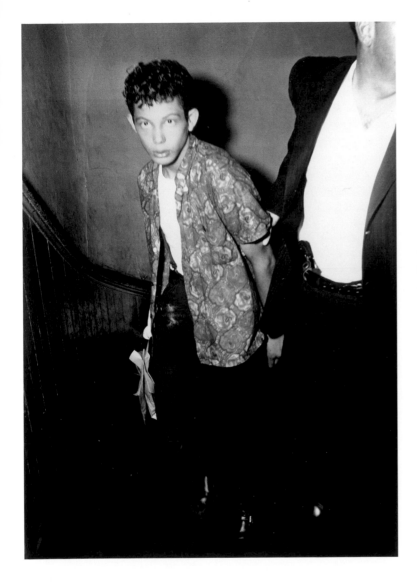

(facing page) Anthony Krzesinski lies dead in the hallway of a building where he ran after being attacked by Salvador Agron, Antonio Hernandez, and other gang members. A patrolman points to a stab wound in the body.

(left) Agron is hustled up the steps of the West Forty-seventh Street police station for booking after the murder in Hell's Kitchen.

(below) Reporters crowd around Hernandez (in hat) and Agron as detectives lead the pair from police headquarters.

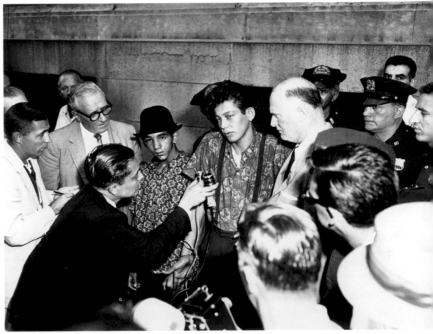

West Side Story was on Broadway. On the evening of August 29, 1959, one day after his sixteenth birthday, Salvador Agron traveled from the Upper West Side to West Forty-sixth Street with his friend Antonio Luis Hernandez and fellow Vampires gang members. They were on their way to act out their own version of a "rumble," in a park not far from where the musical was playing. Belts and knives, sticks and pipes were the chosen weapons. When the other gang, the Norsemen, didn't show, some of Agron's cronies stayed in the park. Three youths, Robert Young and Anthony Krzesinski, both sixteen, and Edward Riemer, eighteen, who were not part of any gang, started making fun of the black cape Agron was wearing. With the help of Hernandez, known as "The Umbrella Man," and various gang members, Agron attacked the three other youths, killing Young and Krzesinski and injuring Riemer. Agron was the only one to admit to the murders.

The case of "The Capeman and The Umbrella Man" became a sensation.

Agron's words to the press both confounded and confirmed people's worst fears. Asked why he committed the murders, he said, "Because I felt like it."

He was charged with two counts of first-degree murder and one count of attempted first-degree murder. At the age of sixteen, he was sentenced to death, and was the youngest prisoner at Sing Sing on death row. Eleanor Roosevelt campaigned to have the sentence commuted to life, an action supported by the father of one of the victims. On February 7, 1962, six days before Salvador Agron's scheduled execution, Governor Nelson Rockefeller commuted his sentence. Agron was released from jail in 1979. Seven years later he died, of natural causes, at the age of forty-three.

When Paul Simon's musical *The Capeman* opened on Broadway in 1998, protesters charged that the musician was glorifying a murder at the expense of victims of senseless crimes.

John List

The year is 1971. Jim Morrison dies, and Beatle George Harrison organizes a concert to raise money for Bangladesh. Germaine Greer publishes *The Female Eunuch,* and Tim Rice and Andrew Lloyd Webber stage *Jesus Christ Superstar.* United States aircraft attack Cambodia and North Vietnam, while President Nixon promises to reduce by a quarter from the current 400,000 the number of U.S. troops in Southeast Asia. William Calley is found guilty and sentenced for his participation in the My Lai massacre.

In November, John List, devout Lutheran and certified public accountant, kills his family in Westfield, New Jersey. He writes a letter to his pastor, then disappears. In the letter he enumerates his reasons for killing his wife, three children, and mother: He isn't earning enough to support them, and fears their having to go on welfare. He is likewise afraid his daughter's interest in acting will adversely affect her Christianity. His wife doesn't attend church, and this harms the children. And so on. By removing them from this world, he explains, "at least I'm certain that all have gone to heaven." As a postscript he mentions that his mother, who lives with the family, can be found "in the hallway attic—third floor."

The day of the murders, List had notified his children's school and the family's church that they would be away because of a family emergency. After he slaughtered his family, he wrote letters, tidied up, had dinner, and slept the night in the house. He fed the goldfish, turned down the heat (but left lights on), locked the doors, and was gone. The corpses he left behind were not found for twenty-eight days.

Helen List was shot in the back of the head around nine in the morning, while she was having breakfast. The children were murdered when they came home from school. They still wore their jackets. List laid their bodies out in the thirty-seven-foot ballroom of his eighteen-room mansion.

Alma List was murdered by her only son while she stood near a storage room adjacent to her kitchen.

John List was brought to trial—finally—in 1990. His attorney argued that the accountant believed he had acted to save the souls of his family in a godless world that no longer made sense to him. The prosecutor described him as cruel and calculating: List wanted to start a new life, so he decided to close the accounts, sign off, and move on. A jury found him guilty and sentenced him to life imprisonment without the possibility of parole. How was List tracked down, after almost two decades?

In February 1988, *America's Most Wanted* premiered on television, something of an electronic Wanted poster. Police officials in Westfield and Union County would have liked to bring network attention to the unsolved murder, but the program did not consider such old unsolved cases. In 1989, however, the producers altered their policy and started investigating in Westfield.

What would John List look like in 1989? A forensic sculptor was hired to create a three-dimensional bust based on anatomical and other studies. List liked meat and potatoes; if he had kept to that diet, his jowls would be sagging. His complexion would be pale, as he was not an outdoorsman. The sculptor gave him a receding hairline, and re-created the large scar behind his right ear. Psychologists even helped determine, on the basis of List's previous choices and his desire to be viewed as an authority figure, the type of eyeglasses he might be wearing.

The program was aired on May 21. Photographs of List in 1971 and the new bust were shown after a reenactment of the murders. Would anyone turn in a law-abiding, churchgoing, soft-spoken elderly man after having seen only outdated photographs and an artist's imagined rendering of his features? Some 250 people called in, among them one who recognized the man and knew his whereabouts.

On June 1, FBI officials had in their custody a man identified as Robert P. Clark. His fingerprints matched those of John List.

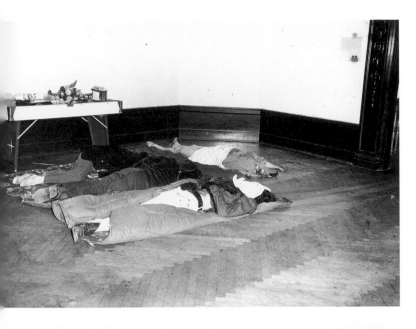

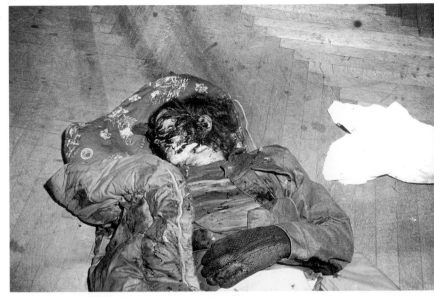

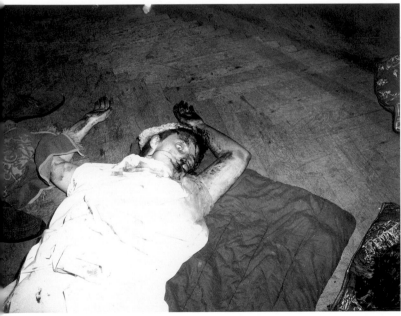

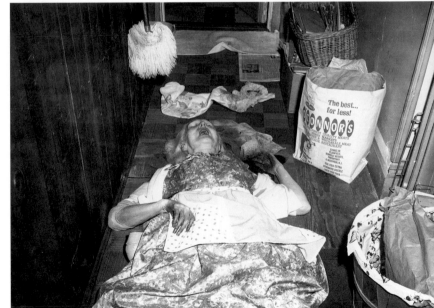

Son of Sam

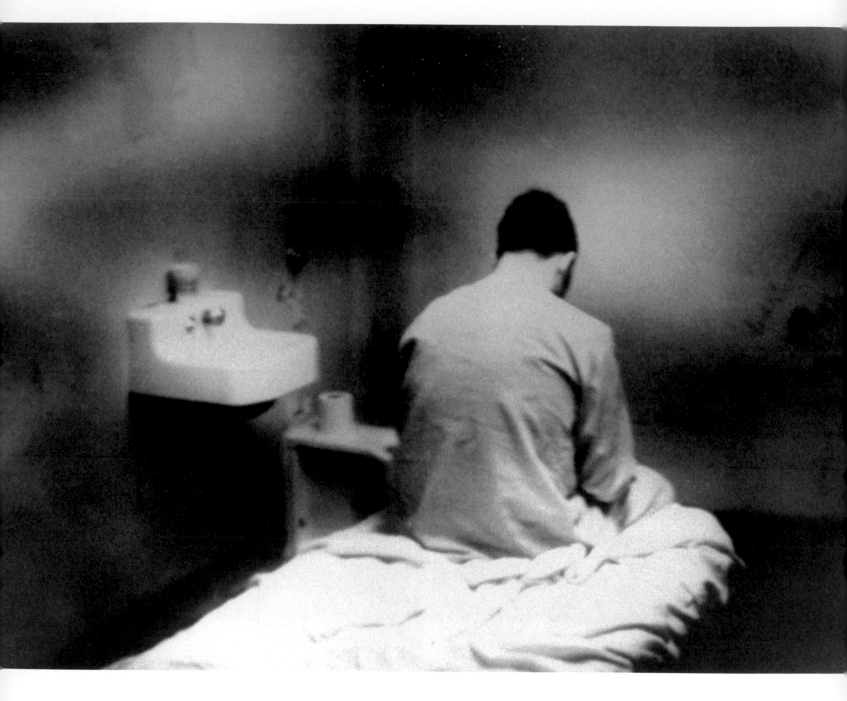

David Berkowitz did not want to hurt people, he said. He just wanted to kill them. From July 1976 until August of the following year, Berkowitz scared the living daylights out of New Yorkers. Son of Sam, as he was known, was Son of Satan in everyone's mind. Unlike other serial killers who rape, mutilate, and violate their victims, David Berkowitz never went nearer than a gunshot away from the people he killed. The randomness with which he chose his targets made his exploits especially frightening, even among the many other sensational stories of the 1970s.

The decade saw: the slashing to death of Dr. Jeffrey MacDonald's wife and two children, of which he was accused (1970); a shootout in front of the San Rafael Courthouse in Marin County, California, in which a white judge and three blacks were killed with weapons owned by Angela Davis (1970);

the trials of Charles Manson and his "family," and Lieutenant William Calley (1971); the murder of Katherine Cleary by Joe Willie Sampson (1973), which inspired the novel and then the movie *Looking for Mr. Goodbar*; John Wayne Gacy's attacks on young men; Patty Hearst's kidnapping by the Symbionese Liberation Army and her participation in a bank robbery (1974); murders by Gary Gilmore, Ted Bundy, and John List; the first Unabomber attack (1978); Dan White's assassination of San Francisco mayor George Moscone and city supervisor Harvey Milk (1978); and the deaths, mainly by suicide, of more than nine hundred followers of Jim Jones at his People's Temple in Guyana (1978).

David Berkowitz used a .44-caliber pistol to take potshots at young people seated in parked cars or on the stoops of apartment buildings, or simply

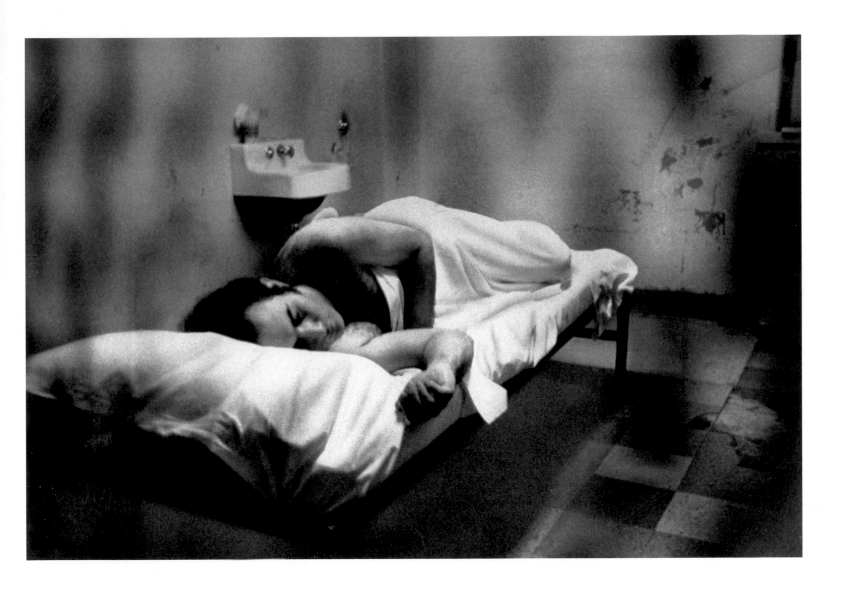

walking down the street. All the attacks involved at least one woman whom he thought pretty, and all took place in the Bronx and Queens. Berkowitz later stated that he became sexually aroused stalking and shooting the women. He murdered six New Yorkers and left seven severely wounded.

"Son of Sam" was caught after he removed a parking ticket from the windshield of his car and threw it to the ground near the scene of one of his crimes. A passerby thought the pudgy-faced man looked suspicious.

An obvious paranoid schizophrenic, Berkowitz was deemed sane enough to stand trial. On August 23, 1977, after pleading guilty, he was sentenced to 365 years in prison. Shortly afterward, he was moved to an isolation cell at Kings County Hospital prison ward, where for months he withdrew further into himself and away from reality. When newspapers

published photographs of him asleep and sitting on the edge of his bed, questions were raised concerning inmates' privacy rights. Even before his capture, the New York State legislature passed a law that would bar Berkowitz from capitalizing on his story. The "Son of Sam law" prohibited accused or convicted criminals from benefiting financially from accounts, in film or written form, of a crime. Income derived from any such retelling would go to the victims and their families. In 1991, the U.S. Supreme Court unanimously ruled the law unconstitutional, saying that it suppressed the First Amendment right to free expression.

Berkowitz, who is currently incarcerated in Sullivan County Correctional Facility in the Catskill Mountains, has his own website and says he has found God.

O. J. Simpson

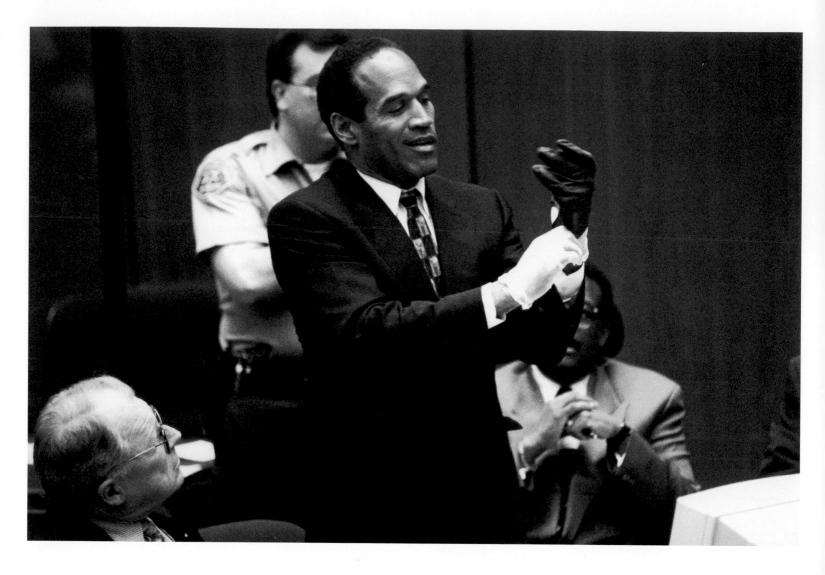

During the nine months of the O. J. Simpson murder trial, which began in January 1995, more Americans could identify Kato Kaelin as O.J.'s friend than could identify Al Gore as the vice-president of the United States. Why did this case become monumental in the imagination of millions? It is not insignificant that O.J. was a famous athlete. Viewers tuned in to watch the proceedings as they might a sporting event: to see which side would win, and how the points were scored. For many, the teams had names—White versus Black. The scales of justice teetered, and truth was not well served in the L.A. courtroom.

No testimony during the longest jury trial in California history since the Manson case could fully transmit the gruesome details of the murder scene. Only the police evidence photographs could convey the violence and the bloodletting that took place on Bundy Drive on the night of June 12, 1994.

Nicole Brown Simpson purchased for her husband two pairs of extra-large cashmere-lined dark brown leather Aris Isotoner gloves on December 20, 1990. The gloves were part of a batch of 240 pairs sold exclusively at Bloomingdale's in New York City between 1989 and 1992. Videotapes showed O. J. Simpson wearing them at two football games.

Simpson's attorney Johnnie Cochran insisted that his client wear latex liners while trying on a pair of gloves found at the crime scene and presented as evidence in court. Television and still cameras filmed Simpson struggling to get the gloves on, and audio equipment recorded him saying, "They're too tight." Although he later was able to slip on a new pair in the same size, the damage to the prosecution's case was done. Linking the gloves from the crime scene to Simpson was key in identifying him as the murderer of his former wife and Ronald Goldman. That the gloves could have shrunk because of blood and moisture, or that they did not fit because Simpson tried them on over latex liners, did not seem to resonate with the jury.

"You will always remember those gloves," Cochran said in his summation to the jury. "When [prosecuting attorney Christopher] Darden asked him to try them on . . . they didn't fit." And, Cochran concluded, "if it doesn't fit, you must acquit." O. J. Simpson was acquitted of the murders of Nicole Brown Simpson and Ronald Goldman.

The body of Nicole Brown Simpson is seen as it was found on the blood-stained walkway of her Bundy Drive condominium. Her neck was slashed and her head almost severed from her body. Blood flowed from the wound down the walkway, almost to the gate fifteen feet away. The photograph below shows Los Angeles police detective Mark Fuhrman pointing to a piece of evidence, a glove found near the body. It was introduced and accepted as evidence in the O. J. Simpson wrongful-death civil trial on October 25, 1996.

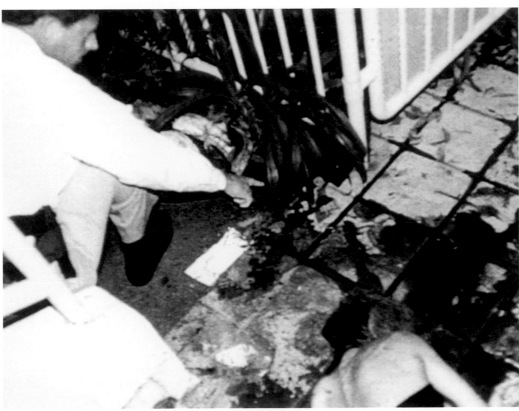

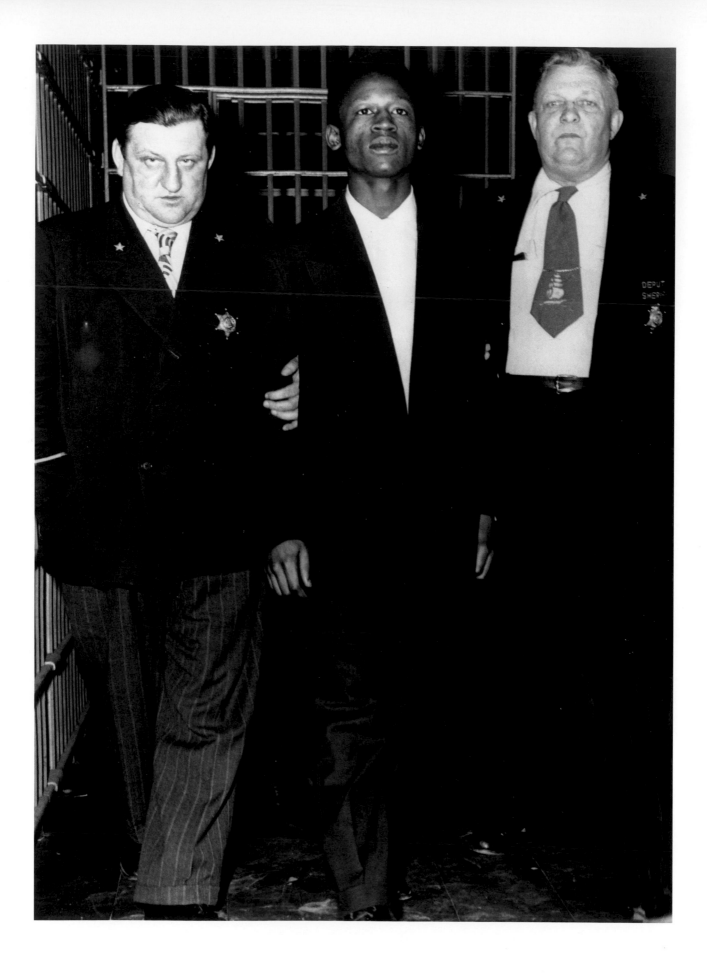

The motives and goals that underlie crime are the the same as those that underlie punishment —namely, pursuit of what the violent person considers "justice." What is conventionally called "crime" is the kind of violence that the legal system calls illegal, and "punishment" is the kind that it calls legal. But the motives and the goals that underlie both are identical— they both aim to attain justice or revenge for past injuries and injustices.
—James Gilligan, *Violence: Our Deadly Epidemic and Its Causes*

Retribution

How do we punish fairly? We could also ask, "How many victims must there be?" We have been trying to be just in punishing wrongdoers since biblical times. Gilbert and Sullivan's Lord High Executioner may sing, "Let the punishment fit the crime," but can punishment ever fit crime? At best, some logic relates the offense and the retribution. The only thing to make them equal is the heightened emotion that each evokes.

Two million Americans are in prison today. Anthony Lewis recently reminded his readers in *The New York Times* that the United States "imprisons a higher percentage of its population than any other [country] in the world." More than sixty percent are from racial minorities; more than half are African-American. Of current federal prisoners, fifty-eight percent have been convicted for drug crimes. Since 1980 the number of inmates in the country as a whole has more than tripled; the number of women inmates has quadrupled.

In a letter published in *The New York Times* of April 23, 2001, the president of the Center on Juvenile and Criminal Justice in Washington, D.C., reported that in one recent year alone, 200,000 youths were prosecuted as adults and that more than 16,000 minors are locked up with adults in America on any given day. Seeing photographs of fourteen-year-olds tried for homicide is wrenching. When law-and-order advocates during the Nixon administration introduced mandatory sentencing and mandatory minimum stays, did they consider children and the mentally retarded? Did they consider how many people would be sent to prison for lesser drug offenses? Did they consider the sons and daughters without parents? Incarceration takes the criminal out of society, but it does not remove the roots of crime. Photographs, while they may not bring the viewer to identify with the convicted, allow for empathy with another human being.

Facing page: Sidney Johnson, found guilty of killing a Chicago police officer, is led out of criminal court on May 13, 1950, after learning he has been sentenced to die in the electric chair.

By five twenty-three on an August morning in 1936, a crowd of 20,000 whites had gathered in Owensboro, Kentucky. Part of the draw was to watch the town's woman sheriff, a mother of four, participate in an execution (she did not). The press spoke of "children of primary school age and women with babies in their arms . . . in the crowd which had waited all night to witness the execution at dawn." They had come from several states and nine counties in Kentucky to see Rainey Bethea, a young black man, hang. At five-thirty the carnival atmosphere turned somber; spectators parted to make a path for Bethea as he was led handcuffed from the jail to the gallows. He climbed the steps without his shoes; he had removed them at the bottom of the stairs in order to put on a pair of clean socks.

A small man with only three years of schooling, Bethea was accused and convicted of the rape and murder of a seventy-year-old white woman for whom he had once worked. There were no eyewitnesses, but the police found his fingerprints and a ring of his at the crime scene. A local newspaper published the popular opinion early on: "Owensboro citizens are demanding that those sworn to preserve the peace of the community and protect its people act and act quickly." The murder took place on June 7. Bethea was hanged on August 14, in what is generally considered the last public execution in the United States. The spectacle associated with this young man's death caused such an outcry that hangings in this country would hereafter take place away from the public eye.

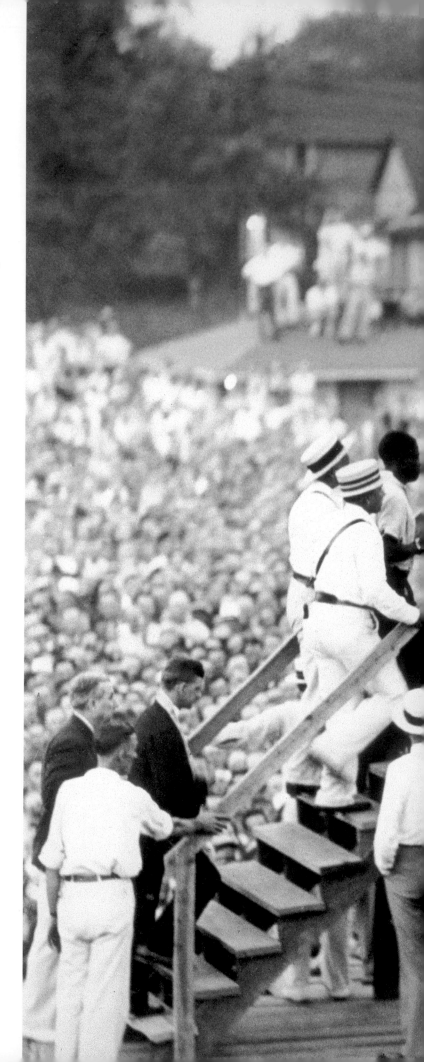

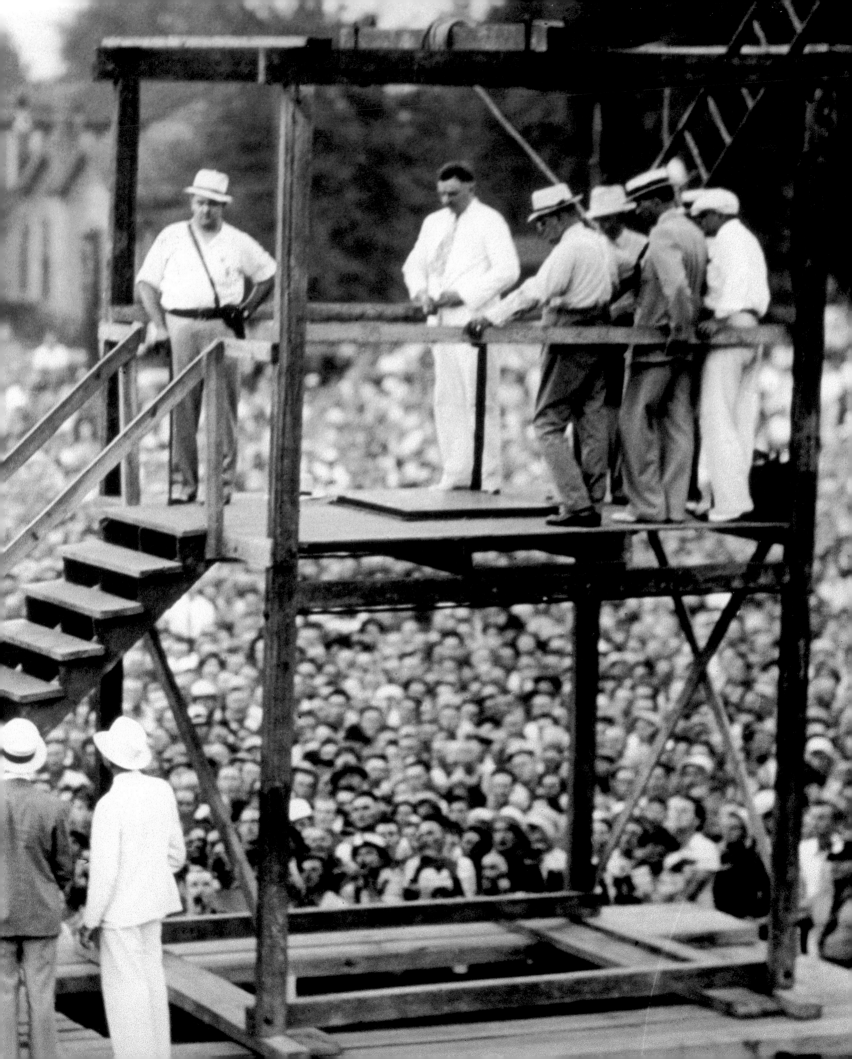

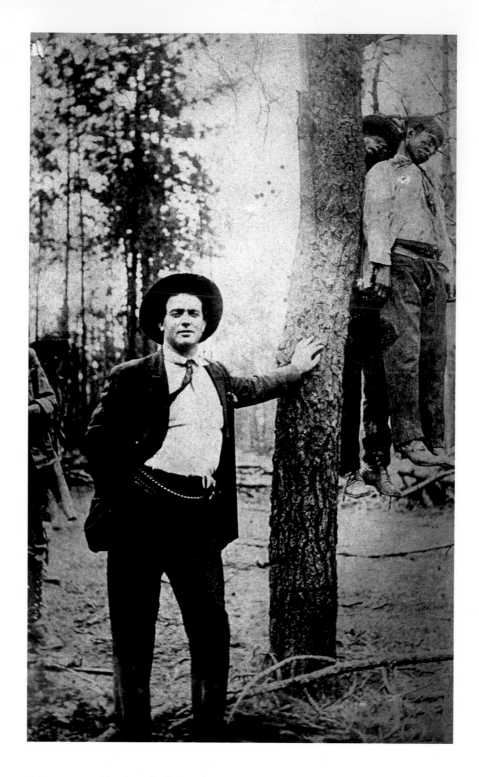

Photographs of lynchings were sometimes sent to friends and relatives as picture postcards. The sender of the one reproduced here discussed the weather in Mississippi; others were inscribed with variations on "Wish you were here." A writer might take a perverse pleasure in being pictured with the victim—and indicate himself in the photograph with an arrow or a circle. Out of spite, known opponents of lynching might regularly be sent lynching postcards.

 Lynching photographs have been brought to public attention in the recent exhibition and book *Without Sanctuary,* compiled by the collector James Allen. In the late nineteenth and early twentieth centuries, Leon Litwack states in his introduction to the book, an average of two or three blacks were lynched weekly in the South. In the 1890s, of the approximately

140 lives lost to lynching, three-fourths were black. Although the total number of lynchings declined, the percentage of black victims rose. Between 1882 and 1968, an estimated 4,742 blacks were lynched by mobs. These lynchings were variously "legal" executions after speedy trials (for sometimes trivial or imaginary crimes), instances of private white violence, or the outcome of "nigger hunts." As Litwack explains: "To kill the victim was not enough; the execution became public theater, a participatory ritual . . . a voyeuristic spectacle prolonged as [much] as possible . . . for the benefit of the crowd." Newspapers might announce the time and place of an upcoming lynching, and special trains would transport spectators to the site. "Entire families attended, the children hoisted on their parents' shoulders to miss none of the action and accompanying festivities."

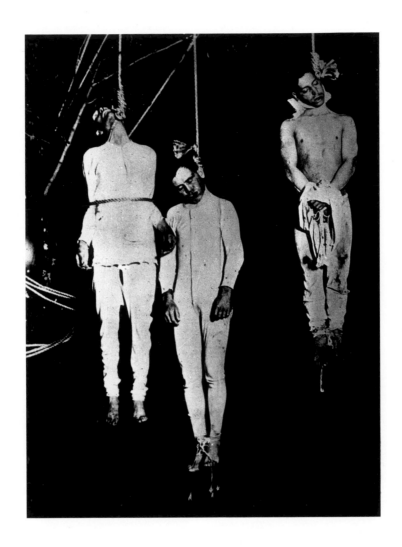

The three Howard Street gang members George Boyd, Terry Fitts, and "Spanish" Charles Valendo were wanted in San Francisco for questioning about the rape of two women. When policemen entered their hideaway, shots broke out and the sheriff and his deputy were killed. The bandits were soon captured and arrested, and taken to the Sonoma County jail. An angry crowd was said to have stormed the jail and lynched the three men from a tree in the local cemetery. In reality, a group of the dead sheriff's friends and businessmen loyal to him planned the lynching and carried it out themselves, on December 10, 1920.

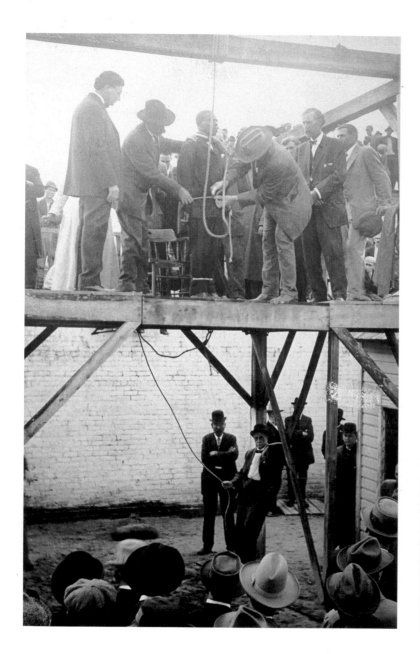
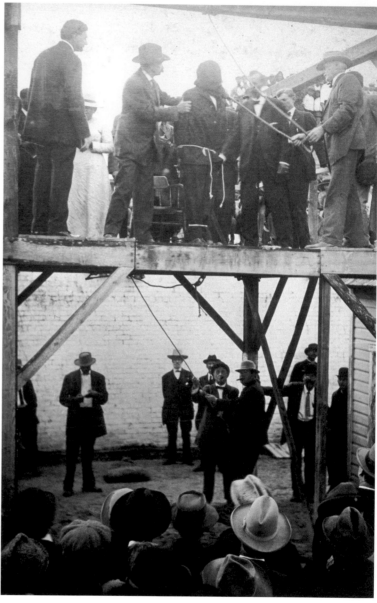

Just before the trapdoor was pulled open, the sheriff placed his hands on the convicted man's shoulders and asked God to "have mercy on his guilty soul." The hanging of the unidentified African-American, found guilty of murdering six or more people, took place around 1905.

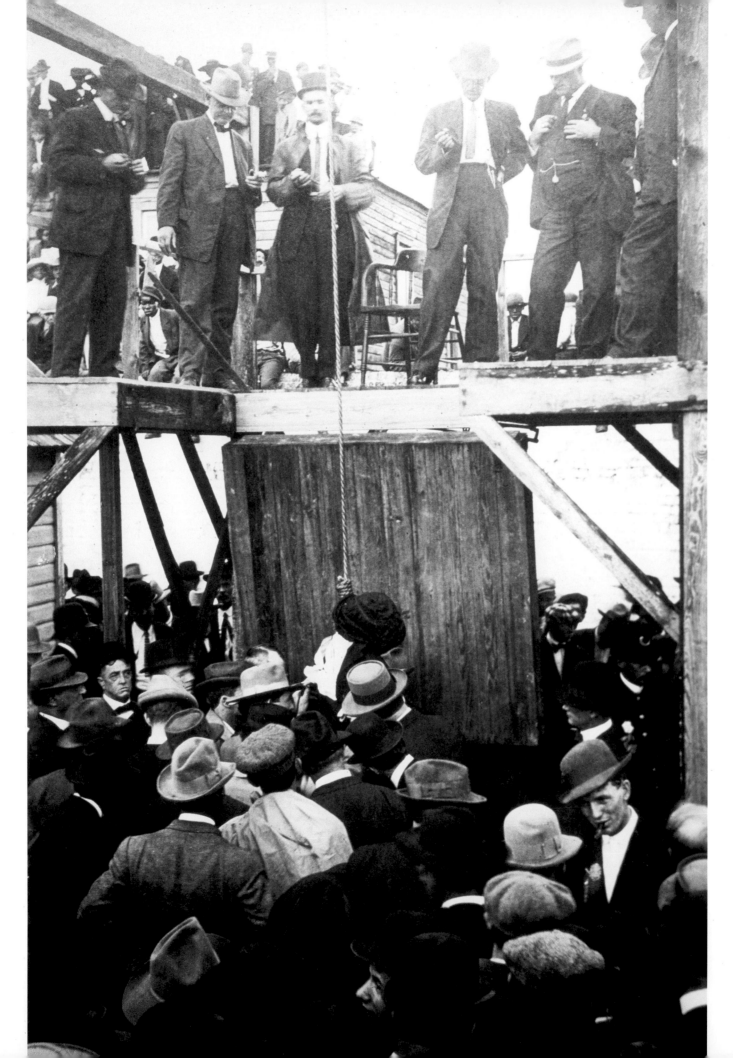

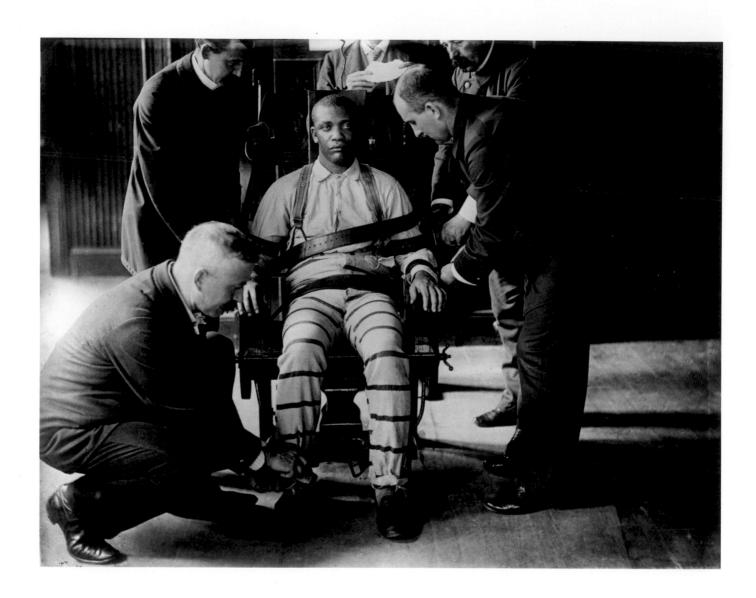

Why a chair? One may ask. The scholar Arthur Danto has pondered this question in an essay, "The Seat of the Soul" (published in the volume *397 Chairs*). Even beyond the leap of imagination necessary to see in electricity "a lethal fluid," someone had to conceive of a chair as the "appropriate device to administer death." The sitting position, Danto writes, "gives a certain dignity to the death administered. It is . . . like the last words, the last meal, all those concessions to the prisoner's ceremonial humanity as we send him from our midst."

The chair illustrated here was relatively new, used only a few times, when the picture was taken around 1900. The law permitting electrocutions went into effect January 1, 1889, in New York State, but there were no suitable chairs. An electrician was hired to build four. The lawyers for William Kemmler, the first man to face the electric chair, argued that it was "cruel and unusual punishment," but Kemmler's execution went forward nevertheless, on August 6, 1890. It was noted that he took off his coat and "sat himself down" in the chair. After he was strapped in, the switch was thrown and electric current shot through his body. He remained rigid for seventeen seconds, until the current was turned off. Fourteen doctors were present in the room to pronounce him dead, but after thirty seconds Kemmler's body moved spasmodically and the warden ordered another dose of electric current. This lasted until smoke rose from the spinal electrode. Those present smelled burning flesh. On the day of the execution, *The New York Times* deemed electrocution "far worse than hanging." The introduction of electricity in conjunction with a chair was in fact intended to make capital punishment more "humane" than existing methods.

Ruth Snyder was executed in the electric chair at Sing Sing on January 12, 1928. This is the first published photograph of an execution by electrocution.

Allen Lee Davis was executed in Florida's electric chair on July 8, 1999. This is one of three photographs that a dissenting judge attached to a Florida Supreme Court ruling supporting the constitutionality of execution by electrocution. The pictures are disseminated on the World Wide Web. The Florida electric chair is known familiarly as "Old Sparky."

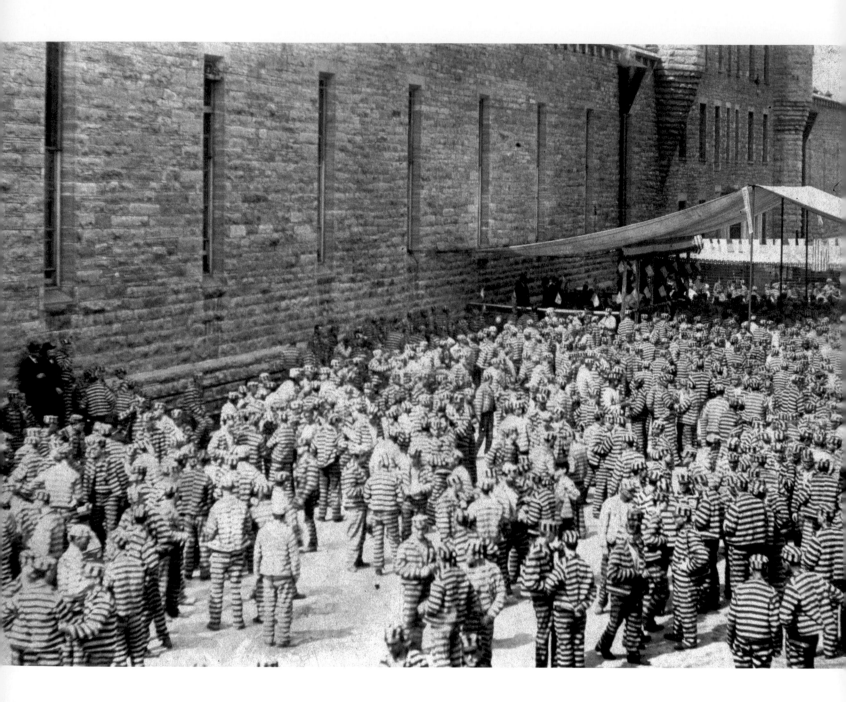

Stripes were the fashion at Joliet penitentiary in the 1890s, when this photo-
graph of the courtyard was taken, almost certainly by an inmate. The prison,
built in 1858, outside Chicago, has a long history of hosting major crime fig-
ures. Until the 1920s, Joliet had darkrooms for inmates and encouraged them
to document activities and facilities there. Thousands of images exist show-
ing daily prison life. Generally nowadays, prison officials frown on scrutiny
by the camera. In Joliet, the convicts themselves were responsible for mak-
ing mug shots, and they employed innovative techniques. The courtyard pho-
tograph is mounted on card and is part of a promotional set used by officials
to illustrate conditions at the prison.

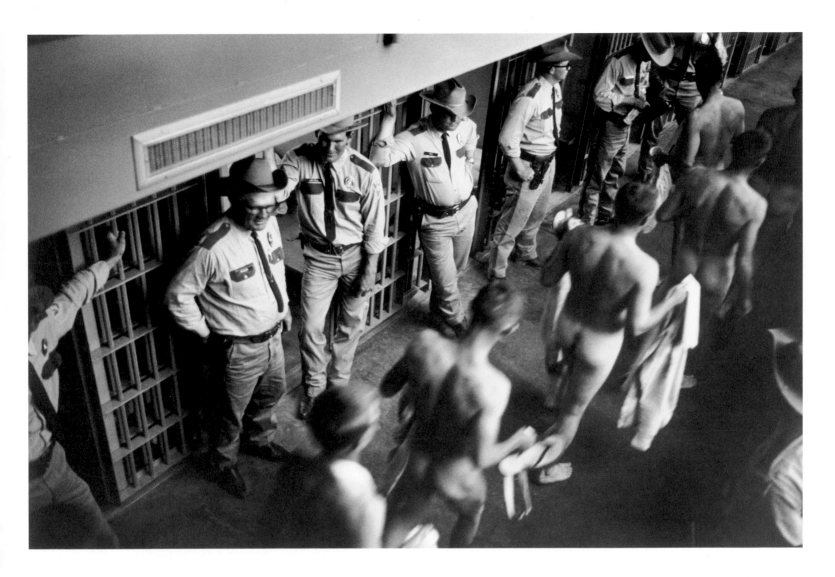

In late 1967, the photographer Danny Lyon was given permission by the director of the Texas Department of Corrections to move freely among six of the state's penitentiaries. His fourteen-month journey resulted in a book, *Conversations with the Dead: Photographs of Prison Life with the Letters and Drawings of Billy McCune #122054*. Lyon's stated goal was to "emotionally convey the spirit of imprisonment shared by 250,000 men in the United States," while recognizing the differences between one facility and another. Inmates in some prisons were permitted to take outside college courses; inmates in others worked on chain gangs and were subjected to twice-daily strip searches.

Penitentiary is related to the Latin words for both *penitence* and *punishment*. The nineteenth-century American ideal for a prison system was as a "correctional" facility, with emphasis on rehabilitation. The pendulum swings, often reflecting political will, from making prisons the most miserable of places, with no recreational activities or classes, to environments that help an individual set a new course in life. A prison official was quoted recently in *The New York Times*: "People ask, 'How much time is enough?' But they should ask, 'How do you want them when they come home?'"— because ninety-seven percent of inmates in this country are eventually released.

Unless drastic measures are taken, the statistics for recidivism will not change. Within three years of their release, sixty-two percent of former convicts will be arrested and forty-one percent sent back to jail. To combat this pattern, some states now release men and women with a printed résumé, including a record of jobs held in prison and classes passed, and letters of recommendation from prison officials. "For guys whose lives have been way out of control," says Steven J. Ickes, assistant director of the Oregon Department of Corrections, "a résumé puts them back in control of their lives." He also notes, "We want inmates practicing on the inside what works on the outside."

The woman in the photograph, Jaime, was convicted of malicious destruction of property worth more than one hundred dollars and sentenced to four years in prison. Five months total of her sentence were spent chained down; the first time, without explanation, was for an entire week.

Rule 33 of the United Nations Standard Minimum Rules for the Treatment of Prisoners states clearly: "Chains or irons shall not be used as restraints." According to international standards, other instruments of restraint should be used only in very specific instances, and never as a means of punishment.

In 1999, Amnesty International published *"Not Part of My Sentence":* *Violations of the Human Rights of Women in Custody.* Amnesty is particularly concerned about women prisoners who are chained during pregnancy, labor, and delivery. The worst instances—and Amnesty has documented such cases—occur when women have their legs still shackled together just before giving birth, and require the permission of a prison supervisor, not a doctor, to have the lock opened.

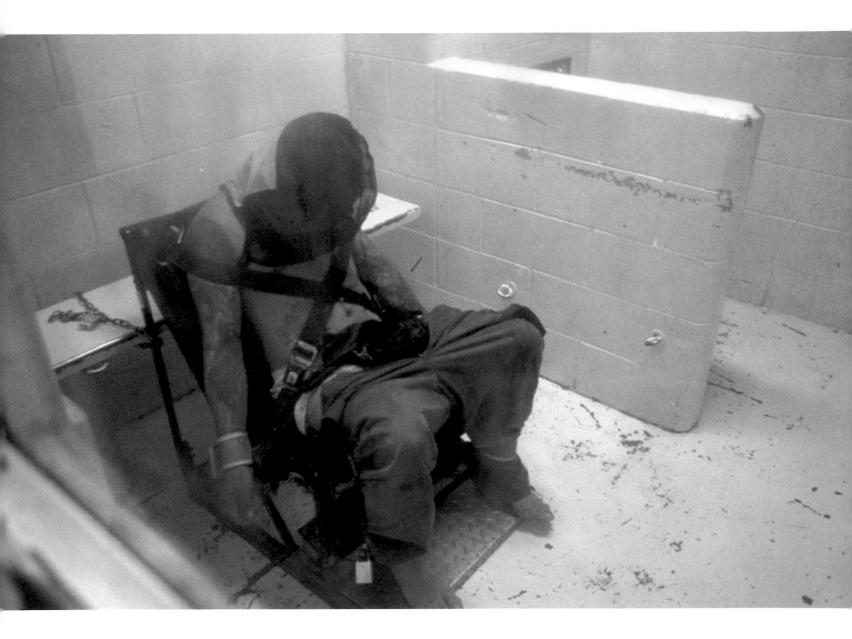

The prisoner had just been arrested, in 1997, and was fighting his jailers. They covered his head to protect themselves from being bitten and spat at before strapping him into a restraining chair at Maricopa County prison, Phoenix. In his April 21, 2001, column in *The New York Times*, entitled "A Test of Civilization," Anthony Lewis discusses the restraining chair found in some federal penitentiaries. He describes a prisoner held for five days in "a 'four-point restraint.' He was chained by his wrists and ankles. . . . He was forced to urinate and defecate on himself." Five days!

Amnesty International has taken up the cause of individuals in American prisons who face various forms of torture. Lewis cites a case in 1999 in which an inmate died while in one of these restraining devices.

Doctors and psychologists speak about the harmful effects to the body and the mind when one cannot move for extended periods of time.

"Brutal prison conditions," writes Lewis, "should concern us [Americans] the more because this country now imprisons a higher percentage of its population than any other in the world." He argues that "we should be doing much more to enforce legal rules against brutality in prisons. That is for the sake not only of the prisoners but of us, the law-abiding." Finally, he recalls the words of Winston Churchill in 1910: "The mood and temper of the public in regard to the treatment of crime and criminals is one of the most unfailing tests of the civilization of any country."

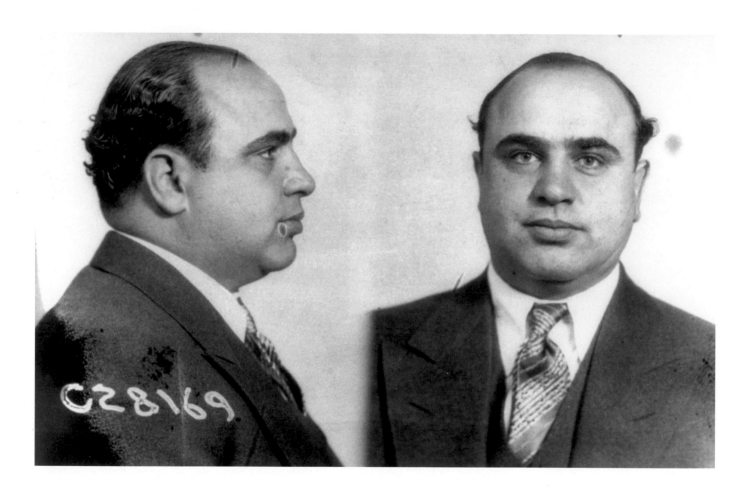

Al Capone was convicted in 1931 of income tax evasion and sentenced to eleven years in jail. "A point of law rather than the point of a pistol," Harold Evans writes in *The American Century,* finally brought Capone down: the Supreme Court had ruled in 1927 that income from illegal transactions was taxable. Eliot Ness, who had been Capone's nemesis during the gangland days, accompanied him to the train that would take him cross-country to prison. When the "Big Man" left Alcatraz, he was, in the words of the gang accountant Jake Guzik, "nutty as a fruitcake."

Flamboyance is photogenic. There are plenty of good-lookers and dapper dressers in the underworld. A certain swagger comes with power—among kingpins as well as kings. John Gotti was in a well-creased line that includes John Dillinger, Bugsy Siegel, Lucky Luciano. The well-cut suit, the cashmere overcoat, the tilted fedora—gangsters dressed to kill, one might say. Once they were notorious, they could be relaxed about the camera, but lesser fry were camera shy. A Chicago journalist overheard "Little Hymie" Weiss tell a police mug shot photographer, "I'll kill you for this." He meant it.

The goodfellas may look good partying or parading or, in Al Capone's case, fishing off a boat in a striped dressing gown, a big cigar in his mouth. They look less seemly slumped over steering wheels with their brains blown out, sprawled in the gutter, or tagged and displayed on a slab in the coroner's office, with the unforgiving stitches from the autopsy. Visually, the public does not discriminate between living and dead gangsters: gawkers want a look at both. Newspaper editors filled their pages with images like those of police pointing out the bullet holes in Baby Face Nelson's chest and a dead Dillinger being fingerprinted to prove his identity. Most extraordinary, perhaps, was the access the police gave the press to prey on dying mobsters, notably Dutch Schultz, who died in his hospital bed, and Frank Nitti, who did not.

The anonymous newspapermen who compiled the 1930 classic *X Marks the Spot: Chicago Gang Wars in Pictures* (the "first actual photographic story ever published of the world famous beer wars of Chicago Gangland") suggested that after the St. Valentine's Day massacre in 1929, papers began regularly printing images of violent, Mafia-style crimes. When murder became massacre, the notion of the romantic outlaw gave way to that of the hardened criminal and his nasty handiwork. For many years newspapers featured pictures of crime scenes with an X marking the spot where a body had fallen. Depression-era tabloids sensed that dramas would be welcome to millions with survival on their minds, and the establishment was not averse to reminding the hungry and the jobless that lawbreakers met nasty ends. The temptation to rob a bank might be curbed by the sight of a bloodied perp hustled into police headquarters. Gangland photographs in the tabloids provided not only great entertainment but also a dose of morality.

Crime in the United States, as Arthur Schlesinger, Jr., observes, has been one means of upward mobility. Nineteenth-century "independent businessmen"—the frauds and the forgers, the thieves and the tricksters—were replaced by the "Red Rocks Farrells, Dion O'Banions, and Bugs Morans, who were jostled by the Arnold Rothsteins, Legs Diamonds, and Lepke Buchalters, who in their turn were shouldered aside by the Lucky Lucianos, Frank Costellos, and Vito Genoveses." With each new crop of wiseguys, the public clamored to see their faces. America has many kinds of rags-to-riches stories.

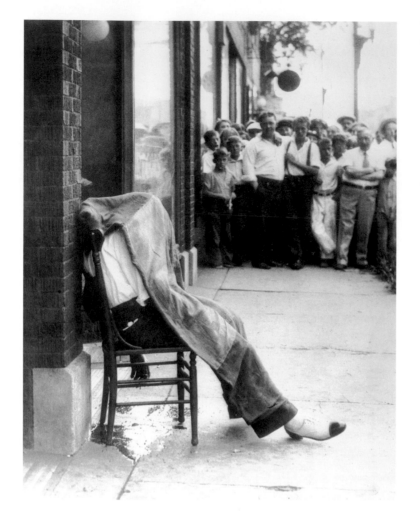

Tony Moreno, alias Dominick "The Rat" Russo, felt secure enough in his position as gang chief of Cicero, Illinois, to sun himself on his own turf. Moreno, described as a "pupil of Capone," was not protected by his mentor once Capone was in prison. On August 2, 1933, gunmen fired four bullets into Moreno's chest. The pool of blood and the gazing crowd are standard fixtures in photos of gangland slayings. The pointed shoes and dangling hand make Moreno a much more elegant corpse than most dead mobsters.

The tagged corpse of John Dillinger after autopsy on July 22, 1934.

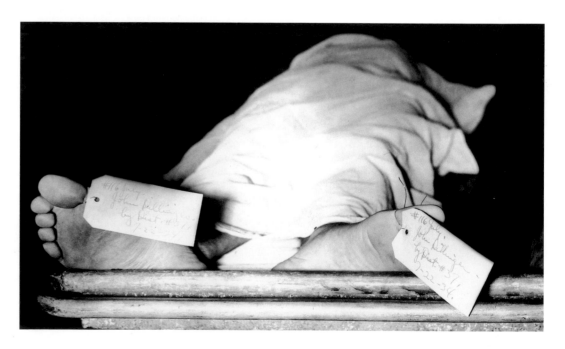

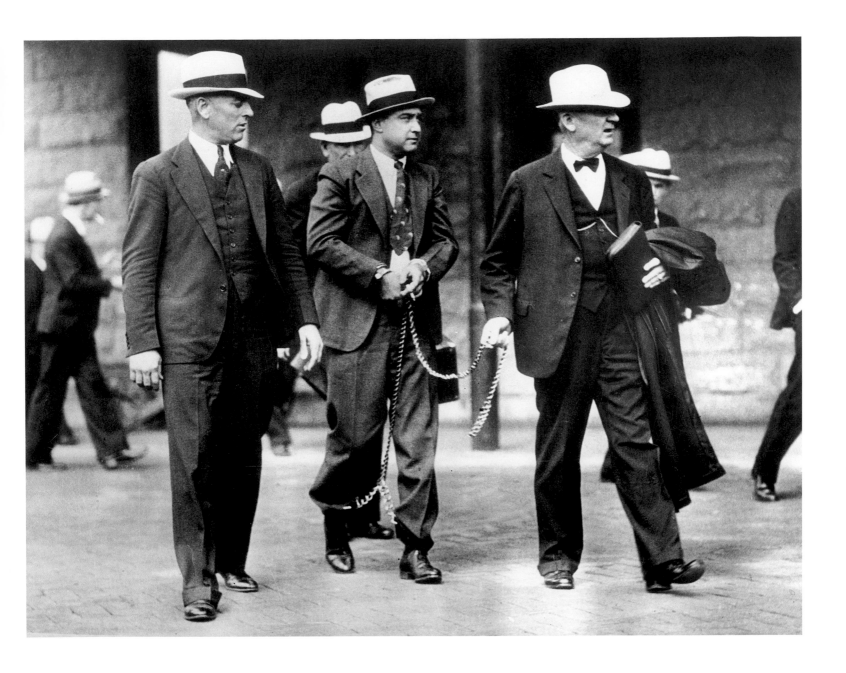

George "Machine Gun" Kelly, in chains, is escorted by law enforcement officials. He was arrested in Memphis on October 15, 1933, and extradited to Oklahoma City for trial. Kelly was convicted and sentenced to life in prison.

David E. Ruth, in his book about gangsters in American culture *Inventing the Public Enemy*, argues that the young men going into crime in the 1920s and 1930s "would perplex any of those scientific old gentlemen who talk about a 'criminal type.'" *Collier's* magazine reported that a typical young criminal was "as normal a boy as you would care to meet." Young men went into crime, after evaluating other career options, because it was lucrative. They could have expensive clothes, fast cars, an exciting nightlife. "The man who took up crime because of an aversion to hard work," Ruth says, "seemed to be modeled after the most respectable and modern of his contemporaries." Basil Gallagher, a reporter for the *New York Post* and UPI and the only journalist permitted to ride with John Dillinger and his right-

hand man, Homer Van Meter, after they were captured in 1934 in Tucson, recounted that "Dillinger discussed every story I had ever written about him. He discussed bank robbery as other men would discuss their business. He said . . . there really wasn't anything else he wanted to do. He was completely casual, but I had the feeling that every second, every minute, his mind was working. . . . I could almost hear the gears mesh" (quoted in James D. Horan, *The Desperate Years*).

Gangsters like Dillinger, Baby Face Nelson, and Machine Gun Kelly wanted their share (or more than that) of the American pie. And once they proved their mettle—succeeding in bank heists, flaunting themselves in public, breaking out of jail, killing law enforcement officers—the public wanted a share of them. People wanted to know what living outside the law was really like. The tabloids understood this fascination and turned crime into a spectator sport.

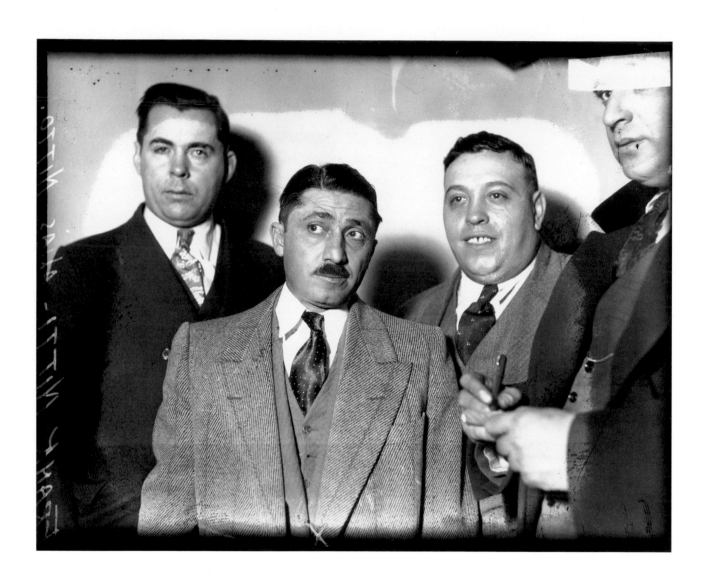

The fictionalized Frank Nitti—"The Enforcer"—was on television every week. Millions knew him as the brains of the Chicago underworld in the popular program *The Untouchables*. But the real Frank Nitti (above, center) was not nearly as powerful as he was portrayed.

Nitti started out as a barber with a potent clientele. Prohibition created opportunities for him, and hundreds like him, to make good money from bad sources during the Depression. He started to sell hijacked booze for Al Capone, and rose in the organization after his boss went to prison, but never all the way to the top. In 1932, the new mayor of Chicago, Anton Cermak,

who wanted to redistribute Capone's old operations to his own favorite gangster, had two policemen shoot Nitti, severely wounding him. Nitti was for a time near death, but he recovered (the photograph on page 123 shows him in his hospital bed).

In the early 1940s, federal agents obtained evidence against a group of mob leaders; as in the past, they wanted Nitti to plead guilty and take the heat for all of them. On March 19, 1943, unwilling to return to jail, in an action atypical for a mobster, he shot himself.

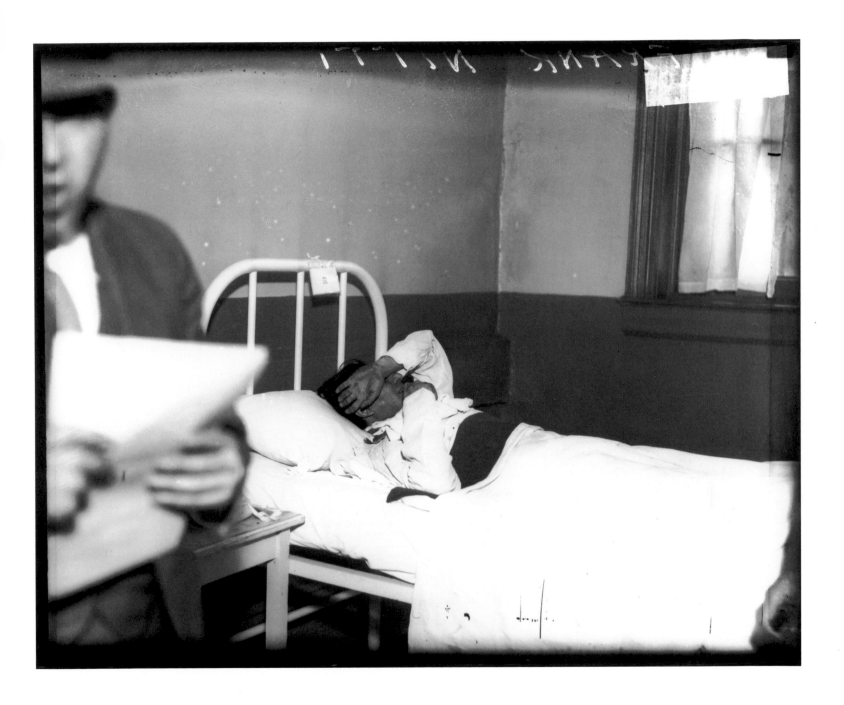

Abe Reles (center) was the second Kid Twist, the first being one Max Zweibach. Kevin Baker, who modeled the hero of his book *Dreamland* on Zweibach, explains that it was the custom of New York gangsters to give or take on "the names of past stars of the underworld, as a sort of tribute. This was apparently especially true of Jewish gangsters, who wanted at all costs to keep their mothers from finding out what they were doing."

Reles was one of Louis "Lepke" Buchalter's hit men and had plenty of murders under his belt. He was arrested for one of these, and after a year decided to use his famous ability of total recall to talk to the police in exchange for protection and immunity from prosecution. He talked for twelve days, his recollections of gangland misadventures filling twenty-five steno-

graphic notebooks. Many heads rolled, and even Buchalter, already in prison, was implicated. Reles's testimony about Buchalter's role in garroting, icepick stabbing, and various other forms of extermination resulted in the first and only conviction and execution of a member of the syndicate board.

In 1941, Reles was scheduled to testify in the trial of Albert Anastasia for the murder of a teamster official, Morris Diamond. Early on the morning of November 12, the second Kid Twist "fell" forty-two feet out the window of a hotel room being guarded by six policemen. Now that the star witness was unavailable, the case against Anastasia was dropped. Burton Turkus, a former assistant district attorney, said of Reles, "The canary sang—but couldn't fly."

From the time of the St. Valentine's Day massacre in 1929, Al Capone was known for his leadership of ruthless gunmen who killed on command. Normally it was a fellow gangster who was gunned down, but Capone had no compunction about putting out contracts on government agents. Men like Louis Clementi and Phillip Mangano tried three times, unsuccessfully, to assassinate Eliot Ness and decommission the "Untouchables."

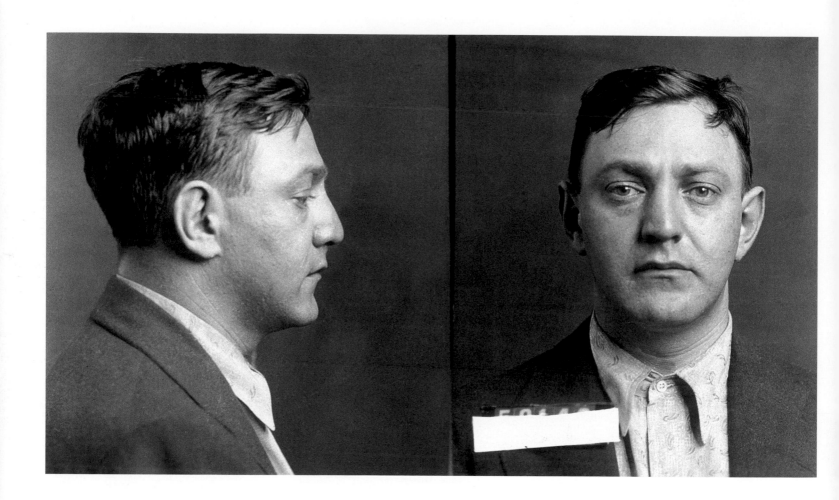

In his classic history *Murder, Inc.: The Story of the Syndicate,* Burton Turkus wrote about Dutch Schultz: "[He] was of that era and ilk of power-mad paranoics so pampered and fawned upon by favor-seeking punks that they came to believe their orders were royal decrees and their wishes ordained commandments." Schultz first made his mark in the crime world by running beer during Prohibition, then branched into labor unions and crooked fights. Indicted for tax fraud, he hired a public relations firm to create some good press. The firm coined the slogan "The Dutchman's trouble might be yours or mine," to drive home the idea that Schultz was just an average Joe.

Dutch stubbornly refused to follow the majority rule when the syndicate ordered that Special Prosecutor Thomas Dewey, appointed by the governor of New York, should not be gunned down. "If you guys are too yellow to go after Dewey," Schultz said at a meeting, "I'll get him myself and I'll get him in a week." After he walked out, the board members consulted. Albert Anastasia put it succinctly: "Okay, I guess the Dutchman goes." That night, in a Newark restaurant, Schultz's body was perforated with bullets. He held on for twenty-two hours.

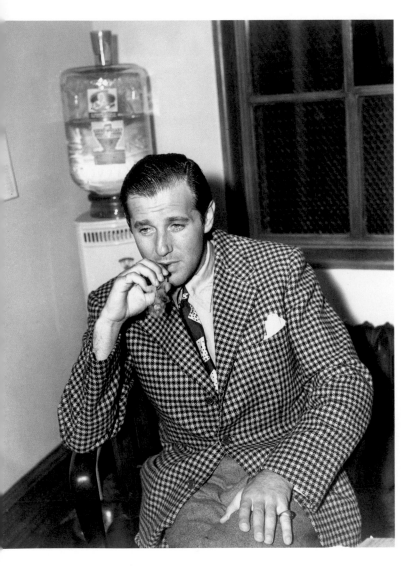

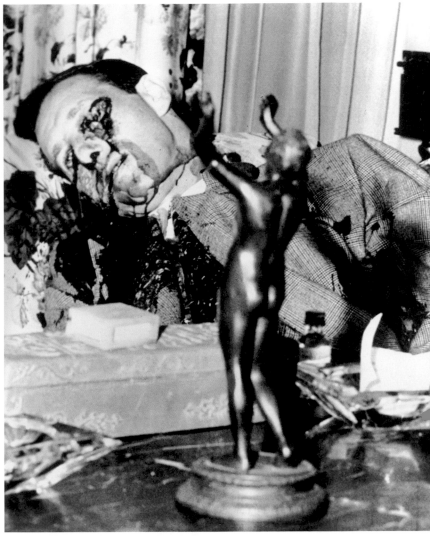

No one called him "Bugsy" to his face. Unless you knew him well, even "Ben" was off limits. "Mr. Siegel" was the preferred form of address. Burton Turkus described him as "a natural for Hollywood. Handsome as a romantic star . . . smooth-talking, *bon vivant*, he had a brashness, built around his well-padded ego, that was made to order to fit film society."

Bugsy Siegel ran the West Coast operations for the syndicate from his thirty-five-room mansion. When the mob decided there was money to be made from the movies, but recognized the major studios were too much to tackle all at once, Bugsy went directly to the Hollywood stars and threatened them, in the nicest possible way, until they paid him five-figure sums to assure that movie "extras" would stay on the job during filming. His dealings never destroyed his reputation as a raconteur and social fixture. He was even introduced to titled heads of Europe.

Among Siegel's more memorable pronouncements: "We don't run for office, we own the politicians." He took over bookmaking and gambling on the West Coast, and until 1939 managed his "expansion" without any gangland slayings.

In the early 1940s, Las Vegas, the only place in the country with legalized gambling, was a natural destination for the mob. Siegel "acquired" interests in the Golden Nugget and the Frontier Club and built a dream hotel, the Flamingo, for $6 million, on money borrowed, some say, from Frank Costello and other financial tycoons. While Siegel was concentrating on Las Vegas, his boys in Los Angeles moved into narcotics and other forms of gambling.

In 1946, he defied the syndicate by refusing to give up control of the wire service in Los Angeles that was the link to bookmakers. Defiance came with a mandatory death sentence, and one day, as he sat in his girlfriend's apartment, Siegel, well dressed as always, was shot to death through an open window.

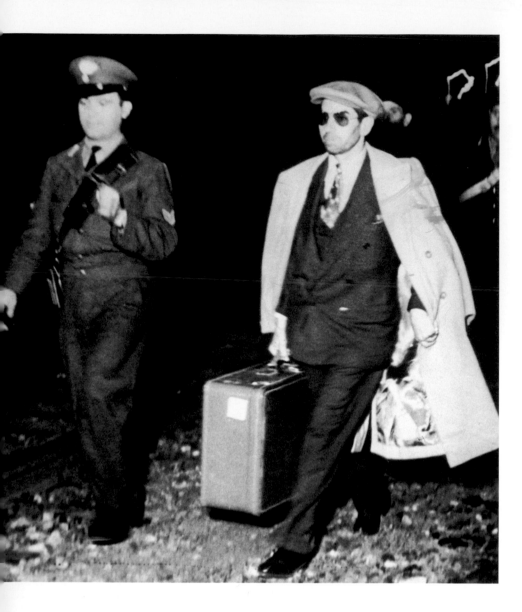

Charles "Lucky" Luciano arrived in New York's Lower East Side as nine-year-old Salvatore Lucania. In his teens he was a natural organizer and a bully, and when his gang picked on a skinny Jewish kid from the neighborhood, they could not help being impressed by his pluck at fighting back. The kid was Meyer Lansky, and thus began the merger of Italian and Jewish gangs.

Prohibition provided the opportunity for illegal movement of alcohol to Manhattan speakeasies in the 1920s. Lansky and Luciano soon had New York dockworkers under their control, and instead of small-time hoods unloading booze offshore, they worked off ships docked right in the harbor.

Luciano envisioned a corporate structure for the Mafia, with a board of directors and an eye on the bottom line—a national crime syndicate. When other Mafia kingpins challenged his vision, Lansky and Bugsy Siegel rubbed them out. The syndicate was run by a few dozen family bosses who controlled bootlegging, betting, narcotics, prostitution, the docks, the unions, food distribution, bakeries, and the garment industry. When necessary, they infiltrated politics and law enforcement.

Luciano lived like the CEO of a Fortune 500 company. He resided at the Waldorf-Astoria, and partied with Frank Sinatra and George Raft. He wore silk shirts, expensive suits, cashmere coats. He liked the ladies, and the ladies liked what he could buy them. An aging mobster remembers that Luciano would "give a girl a hundred dollars just for smiling at him."

In 1936, Special Prosecutor Thomas Dewey finally pinned Luciano, on a charge of compulsory prostitution. Fellow gangsters maintained the charge was a frame-up "to get him off the streets," but everyone knew Luciano was the biggest criminal in town. He was convicted on sixty-two counts and sentenced to thirty to fifty years in prison. Fortunately for him, World War II broke out.

Merchant ships were being sunk off New York harbor by German U-boats. Government intelligence units were at an impasse. Their representatives asked Lansky, an all-time Hitler hater, to visit Luciano in prison and enlist his aid. Dockworkers, fishermen, and gangsters understood that Lucky wanted their help in the war effort. When the United States was planning to land in Sicily before invading the Italian mainland, the government again turned to prisoner Luciano. For services rendered (although he had never become a U.S. citizen), his sentence was commuted, on the condition he return to Italy. Mayor Fiorello La Guardia personally apologized to Luciano's country of origin for sending "this bum back." The photographs above show him returning to Italy and enjoying the good life.

A journalist who spotted Luciano in Naples asked him how he would live his life over if he had the chance. "I'd do the same thing all over again," he said, "only I'd do it legal. I learned too late that you need just as good a brain to make a crooked million as you need to make an honest million. These days you apply for a license to steal from the public."

Sam Giancana (at right) with Christine, Dorothy, and Phyllis McGuire (his girlfriend, next to him), and hairdresser Frederic Jones at a nightclub, May 31, 1965.

From the 1930s until his death at the hand of an unknown gunman in 1975, Sam Giancana wielded as much power in the United States as any politician or major business executive. He could make or break public officials, even at the highest level. Much has been made of Giancana's getting the union vote out for John Kennedy during the 1960 presidential election. The gangster had been involved with Joseph Kennedy since Prohibition and, according to some sources, saved him from extermination at the hands of Frank Costello. It was not out of fondness that Giancana helped the elder Kennedy, but out of pragmatism. He could use politicians. Giancana shared his mistresses with John and Robert Kennedy, most notably Marilyn Monroe and Judith Campbell Exner. And as he wanted to reestablish his gambling empire in Havana, he was a key player in the Bay of Pigs fiasco. Giancana helped many a distinguished person with one hand and held him hostage with the other.

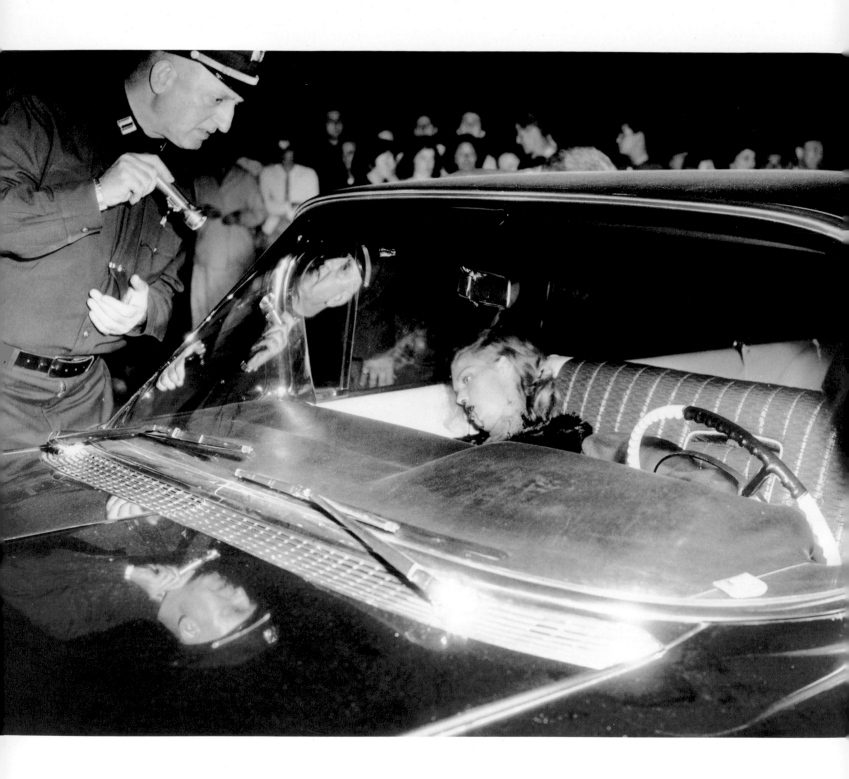

Janice Drake was killed on August 29, 1959, by two bullets through the head and one through the neck. The driver of the Cadillac, who received similar treatment, was Little Augie Pisano, once Al Capone's representative on the East Coast.

A Miss New Jersey right after high school, described by friends as a sweet wife and mother, Janice Drake nevertheless kept bad company. She had dinner with Albert Anastasia the night he was gunned down. Known publicly as a dinner companion to gangland's finest, she probably also transported narcotics and money between big-timers.

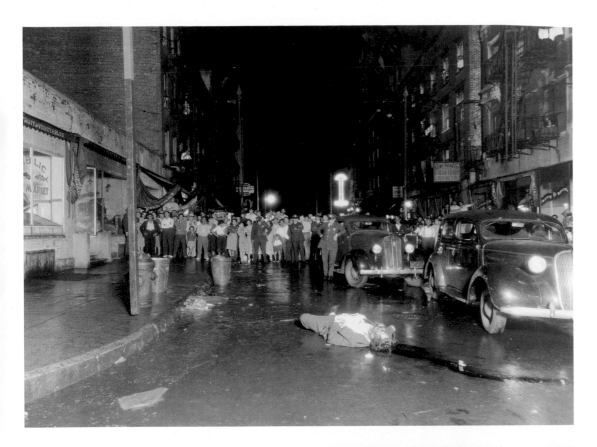

The killing of small-time gangster Carmine Napolitano on Mulberry Street in Manhattan in July 1940 provides big-time drama on a hot summer evening. According to Burton Turkus, the assistant district attorney who prosecuted many of Murder, Inc.'s most notorious cases, organized crime was responsible for a staggering one thousand murders between 1930 and 1940. Almost every murder had only one purpose: the preservation and expansion of the rackets, the syndicate's illegal business dealings.

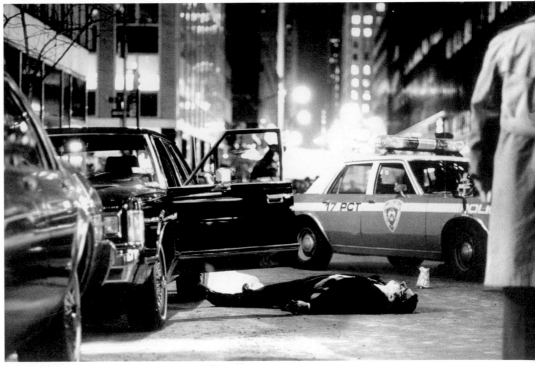

The murder of Paul Castellano and his friend and chauffeur Tommy Bilotti was carried out at the instigation of John Gotti in 1985. Castellano, head of the Gambino crime family, was famous for cloistering himself in his mansion on Todt Hill, on Staten Island, and venturing out only infrequently. On the evening of December 17, he and Bilotti (in picture) were shot down outside Sparks Steak House on East Forty-sixth Street in Manhattan. With the elimination of Castellano, Gotti took command of what was then the strongest crime family in New York City.

Sammy Gravano admitted to nineteen murders. He was sentenced to twenty years in prison and served fewer than five.

The United States treats "family members" well if they abandon *omertà*, their code of silence, and turn state's evidence. In 1991, the big boss John Gotti, his underboss Gravano, and consigliere Frank Locascio were indicted on charges of racketeering and conspiracy to murder. In a shocking move, Gravano agreed to testify against his chief, and appeared at a hearing of the Senate Permanent Investigations Subcommittee on Capitol Hill in April 1993.

In 1980, John Favara, a neighbor and friend of John Gotti, accidentally ran over and killed Gotti's twelve-year-old son. Four months later, Favara was shoved into a car as he left work, and was never seen again. Informers told police that Favara had been chainsawed to death, and his body put into a car that was run through a demolition machine and reduced to a one-foot cube.

John Gotti, once hailed as the "Teflon Don," is now serving a life sentence without parole. His swagger and good looks are embedded in New Yorkers' minds. The former boss of the Gambino family was responsible for countless murders, and the crimes committed by the various Mafia families include—in addition to murder—drug trafficking; loansharking; illegal gambling; extortion; bank robbery; firearms possession; mail, wire, and stock fraud; money laundering; obstruction of justice; and bribery.

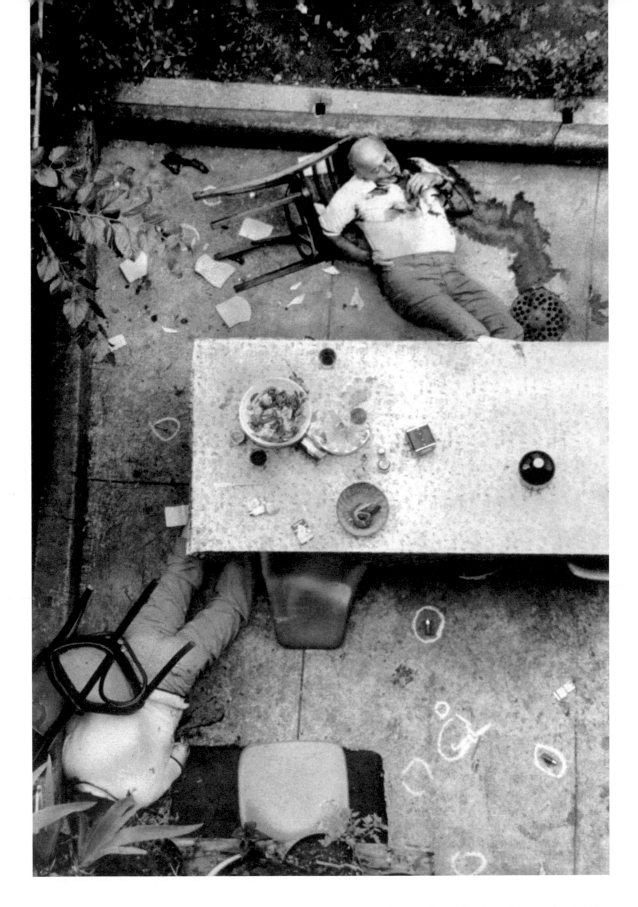

The bodies of Carmine Galante (top) and associate Leonardo Coppolla in the back garden of Joe and Mary's Italian restaurant at 205 Knickerbocker Avenue in Brooklyn, on June 12, 1979. Chalk marks indicate slugs, casings, and impact points.

Galante, the godfather of the Bonanno family from 1974 until 1979, was known to enjoy his cigars. He died with one clenched between his teeth, in a shootout that took the life also of the restaurant owner and injured his son. Galante's Sicilian bodyguard is thought to have instigated the murder. He certainly benefited, becoming at age twenty-four the youngest head of a crime family.

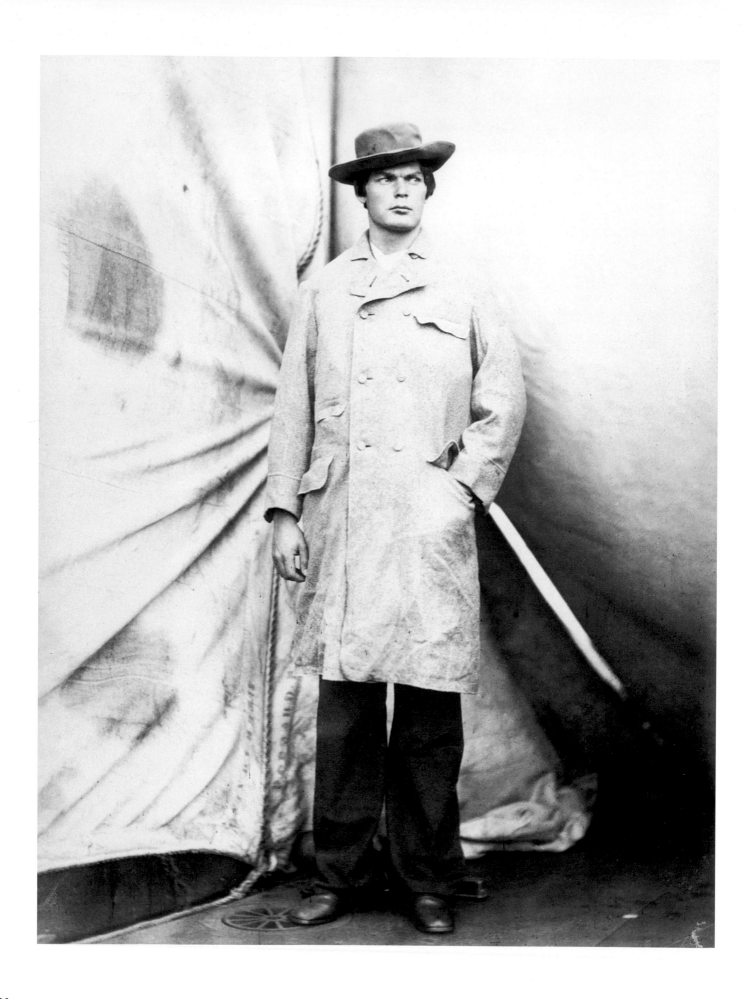

In late summer 1864, John Wilkes Booth began devising a plan to kidnap President Abraham Lincoln and hold him in return for thousands of Confederate prisoners of war. By the following January, Booth had organized a group of conspirators who included Samuel Arnold, Michael O'Laughlin, John Surratt, Lewis Thornton Payne (or Paine, or Powell; see facing page) George Atzerodt, and David Herold. The group met in the boardinghouse run by Surratt's mother, Mary.

The initial scheme to abduct Lincoln while he was attending a play in March was foiled when the president's schedule changed. In April, infuriated by a Lincoln speech supporting voting rights for some African-Americans, Booth shifted his sights toward assassination.

When he learned that Lincoln would attend the evening performance of *Our American Cousin* at Ford's Theatre in Washington on April 14, Booth found his opportunity. In a meeting with his co-conspirators he designated their assignments: Booth, who most sought immortality, was to kill Lincoln at the theater; Atzerodt to kill Vice-President Andrew Johnson; Payne, with Herold's assistance, to eliminate Secretary of State William Seward at his home. The attacks were to take place simultaneously.

At ten-eighteen on that Good Friday night, Booth entered the unprotected presidential box at the theater, put a derringer to the back of Lincoln's head, and shot. He then leaped to the stage below, where he snapped his fibula. A consummate actor, Booth turned to the audience, uttered, *"Sic semper tyrannis"* ("Thus always to tyrants"—the state motto of Virginia), and escaped out the back of the theater to a waiting horse.

Atzerodt made no attempt to kill Johnson—he went no further than the bar of the hotel where the vice-president was staying. He got drunk instead. Payne succeeded in forcing his way past Seward's sons and stabbed the secretary of state many times, but failed to kill him. Seward's neck and jaw had been immobilized with an iron brace after a carriage accident, and this, and a heroic male nurse, prevented Payne from cutting his throat. Herold escaped, followed by Payne.

Photography played a role in the apprehension of the conspirators. The day after Lincoln was shot, and the day he died in a room across the street from the theater, a young man named Louis Weichmann was randomly picked up by the police. He resided at Mary Surratt's boarding-house and was a college friend of her son's. Weichmann helped the police find photographs of Booth, John Surratt, and Herold. The Civil War photographer Alexander Gardner copied these, and the police used the images on what were the first Wanted posters to include actual photographs.

By April 17, Edman Spangler, who had been engaged to hold Booth's horse behind Ford's Theatre, was in custody. So, too, were Samuel Arnold and Michael O'Laughlin, boyhood friends of Booth's. In the evening of that day, now that they had sufficient evidence, the police raided

Presidential Assassins

Mrs. Surratt's boardinghouse. While they were there, Lewis Payne entered. He was taken into custody with Mrs. Surratt, and identified by one of Secretary Seward's houseboys. On April 20, George Atzerodt was discovered at the home of his cousin Hartman Richter, and both men were arrested.

John Wilkes Booth and David Herold were hiding in a barn near Port Royal, Virginia, when a detachment from the 16th New York Cavalry surrounded it on April 26. Herold surrendered but his companion refused. The barn was set on fire, and Booth was shot dead—by his own hand or by cavalry sergeant Boston Corbett.

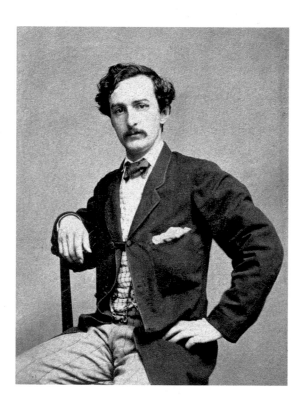

One of the great mysteries in the history of photography is the disappearance of the one glass negative and print made of the corpse of John Wilkes Booth. It is documented that the two great Civil War photographers Alexander Gardner and his assistant Timothy O'Sullivan were assigned to be present at Booth's autopsy aboard the USS *Montauk*. They were to photograph the quickly decomposing body of the assassin.

The April 28, 1865, *New York Tribune* reported: "Yesterday, a photographic view of the body [of John Wilkes Booth] was taken." James A. Wardell, a detective with the War Department and the officer responsible for accompanying Gardner and O'Sullivan on the *Montauk* and delivering the glass plate and print to the War Department, wrote in a signed statement that the Department "was very determined to make sure that Booth was not made a hero," for "some rebel would give a good price for one of those pictures or the plate." Wardell, who had seen the picture and held the plate, was quite sure they would have been destroyed.

Mary Surratt was the landlady of the boardinghouse where Booth and his co-conspirators met. Her son John was a courier for the Confederate secretary of war. Although some claimed she was innocent, she did lie to police officers about not knowing Lewis Payne and she did prepare a package of a carbine, cartridges, binoculars, and whiskey, which Booth and Herold picked up from her boardinghouse the morning after the assassination. Payne, who stood next to her at the gallows, proclaimed her innocence until the time he died.

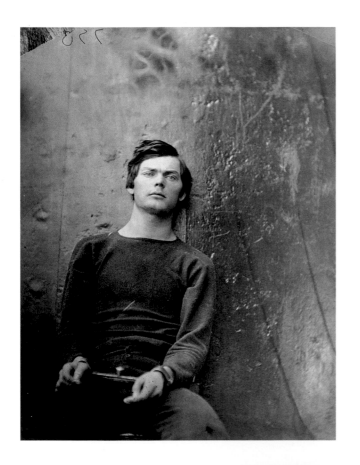

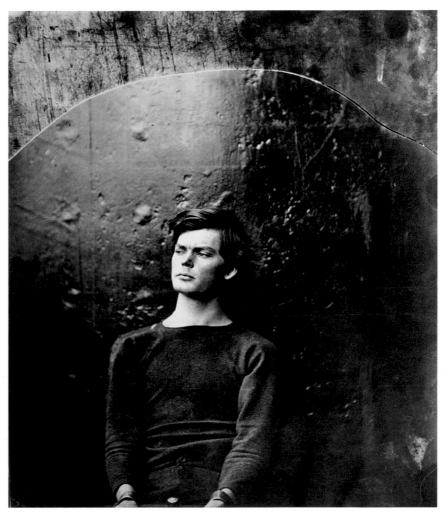

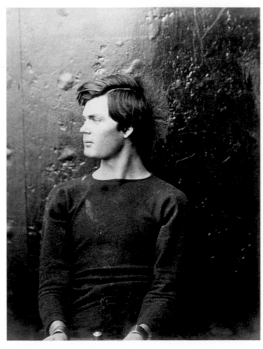

Lewis Payne joined the Confederate Army when he was sixteen, and was an agent of the Confederate Secret Service at the time of his assault on Seward. Strikingly handsome, he charmed the ladies who visited the court-room; they clamored at the doors to see him. Alexander Gardner recognized his was a face worth copyrighting and registered six different views at the copyright office; no other pictures taken by Gardner of the conspirators were copyrighted. The photographer was apparently as dazzled by Payne as anyone, and he made at least ten images of him using the cumbersome wet-collodion process, one of which was copied as a woodcut for the cover of *Harper's Weekly*. In the close-up portraits, Payne, in long-sleeved crewneck shirt, button-fly trousers, and iron handcuffs, looks like Hollywood's idea of a rebel with a cause. He was sentenced to death by hanging.

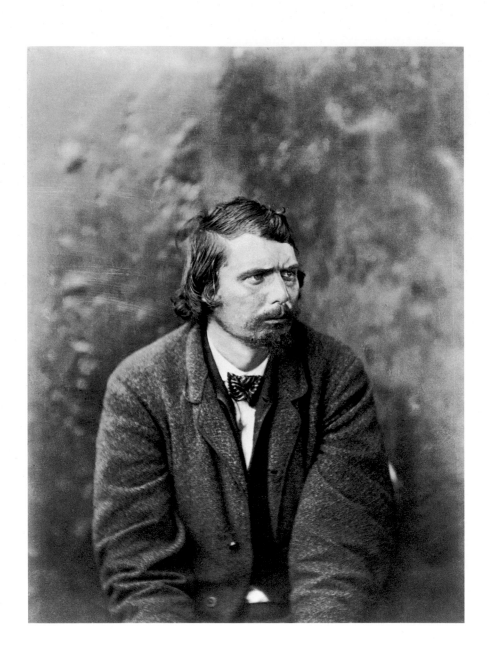

A semi-literate German immigrant who never acquired U.S. citizenship,
George Atzerodt had a coach-painting business in Maryland. He was also a
boatman who transported Confederate soldiers across the Potomac. He lost
his nerve and his way on April 14, and failed to assassinate Vice-President
Johnson. He was sentenced to death by hanging.

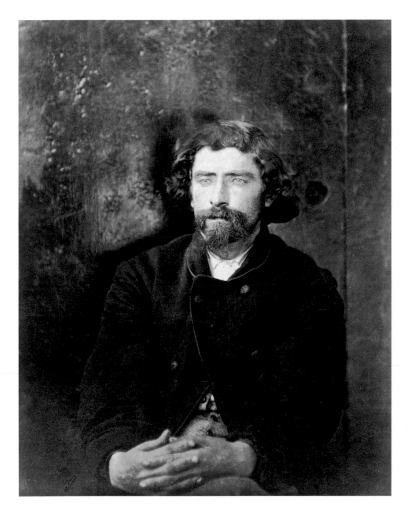

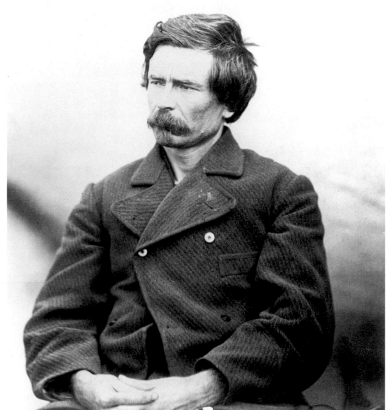

Hartman Richter was George Atzerodt's cousin. He had no prior knowledge of the plans to assassinate the president, but he did harbor his cousin at his home in Germantown, Maryland, where, on April 20, Atzerodt was arrested by federal troops. Richter himself was arrested and later released.

João M. Celestino was a Portuguese sea captain implicated in the conspiracy. He was detained and then released.

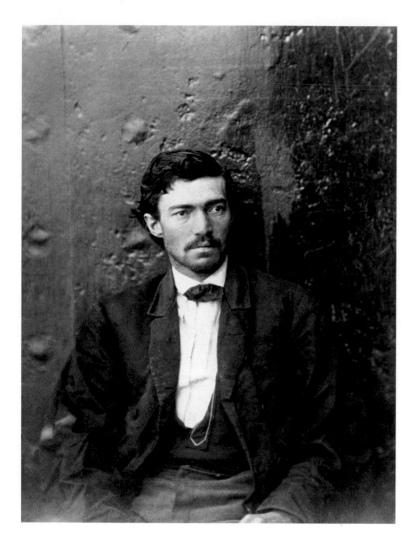

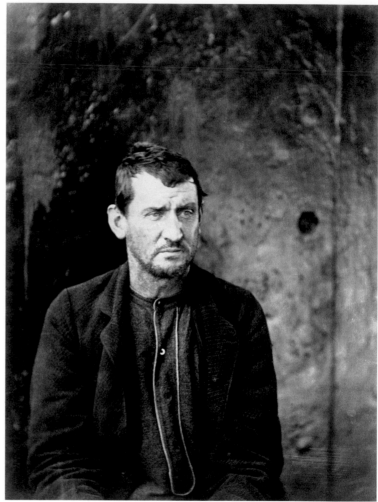

Samuel Arnold, an old school friend of Booth's, had served in the Confederate Army and been discharged because of illness. He collaborated with Booth and the others until March 1865, but left them after the foiled kidnapping plan. He was sentenced to life in prison.

Edman Spangler worked on the Booth family farm in Maryland. Booth helped him find a job at Ford's Theatre as a carpenter. Appointed to hold the actor's horse during the assassination, he delegated the task to someone else. He was sentenced to life in prison.

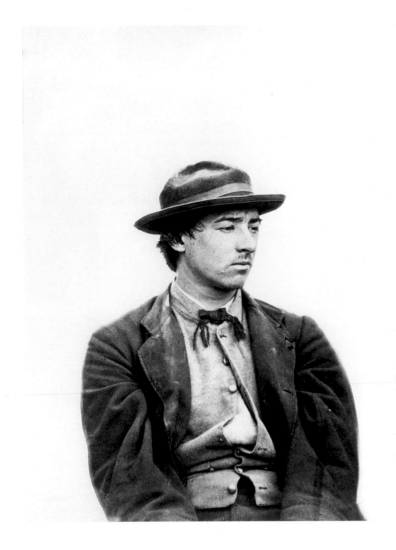

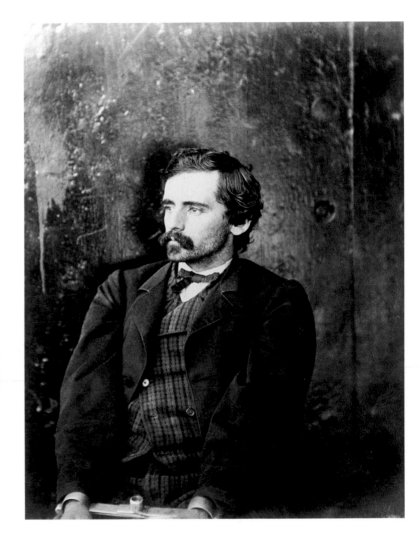

David Herold, a "light and trivial youth" whose courtroom demeanor was characterized as "nothing outside of frivolity," has been consigned to history as Booth's sidekick. Once a pharmacy student at Georgetown, he dropped out to devote himself to hunting. His father, aware of his lack of maturity, specified in his will that David have "no affair in the settling of [his] estate whatsoever." Some historians believe the young man was mentally retarded. He was sentenced to death by hanging.

Michael O'Laughlin was another Booth boyhood acquaintance who served in the Confederate Army. He renewed his acquaintance with Booth in late 1864 and left the conspiracy after the unrealized kidnapping plan. He was sentenced to life in prison.

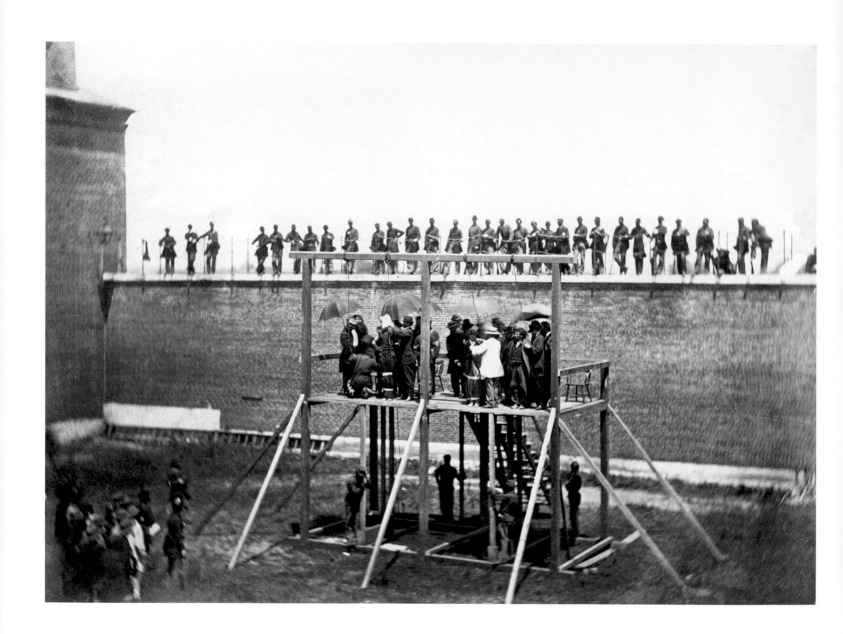

On July 5, 1865, after two months of testimony, Mary Surratt, Lewis Payne, George Atzerodt, and David Herold were sentenced to death by hanging. The sentences were carried out two days later, on July 7, in the courtyard of the Old Arsenal Prison in Washington. Alexander Gardner was the only photographer given a pass to document the executions; his assistant, Timothy O'Sullivan, was permitted to attend. They set up their cameras, an eight-by-ten for O'Sullivan and a stereoscopic for Gardner, in a window directly across from the gallows.

At one-fifteen on the unbearably hot afternoon, the prisoners were led out of their cells to the gallows. The debonair and cheeky Payne was the only one not collapsing. He snatched a straw hat off the head of a sailor as he walked toward the platform. Armchairs were placed for the foursome to sit, and an umbrella was held over Mrs. Surratt, the first woman to be executed in U.S. history. Other umbrellas were opened, to shield the men reading the warrants, and the male prisoners, from the scalding sun.

The trapdoors opened and the four bodies dropped. They swung for thirty minutes before being cut down, placed in pine boxes, and buried on the prison grounds. Spectators were then served lemonade and cake.

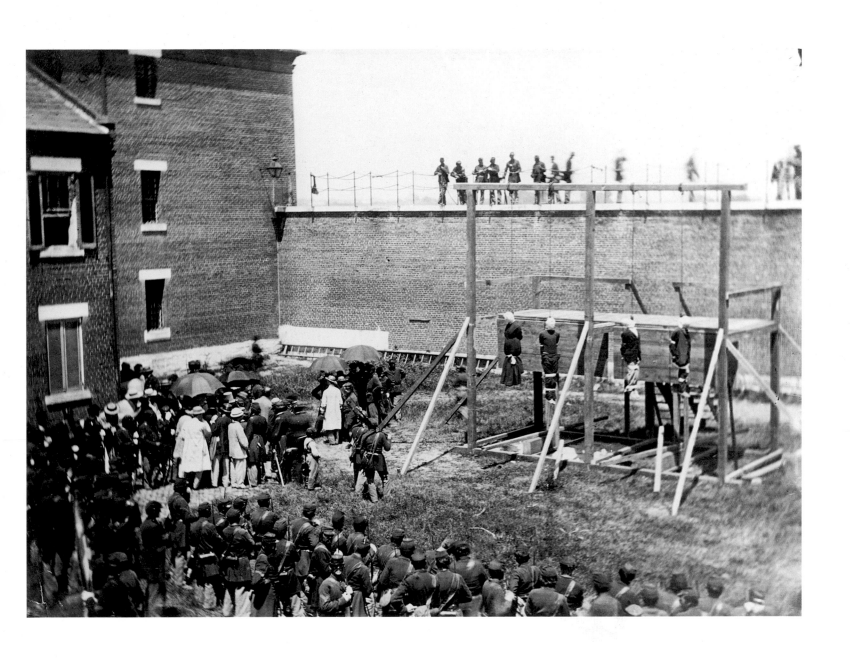

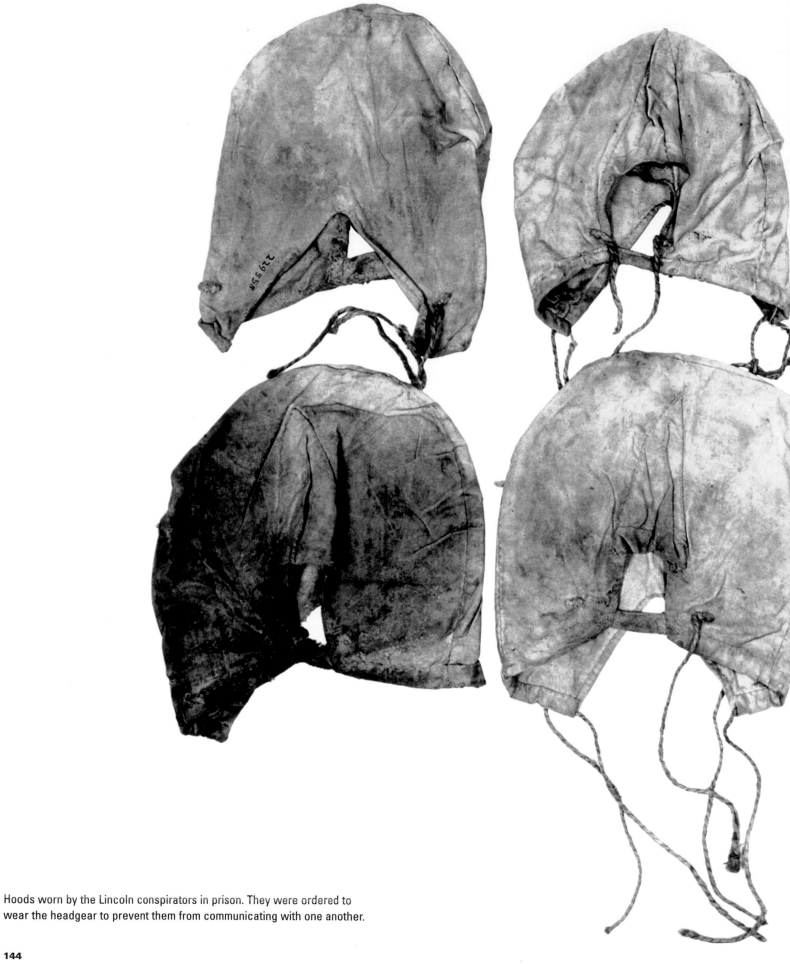

Hoods worn by the Lincoln conspirators in prison. They were ordered to
wear the headgear to prevent them from communicating with one another.

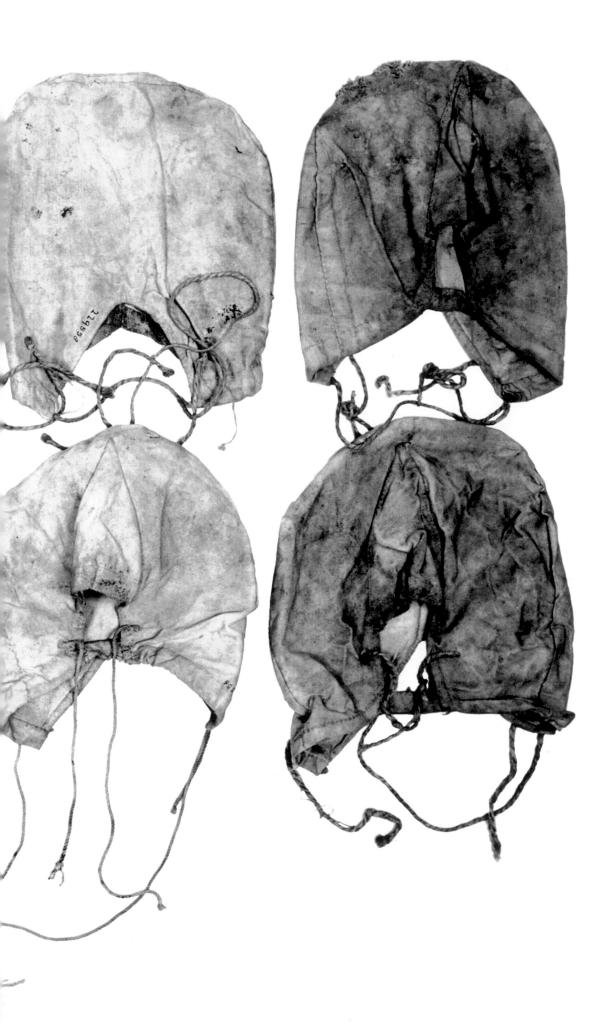

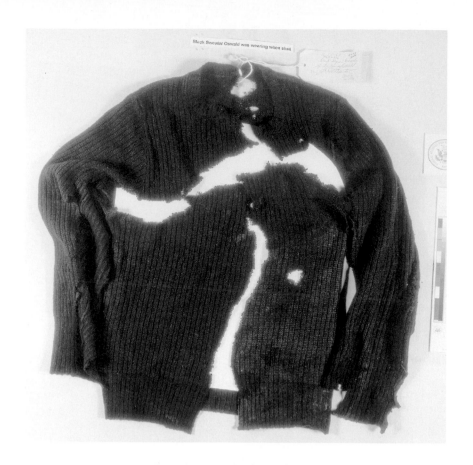

Evidence photographs of clothing worn by Lee Harvey Oswald that were
included in the Warren Commission Report.

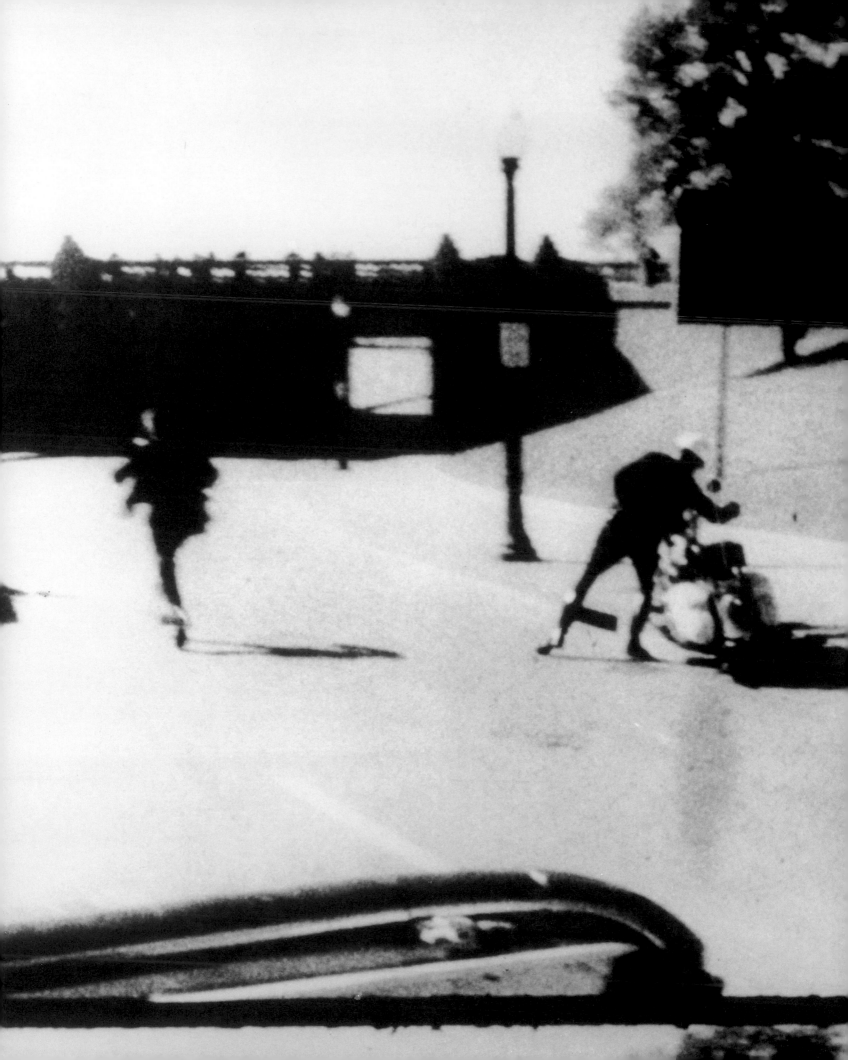

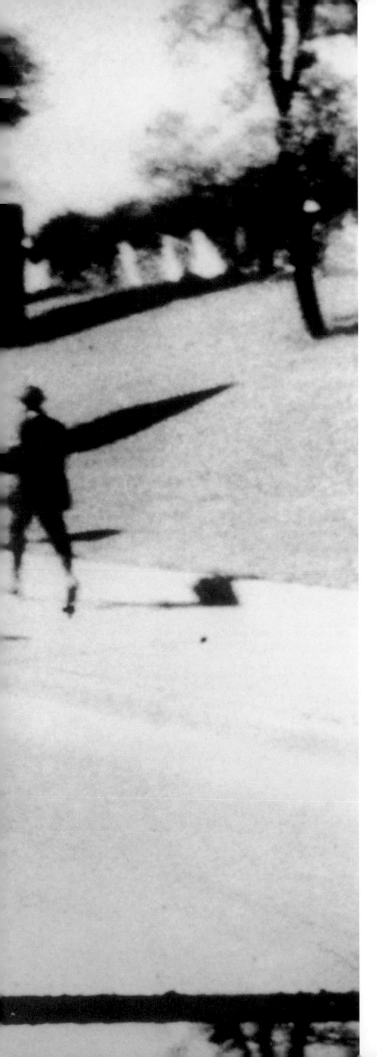

A week afterward, only twenty-nine percent of the American people believed that Lee Harvey Oswald, acting alone, had killed President Kennedy. It was the beginning of an efflorescence of rumor and surmise, of speculation and hypothesis, of falsehood and distortion, of fantasy and fabrication, whose hallucinogenic colors began to fade only after thirty-five dizzy years.

It was altogether natural that there should be suspicion. The killer was an ex-Marine who had defected to Russia, a self-proclaimed pro-Castro Marxist; his killer in turn a minor thug with ties to the Mafia. The elements of the mystery could hardly have been richer.

President Johnson acted quickly to find the truth. He set up a seven-man commission of inquiry on Friday, November 29, headed by Supreme Court Chief Justice Earl Warren, and including Allen Dulles, John McCloy and future president Gerald Ford. In September 1964 it concluded there was no evidence that either Oswald or Ruby was part of any conspiracy, domestic or foreign: the Russians and Cubans were not involved. It was a sound conclusion on the evidence then available, but the Warren Commission accidentally set the bats flying by a series of omissions, errors and contradictions; it underplayed Ruby's links with the mob and also his mental fragility. The reluctance of the FBI and CIA to disclose anything was their natural bureaucratic mind-set, but it was interpreted as the government's having something more sinister to hide than a series of mistakes. So was the secrecy of the autopsy—which was botched anyway. In 1978, anxiety was regenerated by another investigation by the House Select Committee on Assassinations. It debunked many theories, corrected the misleading autopsy, then added mischief of its own. In a hasty revision written after the final draft, it concluded there was a second gunman because audio experts examining a recording from the open microphone on a police motorcycle in Dealey Plaza had discovered "impulse patterns" suggestive of four shots, not three. The Committee then pointed the finger at the Mafia. Alas, the "impulse patterns" turned out not to be gunfire and the motorcycle was not even in Dealey Plaza at the time.

By 1993, several hundred books and still more self-published tomes and manuals [had] piled up from these confusions, an incremental Tower of Pisa leaning ever more crazily toward the ground. Oswald's body was exhumed in 1981 to check the theory that when he was in Russia the New Orleans boy had been switched with an identical imposter, a KGB assassin.

The common feature of the conspiracy theories was that Oswald did not act alone. The plotters and their motives were variously identified: Lyndon Johnson, with or without Lady Bird Johnson (to gain the presidency); Nikita Khrushchev (to avenge his Cuban missile defeat); Fidel Castro (to pay back Kennedy's attempts to remove him); and anti-Castro activists (for JFK's failure at the Bay of Pigs); the Mafia doing it either for Russian-Cuban gold or to punish the Kennedys for investigations of Jimmy Hoffa. In the most lurid scenarios, which took life with Jim Garrison, the district attorney in New Orleans, there were, at one time or another, sixteen marksmen in Dealey Plaza, working for either a homosexual ring that wanted a thrill or a sinister group in the military-industrial complex frightened that Kennedy would end the war in Vietnam and hence their profits. Oliver Stone's 1991 movie *JFK* gave currency to this fantasy and new life to the conspiracists.

Bureaucratic bungling, paranoia and greed supplied adrenaline for some of the efforts to prove that the killing was by anyone but a lone misfit, yet the rash of theories was an acknowledgment of something deeper. They provided psychological balm for the national trauma. As William Manchester remarked, they invested the President's death with meaning, endowing him with martyrdom. He died for something.

(from *The American Century* by Harold Evans)

This photograph was taken on Dealey Plaza in Dallas on November 22, 1963, near the spot where President John F. Kennedy was shot.

The doctors who treated John F. Kennedy after he was shot were not look-
ing for forensic evidence. They were trying to save his life. One doctor who
helped wheel the president's body from the limousine into the hospital
admitted, "All of us were so shocked . . . and to have Mrs. Kennedy there—
none of us stared very closely [at] the wound." Another doctor confessed,
"I guess I have to say that I was wrong in my Warren Commission testimony
on the wound and in some of my pronouncements since then. I just never
got that good of a look at it" (both quotations from Gerald Posner, *Case
Closed*).

Hence the importance of autopsy photographs. Fifty-two photographs
and fourteen X rays were made by John Stringer, an experienced hospital
photographer, during the abbreviated (and some say bungled) Kennedy
autopsy.

Confusion about the nature of Kennedy's wounds arose because the
photographs taken were not analyzed by forensic experts or studied by
medical personnel after the autopsy. The Warren Commission "created
many of its own difficulties," Gerald Posner observes in *Case Closed*. "The
Commission wanted to use the autopsy photos and X rays as the best evi-
dence of how the President was shot, but the Kennedy family refused to
release them. [Supreme Court justice Earl] Warren feared that if the
Commission had the photos, they might be leaked to the press, and as a
result he was hesitant to pressure Robert Kennedy on the matter." Only
Earl Warren and the Commission's general counsel, J. Lee Rankin, saw
the autopsy images; not even the artist who drew the pictures for the
Commission report was allowed access. It was not until the late 1970s that
forensic scientists and medical examiners were permitted to study the
photographs and X rays and confirm the original finding, that only one gun-
man had shot John F. Kennedy.

It is not easy to look at the photographs of Kennedy here. They are
evidence of a violent crime, however, and must be seen as such. It is the
crime, not the record of it, that violates the man. John McCloy, a member of
the Warren Commission, stated in 1967 that if he might have done one thing
differently, he would have insisted on having the photographs and X rays
before the Commission. "I think we were perhaps a little oversensitive to
what we understood as the sensitivities of the Kennedy family against the
production of colored photographs of the body."

While the National Archives still does not release the Kennedy autopsy
photographs, certain government officials and experts in pathology, with
permission from the estate, may view (but not publish) them. The Kennedy
family has always been concerned to prevent the pictures' being used in
macabre ways. The copies circulating on the Internet derive from a set in
the possession of Robert Groden, the author of *The Killing of the President*,
in which the autopsy photographs are reproduced. Groden was an unpaid
photo consultant to the House Select Committee on Assassinations in the
1970s. In 1998, the Assassination Records Review Board reported the suspi-
cion among many people "that Groden made unauthorized copies of . . . pho-
tos and films when he worked with the Committee."

On December 31, 1991, *The Globe*, a tabloid, published color photo-
graphs from the Kennedy autopsy. Five years later, Groden was called as an
expert witness at the O. J. Simpson trial to comment on a photograph of
Simpson wearing Bruno Magli shoes at a football game. During his testimo-
ny, it was revealed that Groden had sold the reproduction rights for the
autopsy photographs to the tabloid for $50,000.

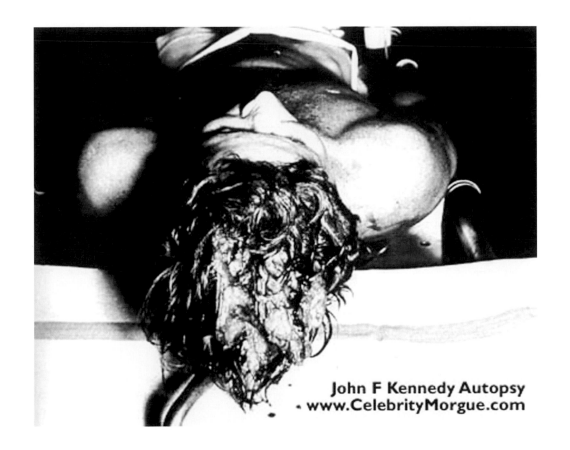

John F Kennedy Autopsy
www.CelebrityMorgue.com

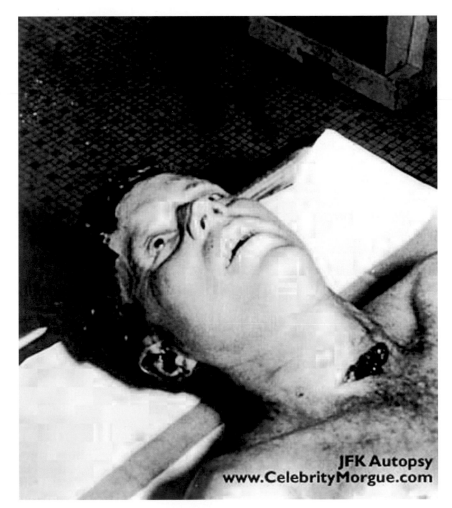

JFK Autopsy
www.CelebrityMorgue.com

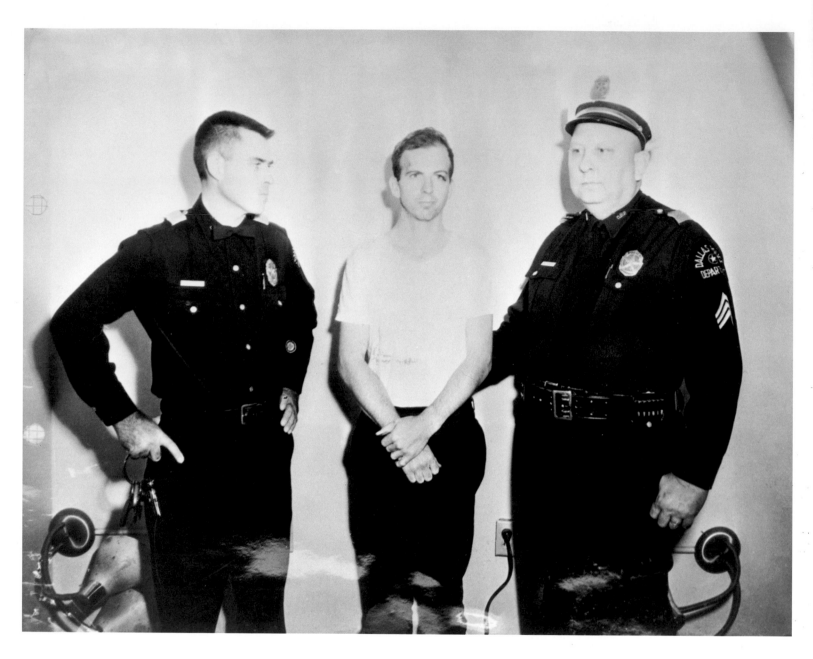

He wrote his own error-laden biographical note: "Lee Harvey Oswald was born in Oct 1939 in New Orleans, L. the son of insuraen Salesman whose early death left a far mean streak of indepence brought on by negleck." His domineering, erratically indulgent mother was always on the move. He was in an orphanage and 12 schools, diagnosed as having a potential for "explosive, aggressive acting out."

The life fulfilled the analysis. At 17, he joined the Marines. He hated being hazed as "Ozzie Rabbit," was court-martialed for fighting and firing a derringer. Obsessed with Marxism, he traveled to the Soviet Union, tried to defect and cut his wrists when he was initially refused.

The KGB reluctantly relocated him to Minsk. He slacked at the factory where he worked, wrote political tracts at night. The KGB tapes of his bugged apartment give a bleak portrait of his disillusion with the workers' paradise and of his marriage to a pharmacology student named Marina

Prusakova. The shock of coming home to the U.S. with his wife and daughter in June 1962 was immense. He was pestered by the FBI. He campaigned for fair play for Castro's Cuba, but could not hold a job and started to beat his wife. He was a nobody in a rage. His solution to reconciling his grandiose self-image with reality was to kill "an enemy of the people." He bought a mail-order rifle for $12.78 and on the night of April 10, 1963, took a shot at right-wing General Edwin Walker sitting in his Dallas home. The bullet just grazed Walker's head. Ozzie Rabbit looked about for another target.

(from *The American Century* by Harold Evans)

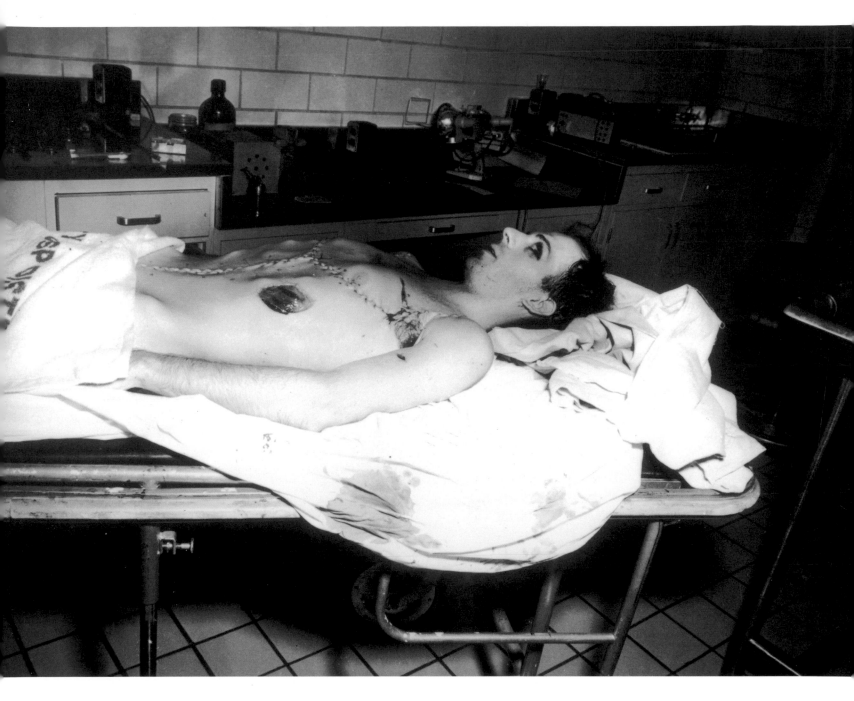

This image of Lee Harvey Oswald's body on the autopsy table, almost never published, is from the Warren Commission Report.

Oswald acted alone in the assassination of John F. Kennedy. In 1993, the investigative journalist and lawyer Gerald Posner exposed and effectively challenged the myths surrounding the case. He dispelled the theory that a shot came from the grassy knoll in front of the president's limousine and explained the fact that Kennedy's head jerked backward as an illustration of the "jet effect"; indeed, the famed Zapruder film showed the president's head moving forward 2.3 inches before it pulled back. Oswald, a Marine sharpshooter, was able to fire three shots in a period calculated by experts as from 8 to 8.4 seconds. There were only three shots. One bullet missed its target. The bullet that wounded Texas governor John Connally went through the president first, penetrated Connally's back, and, with a slight deflection from a rib, struck his wrist. Another bullet entered Kennedy's head and killed him.

Some conspiracy theorists maintain that accomplices helped Oswald get a job at the Texas School Book Depository because it would have provided the opportunity of a perfect line of sight for the Kennedy motorcade. When Oswald started working there in October, however, the route was not yet decided. As Harold Evans writes in *The American Century*, "It is a tantalizing idea that Oswald was a fall guy for the mob, who had him killed by [Jack] Ruby, a minor thug" with ties to the underworld. But, Evans continues, "Ruby could not have been planning to kill Oswald on Sunday [November 24] at 11:21 a.m. Oswald's transfer [from city jail to county jail, after a police interrogation] was due to have taken place an hour earlier. "Ruby was then home and might have stayed, but for a call at 10:19 . . . from one of his strippers, who asked him for $25, which meant he had to go downtown to send it by Western Union." The interrogation ended late; Oswald fussed about what color sweater to wear. Had there been no delays, Ruby would have still been at Western Union. A police guard at the entrance to the city jail basement stepped away momentarily to stop traffic for a police car. Ruby, who always carried a .38 pistol, sauntered into the scene one minute before he yelled, "You killed my president, you rat!" and fired the shot that felled Oswald.

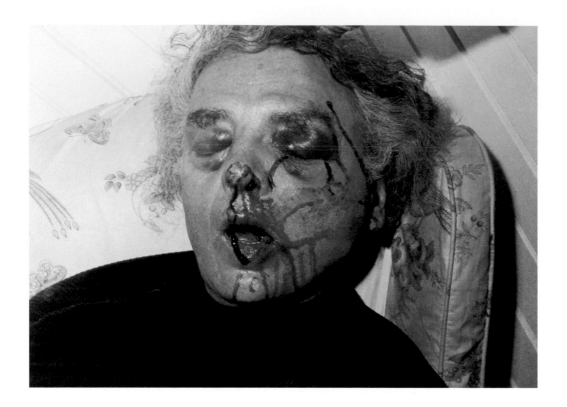

[George] de Mohrenschildt and Oswald seemed a most unlikely pair of friends. Oswald had a ninth-grade education, was humorless and introverted, and, at the age of twenty-two, had a provincial view of the world despite his time in Japan and Russia. . . . It was difficult to get more than a few sentences out of him during a conversation, and he disliked socializing. De Mohrenschildt, an oil geologist, was a handsome six-foot-two-inch, fifty-one-year-old sportsman and adventurer who had been involved in diverse business ventures on five continents. Perennially tanned, he was a womanizer and partygoer [with] numerous university degrees and had the right to call himself a baron since he was born into an aristocratic Russian family. Married four times, friend of the Bouvier family, including the parents of Jacqueline Kennedy, he was loud and boisterous, able to drink heavily without ever showing the effect, and had a wild sense of humor. De Mohrenschildt made a lasting impact on all who met him. Why would the aristocratic baron waste his time in a friendship with Lee Oswald?

Gerald Posner never answers this question he poses in *Case Closed,* but he does confirm that by 1962, Oswald and his Russian wife, Marina, had only two remaining friends—de Mohrenschildt and his wife. According to Posner, "No one in Dallas had political sway over him [Oswald] except de Mohrenschildt, whose opinion he respected." Marina Oswald commented that de Mohrenschildt had "influenced Lee's sick fantasy."

On April 10, 1963, Oswald attempted to assassinate General Edwin Walker, segregationist, outspoken critic of Communism, and John Bircher. He failed. De Mohrenschildt had previously expressed to Oswald his dislike of the John Birch Society and people like Walker. Posner mentions three sources who held that de Mohrenschildt had told Oswald that anyone who "knocked off Walker" would be doing society a favor. De Mohrenschildt and his wife moved from Dallas that April, and when the baron saw Oswald for a final time on April 14, his first words were, "Lee, how is it possible that you missed?"

On March 29, 1977, in Manalapan, Florida, de Mohrenschildt shot himself in the head. Earlier in the day, while he was out, an investigator from the House Select Committee on Assassinations, seeking an interview with him, called at the boardinghouse where he and his daughter were staying. In de Mohrenschildt's pants pocket, police found a recent *Dallas Morning News* article that touched on his possible involvement in, or knowledge of, a conspiracy in the Kennedy assassination.

De Mohrenschildt believed, incorrectly, that he had been with Oswald on the day of the assassination. He was, in fact, at the Bulgarian embassy in Haiti.

Jeanne de Mohrenschildt stated that her husband had been committed to a mental institution in November 1976 after four suicide attempts. He was diagnosed as psychotic.

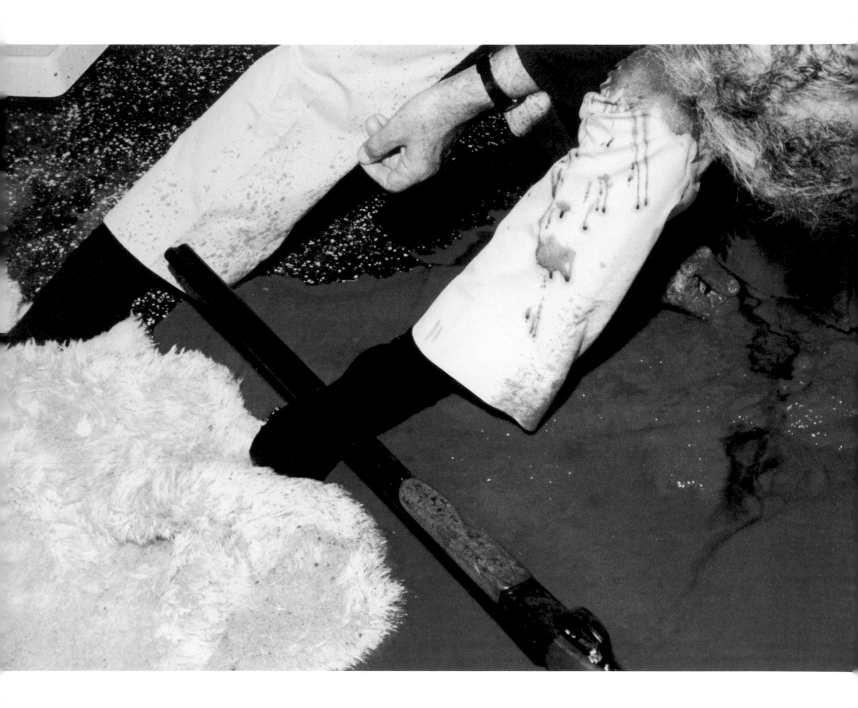

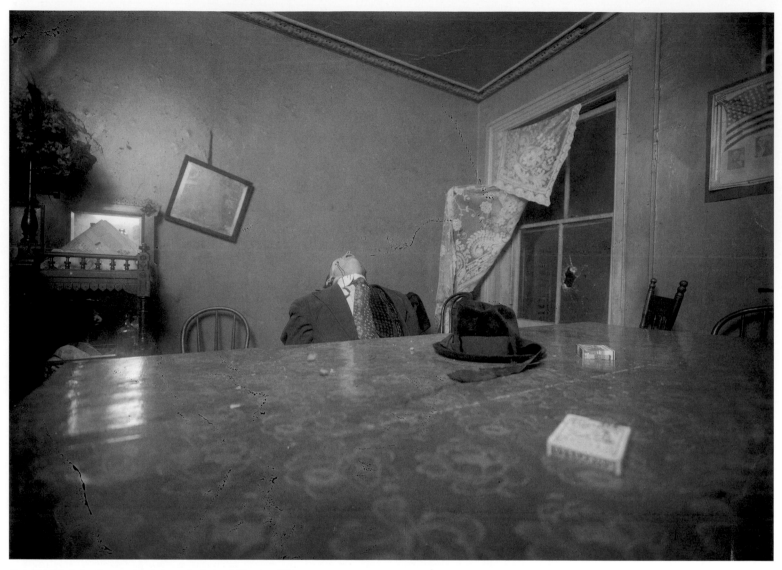

New York City Police Department photograph of a homicide, circa 1915.

Allen, James, Hilton Als, John Lewis, and Leon F. Litwack. *Without Sanctuary: Lynching Photography in America*. Santa Fe, NM: Twin Palms, 2000.

Asbury, Herbert. *The Gangs of New York: An Informal History of the Underworld*. New York: Paragon House, 1990 (orig. pub. 1927).

Barth, Miles. *Weegee's World*. Boston: Bulfinch/Little, Brown, 1997.

Benetton advertising supplement. *Talk*, January 2000.

Benford, Timothy B., and James P. Johnson. *Righteous Carnage: The List Murders*. New York: Charles Scribner's Sons, 1991.

Blumenfeld, Yorick. *Towards the Millennium: Optimistic Visions for Change*. London: Chimera Press, 1997.

Bolton, Richard, ed. *The Contest of Meaning: Critical Histories of Photography*. Cambridge, MA: The MIT Press, 1989.

Buckland, Gail. *First Photographs: People, Places, and Phenomena as Captured for the First Time by the Camera*. New York: Macmillan, 1980.

———. *Fox Talbot and the Invention of Photography*. Boston: David R. Godine, 1980.

Burns, Stanley B. *A Morning's Work: Medical Photographs from the Burns Archive & Collection 1843–1939*. Santa Fe, NM: Twin Palms, 1998.

Byrnes, Thomas. *1886 Professional Criminals of America*. New York: The Lyons Press, 2000 (orig. pub. 1886).

Capote, Truman. *In Cold Blood: A True Account of a Multiple Murder and Its Consequences*. New York: Random House, 1965.

Carlebach, Michael L. *American Photojournalism Comes of Age*. Washington, DC: Smithsonian Institution Press, 1997.

Catton, Bruce. *Picture History of the Civil War*. New York: Wings Books, 1988 (orig. pub. 1960).

Cobb, Josephine. "Alexander Gardner." *Image,* June 1958.

Coleman, A. D. *The Grotesque in Photography*. New York: Summit Books, 1977.

"Dark Days: Mystery, Murder, Mayhem." *Aperture,* 149 (Fall 1997).

Douglas, John, and Mark Olshaker. *The Cases That Haunt Us: From Jack the Ripper to JonBenet Ramsey, the FBI's Legendary Mindhunter Sheds Light on the Mysteries That Won't Go Away*. New York: Scribner, 2000.

Dunn, Katherine. *Death Scenes: A Homicide Detective's Scrapbook*. Los Angeles: Feral House, 1996.

Dwyer, Jim, Peter Neufeld, and Barry Scheck. *Actual Innocence: Five Days to Execution and Other Dispatches from the Wrongly Convicted*. New York: Doubleday, 2000.

Erony, Susan, and Nicole Hahn Rafter. *Searching the Criminal Body: Art/Science/Prejudice*. Albany: State University of New York Press, 2000.

Faber, John. *Great News Photos and the Stories Behind Them*. New York: Dover, 1978.

Garrels, Gary, et al. *Public Information: Desire, Disaster, Document*. San Francisco: San Francisco Museum of Modern Art, and New York: Distributed Art, 1994.

Gibson, John Michael, and Richard Lancelyn Green, comps. *The Unknown Conan Doyle: Essays on Photography*. London: Secker & Warburg, 1982.

Gilligan, James, *Violence: Our Deadly Epidemic and Its Causes*. New York: G. P. Putnam's Sons, 1996.

Goldberg, Michelle. "Vanity Kills: Novel Perspectives on the True Crimes of Andrew Cunanan." *Speak,* Summer 1999.

Hannigan, William. *New York Noir: Crime Photos from the Daily News Archive*. New York: Rizzoli, 1999.

Hynd, Alan. *Murder Mayhem and Mystery: An Album of American Crime*. New York: A. S. Barnes, 1958.

Infamous Murders. London: Verdict Press, 1975.

Jeffrey, Ian. *Revisions: An Alternative History of Photography*. Washington, DC: National Museum of Photography, Film & Television, 1999.

Katz, D. Mark. *Witness to an Era: The Life and Photographs of Alexander Gardner*. New York: Viking, 1991.

Keaton, Diane, ed. *Local News: Tabloid Photos from the Los Angeles Herald Express, 1936–61*. New York: Lookout, 1999.

Kelly, Jack. "How America Met the Mob." *American Heritage,* July/August 2000.

Kent, David. *Forty Whacks: New Evidence in the Life and Legend of Lizzie Borden*. Emmaus, PA: Yankee Books, 1992.

Knappman, Edward W., ed. *Great American Trials: From Salem Witchcraft to Rodney King*. Detroit: Visible Ink Press, 1994.

Kunhardt, Philip B., Jr., Philip B. Kunhardt III, and Peter W. Kunhardt. *Lincoln: An Illustrated Biography*. New York: Alfred A. Knopf, 1992.

Lalvani, Suren. *Photography, Vision, and the Production of Modern Bodies*. Albany: State University of New York Press, 1996.

Lane, Brian, and Wilfred Gregg. *The Encyclopedia of Serial Killers*. New York: Berkley Books, 1988.

Lattimer, John K. *Kennedy and Lincoln: Medical and Ballistic Comparisons of Their Assassinations*. New York: Harcourt Brace Jovanovich, 1980.

Lee, Henry, and Jerry LaBriola. *Famous Crimes Revisited: From Sacco–Vanzetti to O. J. Simpson*. Southington, CT: Strong Books, 2001.

Lesser, Wendy. *Pictures at an Execution*. Cambridge, MA: Harvard University Press, 1993.

Lesy, Michael. *Wisconsin Death Trip*. New York: Pantheon, 1973.

Lyon, Danny. *Conversations with the Dead: Photographs of Prison Life with the Letters and Drawings of Billy McCune #122054*. New York: Holt, Rinehart & Winston, 1971.

Mailer, Norman. *The Executioner's Song*. New York: Warner Books, 1979.

Miller, Larry S. *Police Photography*, 4th ed. Cincinnati: Anderson, 1998.

Norfleet, Barbara P. *Looking at Death*. Boston: David R. Godine, 1993.

Nuttall, A. D. *Why Does Tragedy Give Pleasure?* Oxford, England: Clarendon Press, 1996.

Owen, David. *Hidden Evidence: 40 True Crimes and How Forensic Science Helped Solve Them*. Willowdale, ON: Firefly Books, 2000.

Panzer, Mary. *Mathew Brady and the Image of History*. Washington, DC: Smithsonian Institution Press, 1997.

Parry, Eugenia. *Crime Album Stories: Paris 1886–1902*. New York: Scalo, 2000.

Peterson, Virgil W. *The Mob: 200 Years of Organized Crime in New York*. Ottawa, IL: Green Hill, 1983.

Phillips, Sandra S., Mark Haworth-Booth, and Carol Squiers. *Police Pictures: The Photograph as Evidence*. San Francisco: San Francisco Museum of Art and Chronicle Books, 1997.

Posner, Gerald. *Case Closed: Lee Harvey Oswald and the Assassination of JFK*. New York: Random House, 1993.

Rhodes, Henry T. F. *Alphonse Bertillon: Father of Scientific Detection*. New York: Abelard-Schuman, 1956.

Sann, Paul. *The Lawless Decade*. New York: Crown, 1967.

Sante, Luc. *Evidence*. New York: Farrar, Straus & Giroux, 1992.

Schechter, Harold, and David Everitt. *The A–Z Encyclopedia of Serial Killers*. New York: Pocket Books, 1997.

Scott, Gini Graham. *Homicide: 100 Years of Murder in America*. Los Angeles: Roxbury Park, 1998.

Simon, Brett. "Silent History: The Photographic Archives of Dr. Burns." *Speak,* Summer 1999.

Sobieszek, Robert A. *Ghost in the Shell: Photography and the Human Soul, 1850–2000*. Los Angeles: Los Angeles County Museum of Art, and Cambridge, MA: The MIT Press, 1999.

Staggs, Steven. *Crime Scene and Evidence Photographer's Guide*. Temecula, CA: Staggs, 1997.

Stettner, Louis. *Weegee*. New York: Alfred A. Knopf, 1977.

Sultan, Larry, and Mike Mandel. *Evidence*. Greenbrae, CA: Clatworthy Colorvues, 1977.

Svenson, Arne. *Prisoners*. New York: Blast Books, 1997.

Szarkowski, John, ed. *From the Picture Press*. New York: The Museum of Modern Art, 1973.

Talbot, William Henry Fox. *The Pencil of Nature*. New York: Da Capo Press, 1969 (orig. pub. 1844–1846).

Thomas, Ronald R. *Detective Fiction and the Rise of Forensic Science*. Cambridge, England: Cambridge University Press, 1999.

Time/CBS News. *People of the Century: One Hundred Men and Women Who Shaped the Last One Hundred Years*. New York: Simon & Schuster, 1999.

Turkus, Burton B., and Sid Feder. *Murder, Inc.: The Story of the Syndicate*. New York: Da Capo Press, 1992.

Watson, John H. *The Quotable Sherlock Holmes*. New York: Mysterious Press, 2000.

Weegee. *Naked City*. New York: Da Capo Press, 1975 (orig. pub. 1945).

Welling, William. *Photography in America: The Formative Years 1839–1900*. New York: Thomas Y. Crowell, 1978.

Wideman, John Edgar. *Brothers and Keepers*. New York: Holt, Rinehart & Winston, 1984.

X Marks the Spot: Chicago Gang Wars in Pictures. Chicago: Spot, 1930.

Among the many websites consulted:
http://crimemagazine.com
http://crimelibrary.com

Page 2. Municipal Archives, New York City

Pages 4–5. Stanley B. Burns, M.D., and The Burns Archive

Page 10. Winter Works on Paper

Page 12. New York *Daily News*

Page 13 (left). Federal Bureau of Investigation, U.S. Department of Justice. National Archives and Records Administration

Page 13 (right). Bill Meurer, New York *Daily News*

Page 16. Tom Howard. New York *Daily News*

Page 17 (top left). Brown Brothers

Page 17 (right). New York *Daily News*

Page 17 (bottom left). Both Bettmann/CORBIS

Page 18. Bettmann/CORBIS

Page 20 (top left). *Time* cover, June 27, 1994. © Time Inc.

Page 20 (top right). *Newsweek* cover, June 27, 1994. © Newsweek Inc.

Page 20 (bottom). National Archives and Records Administration

Page 21. All Stanley B. Burns, M.D., and The Burns Archive

Page 22. AP/Wide World Photos

Page 24. All George Seminara

Page 26. Municipal Archives, New York City

Page 27. Belgian Ministry of Justice, Service for Judicial Identification

Page 30. Roger-Viollet, Paris

Page 31. Stanley B. Burns, M.D., and The Burns Archive

Page 33. All Musée National des Techniques du C.N.A.M. (Arts et Métiers), Paris

Page 34. Both Collection Richard T. Rosenthal

Page 35. All Collection Arne Svenson

Page 36. Brown Brothers

Page 37. Courtesy Larry Miller, Ph.D., Department of Criminal Justice and Criminology, East Tennessee State University

Page 39. Winter Works on Paper

Page 40. Charles H. Porter IV. CORBIS/SYGMA

Page 43. Weegee. ICP/LIASON

Pages 44–47. Municipal Archives, New York City

Page 48. Weegee. ICP/LIASON

Page 49. Jack Clarity, New York *Daily News*

Page 50. Bettmann/CORBIS

Page 51. Stanley B. Burns, M.D., and The Burns Archive

Page 52. Both Bettmann/CORBIS

Page 53. Bettmann/CORBIS

Page 54. Stanley B. Burns, M.D., and The Burns Archive

Page 55 (top). Both MurderInc.htm

Page 55 (bottom). CelebrityMorgue.com

Pages 56, 57. Donna Ferrato. Courtesy Domestic Abuse Awareness Inc.

Page 58. Jefferson County, Colorado, Sheriff's Department. AP/Wide World Photos

Page 59. Bettmann/CORBIS

Page 60 (top). Alex Tehrani

Page 60 (bottom). Gregg Smith. CORBIS/SABA

Page 61. Mark Peterson. CORBIS/SABA

Pages 62, 63. Andrew Savulich

Pages 64, 65. Stephen Shames. MATRIX

Page 66. New York *Daily News*

Page 68. Chicago Historical Society

Page 69. UPI Photo. Bettmann/CORBIS

Page 70. Both Samuel A. Marrs. Chicago Historical Society

Page 71. Chicago *Daily News*. Chicago Historical Society

Page 72. Both Bettmann/CORBIS

Page 73. Andrew Savulich

Page 74. Samuel A. Marrs. Chicago Historical Society

Page 75. *Los Angeles Times* Syndicate

Page 76. New York *Daily News*

Page 77. Fred Morgan, New York *Daily News*

Page 78. Bettmann/CORBIS

Page 79. Danuta Ofinowski. MATRIX

Pages 80, 81. UPI Photo. Bettmann/CORBIS

Page 82 (left). Des Plaines, Illinois, Police Department. Chicago Historical Society

Page 82 (right). AP/Wide World Photos

Page 83 (left) JuriLink International Corporation. AP/Wide World Photos

Page 83 (right). CelebrityMorgue.com

Page 84 (left). Bettmann/CORBIS

Page 84 (right). Carol Jacobsen, from the documentary *From One Prison* (1994)

Page 85 (top). Jane Evelyn Atwood/Contact Press Images

Page 85 (bottom). Maude Schuyler Clay

Page 86. All Stanley B. Burns, M.D., and The Burns Archive

Pages 90, 91. UPI Photo. Bettmann/CORBIS

Page 92. Winter Works on Paper

Page 93 (left). Acme. Bettmann/CORBIS

Page 93 (right). AP/Wide World Photos

Pages 94, 95. Chicago Historical Society

Page 96. UPI Photo. Bettmann/CORBIS

Page 97 (left). Phil Greitzer, New York *Daily News*

Page 97 (right). Bob Costello, New York *Daily News*

Page 98. All property Westfield, New Jersey, Police Department

Page 99. All Detective Sergeant Robert Kenney (retired), Westfield, New Jersey, Police Department

Pages 100, 101. AP/Wide World Photos

Page 102. Reuters/Sam Mircovich/Archive Photos

Page 103. Both Los Angeles Police Department. AP/Wide World Photos

Page 104. Chicago Historical Society

Pages 106–107, 108. Stanley B. Burns, M.D., and The Burns Archive

Page 109. Collection Arne Svenson

Page 110, 111. Stanley B. Burns, M.D., and The Burns Archive

Page 112. William ven der Weyde. George Eastman House

Page 113 (top). Tom Howard, New York *Daily News*

Page 113 (bottom). Orange County, Florida, Department of Corrections. MurderInc.htm

Page 114. Stanley B. Burns, M.D., and The Burns Archive

Page 115. Danny Lyon. Magnum Photos

Page 116. Carol Jacobsen

Page 117. Andrew Lichtenstein/Aurora

Page 118. Chicago Police Department. Chicago Historical Society

Page 120 (top). Collection Dancing Bear

Page 120 (bottom). Winter Works on Paper

Page 121. Brown Brothers

Pages 122, 123. Chicago Historical Society

Page 124. New York *Daily News*

Page 125. Chicago Historical Society

Page 126. Archive Photos

Page 127. Both Bettmann/CORBIS

Page 128. Both Acme. Bettmann/CORBIS

Page 129. New York *Daily News*

Page 130. Hy Summers, New York *Daily News*

Page 131 (top). Municipal Archives, New York City

Page 131 (bottom). Thomas Monaster, New York *Daily News*

Page 132 (left). Archive Photos

Page 132 (right). John Dunn. AP/Wide World Photos

Page 133. Frank Castoral, New York *Daily News*

Page 134. Alexander Gardner. George Eastman House

Page 136 (left). Stanley B. Burns, M.D., and The Burns Archive

Page 136 (right). George Eastman House

Page 137 (top left, and right). Alexander Gardner. Library of Congress

Page 137 (bottom left). Alexander Gardner. George Eastman House

Page 138. Alexander Gardner. Library of Congress

Page 139 (left). Alexander Gardner. Library of Congress

Page 139 (right). Alexander Gardner. George Eastman House

Page 140 (left). Alexander Gardner. George Eastman House

Page 140 (right). Alexander Gardner. Library of Congress

Page 141. Both Alexander Gardner. George Eastman House

Pages 142, 143. Alexander Gardner and/or Timothy O'Sullivan. George Eastman House

Pages 144–145. Smithsonian Institution, National Museum of American History

Pages 146–147. All Federal Bureau of Investigation, U.S. Department of Justice. National Archives and Records Administration

Pages 148–149. House Select Committee on Assassinations, photo 003294. National Archives and Records Administration

Page 151. Both John Stringer. CelebrityMorgue.com

Page 152. Dallas Police Department. Warren Commission, exhibit 520. National Archives and Records Administration

Page 153. Central Intelligence Agency, Oswald 201 file. National Archives and Records Administration

Pages 154, 155. Palm Beach County, Florida, Sheriff's Department. House Select Commmittee on Assassinations. National Archives and Records Administration

Page 156. Municipal Archives, New York City

Abu Jamal, Mumia, 88
Admissibility of photographs as evidence, 15, 34, 37–38
Agron, Salvador, 88, 97
Alcatraz, 118
Alfred P. Murrah Federal Building (Oklahoma City), 40
America's Most Wanted, 98
Amnesty International, 116, 117
Anastasia, Albert, 124, 130
Anthropometry, 31. *See also* Bertillon system; Bertillonage
Arnold, Samuel, 135, 140
Atkins, Susan, 78
Atwood, Jane Evelyn, 85
Atzerodt, George, 135, 136, 138, 139, 142, 143
Autopsy photographs, 17, 120, 150, 151, 153
Averbuch, Lazarus, 71
Averbuch, Olga, 71

Benetton, 19
Berkowitz, David, 21, 100–101
Bertillon, Alphonse, 20, 30–34
Bertillon, Louis-Adolphe, 30, 31
Bertillon system, 20, 21, 30–31, 34, 37, 38
Bertillonage, 31, 38. *See also* Bertillon system
Bethea, Rainey, 106–107
Bilotti, Thomas, 131
Biometric surveillance, 23, 25
Bonanno family, 133
Booth, John Wilkes, 135, 136, 140, 141
Borden, Lizzie, 33, 87–88
Borden murders and trial, 86–88
Boston *Daily Herald*, 87
Buchalter, Louis "Lepke," 119, 124
Bundy, Theodore, 19, 34, 67, 83, 100
Bush, George W., 79
Byrnes, Thomas, 28–29

Calley, William, 98, 100
Capeman, The (Simon), 97
Capital punishment, 81, 91, 112. *See also* Execution; Punishment
Capone, Al, 118, 119, 120, 122, 125, 130
Capote, Truman, 67, 80, 88
Case Closed (Posner), 150, 154
Castellano, Paul, 131
Castoral, Frank, 133
Castro, Fidel, 149, 152
Celestino, João, 139
Center on Juvenile and Criminal Justice (Washington, D.C.), 105
Cermak, Anton, 122
Chicago *Daily News*, 71, 74
Chicago *Tribune*, 94
Clarity, Jack, 49
Clay, Maude Schuyler, 85
Clementi, Louis, 125
Clinton, William Jefferson, 22
Clutter family, 80
Cochran, Johnnie, 102
Cohen, Mickey, 75
Collier's, 121
Composite photographs, 27
Connally, John, 153
Coppolla, Leonardo, 133
Corbett, Boston, 136
Costello, Bob, 97
Costello, Frank, 13, 119, 127, 129

Crane, Cheryl, 75
Crime scenes, procedures for photographing, 33–34, 36–38, 45
Cunanan, Andrew Philip, 83
Cvek, George, 12

Daguerre, Louis-Jacques-Mandé, 27
Daguerreotypes, 27
Dahmer, Jeffrey, 12, 67, 82
Danto, Arthur, 112
Darden, Christopher, 102
Darrow, Clarence, 90, 91
Davis, Allen Lee, 15, 113
de Mohrenschildt, George, 154, 155
Death row, 16, 19, 85, 97. *See also* Execution; Punishment
Dewey, Thomas, 16–17, 126, 128
Digital photography, 34, 37–38
Digitizing of images, 19–20, 83
Dillinger, John, 17, 119, 120, 121
DNA analysis, 21, 31, 38, 62
Domestic violence, 55, 56, 57, 64, 72, 73, 74. *See also* Violence against women
Doss, Nannie, 67, 84
Doyle, Arthur Conan, 27
Drake, Janice, 130
Drenth, Herman ("Butcher of Clarksburg"), 67, 76
Drug crime, 60, 65, 70, 105, 128, 132
Drug Enforcement Agency, 60
Dull, Judy, 11, 52
Dunn, John, 132

East Side rapist (Manhattan), 62
Electric chair, 15, 104, 112, 113
Electrocution. *See* Electric chair
Evidence photography, 13–15, 28
 admissibility, 15, 34, 37–38
Execution, 15, 66, 81, 104, 106–107, 108, 109, 110–111, 112, 113, 142–143. *See also* Electric chair; Lynching
Executioner's Song, The (Mailer), 81
Exner, Judith Campbell, 129

Face recognition technology, 23, 25
FaceTrac, 25
Favara, John, 132
FBI, 17, 19, 94, 98, 149, 152
Fellig, Arthur. *See* Weegee
Ferrato, Donna, 42, 56, 57
Fingerprinting, 21, 27, 30–31, 34, 38
 camera, 34
Florida Supreme Court, 113
Folger, Abigail, 78
Fonda, Jane, 24
Ford's Theatre (Washington, D.C.), 135, 140
Frykowski, Voytek, 78
Fuhrman, Mark, 103

Gacy, John Wayne, 67, 82, 100
Galante, Carmine, 21, 133
Gall, Franz Josef, 27
Gallagher, Basil, 121
Galton, Francis, 27
Gambino family, 131, 132
Gangsters, 13, 118–133
Gardner, Alexander, 134–143
Gates, Bill, 24
Giancana, Sam, 129
Gilligan, James, 41, 67, 105

Gilmore, Gary, 81
Glatman, Harvey, 11, 42, 52
Globe, The, 150
Goldman, Ronald, 12, 102
Gotti, John, 13, 119, 131, 132
Gravano, Sammy, 13, 132
Gray, Henry Judd, 15, 16
Greitzer, Phil, 97
Groden, Robert, 150
Guzik, Jake, 118

Harper's Weekly, 137
Harris, Eric, 58
Hauptmann, Anna, 18, 92
Hauptmann, Bruno, 18, 92, 93
Hawthorne, Nathaniel, 27
Hearst, Patricia, 22, 100
Heirens, William, 88, 94, 95
Henry, Annie Beatrice, 66
Hernandez, Antonio Luis, 97
Herold, David, 135, 136, 141, 142, 143
Hickock, Richard, 67, 80, 88
Hidden camera. *See* Video surveillance
Holliday, George, 23
Hoover, J. Edgar, 17, 19
House Select Committee on Assassinations, 149, 150, 154
Howard, Tom, 16, 113
Huberty, James Oliver, 59

In Cold Blood (Capote), 80
Internet, 15, 55, 113, 150, 151
Ito, Lance, 12

Jacobsen, Carol, 84, 116
Johnson, Andrew, 135, 138
Johnson, Lyndon, 149
Johnson, Sidney, 104
Joliet (Illinois) prison, 91, 114
JuriLink, 83

Kasabian, Linda, 78
Kelly, George "Machine Gun," 121
Kemmler, William, 112
Kennedy, John F., 17, 23, 129, 149, 150, 151, 153
Kennedy, Joseph P., 129
Kennedy, Robert, 17–18, 129, 150
King, Larry, 24
King, Rodney, 23
Kinkel, Kip, 58
Klebold, Dylan, 58
Kosner, Edward, 15
Krenwinkel, Patricia, 78

LaBianca, Leno and Rosemary, 78
La Guardia, Fiorello, 128
Lansky, Meyer, 128
Lavater, Johann Caspar, 27
Leavenworth, 20, 121
Lemercier, 27
Leopold, Nathan, Jr., 88, 90, 91
Lewis, Anthony, 105, 117
Lichtenstein, Andrew, 117
Lincoln, Abraham, 19, 21, 135
 assassination conspirators, 134–145
Lindbergh, Anne Morrow, 92
Lindbergh, Charles, Sr., 92
Lindbergh, Charles, Jr., 18, 92, 93
List, John, 88-89, 98, 100

Locascio, Frank, 132
Loeb, Richard, 88, 90, 91
Lucas, Henry Lee, 79
Luciano, Charles "Lucky," 16–17, 119, 128
Lynching, 18, 21, 108, 109
Lyon, Danny, 115

McGuire sisters, 129
McVeigh, Timothy, 15, 40
"Mad Torso Murderer" (Cleveland), 53
Mafia, 21, 23, 128, 131, 132, 133, 149
Mailer, Norman, 67, 81
Malcolm X, 24
Mangano, Phillip, 125
Manhattan District Attorney's Office, 14, 23
Manson, Charles, 55, 67, 78, 100
Manson "family," 55, 78, 100
Maricopa County (Arizona) prison, 117
Media, 12, 15-18, 19, 87, 88, 92. See also
 Press (access); Press photography;
 Tabloid journalism
Metropolitan Police (London), 23
Meurer, Bill, 13
Miranda rights, 80, 94
Mircovich, Sam, 102
M'Naghten test, 80
Monaster, Thomas, 131
Monroe, Marilyn, 129
Montauk, 136
Mooney, Tom, 15
Moreno, Tony (Dominick Russo), 120
Morgan, Fred, 77
Morgenthau, Robert, 14
Morrow, Rena, 70, 74
Mug shot, 10, 19, 20, 23–26, 30, 32, 35, 38, 39,
 82, 90, 114, 118, 124, 126
Murder, Inc., 13, 17, 131
Musso, Antonia, 74

Napolitano, Carmine, 131
National Archives, 150
Nelson, George "Baby Face," 119, 121
Ness, Eliot, 53, 118, 125
New York American, 92
New York Daily News, 15–16, 88
New York Journal, 92
New York Post, 21, 121
New York Times, The, 38, 54, 87, 105, 112, 115,
 117
New York Tribune, 136
Newsweek, 20
Nitti, Frank, 119, 122, 123

Ofinowski, Danuta, 77
Oklahoma City bombing, 15, 40
O'Laughlin, Michael, 135, 141
Old Arsenal Prison (Washington, D.C.), 142,
 143
"Old Sparky," 113
O'Sullivan, Timothy, 136, 142, 143
Oswald, Lee Harvey, 17, 21, 146–147, 149, 152,
 153, 154
 conspiracy theories, 149, 153, 154
Oswald, Marina, 152, 154

Palmer, A. Mitchell, 19
Parent, Stephen, 78
Parker, Ethel, 70
Payne, Lewis, 19, 134, 135, 136, 137, 142, 143
Pencil of Nature, The (Talbot), 28

Peterson, Mark, 42, 61
Photogrammetry, 37
Photography in prison, 114
Photojournalism, 11, 41
Phrenology, 27–28, 33
Physiognomy, 26, 27–28, 33
Pinkerton, Allan, 28
Pisano, Augie, 130
Poe, Edgar Allan, 27
Polanski, Roman, 55, 78
Police photography, 41, 42, 45, 88–89. See
 also Crime scenes; Evidence photogra-
 phy; Mug shots
Porter, Charles H., IV, 40
Posner, Gerald, 150, 153, 154
Press (access), 12, 15–18, 101, 119, 121. See
 also Media; Tabloid journalism
Press photography, 15, 19, 41, 94, 97, 119
PrimeTime Live, 94
Prisons, 105, 114, 115, 116, 117
 statistics, U.S., 105
Privacy, 16, 23, 25, 38, 101
Professional Criminals of America (Byrnes),
 28–29
Prohibition, 122, 126, 128, 129
Prostitution, 61, 128
Punishment, 104–117. See also Electric chair;
 Execution; Prisons

Raft, George, 128
Recidivism, 115
Reles, Abe "Kid Twist," 124
Restraining chair, 117
Retinal image, 29
Rhodes, Henry. F. T., 30, 31, 32
Richter, Hartman, 136, 139
Rockefeller, Nelson, 97
Roosevelt, Eleanor, 97
Ruby, Jack, 21, 153

St. Valentine's Day massacre, 21, 119, 125
Sante, Luc, 17, 21
Sarno, Dick, 92
Savulich, Andrew, 42, 62, 63, 73
Schlesinger, Arthur, Jr., 28, 119
Schmidt, Hans, 67, 69
School violence, 58
Schulman, Sammy, 92
Schultz, Dutch, 13, 16–17, 119, 126
Scotland Yard, 21
Sebring, Jay, 78
Sensationalism, 87–89
Serial killers, 12, 82, 83, 100–101
Seward, William, 135, 136
Shames, Stephen, 42, 64, 65
Sherman, Cindy, 42
Shippy, George M., 71
Siegel, Benjamin "Bugsy," 119, 127, 128
Simon, Paul, 97
Simpson, Nicole Brown, 12, 87, 102, 103
Simpson, O. J., 12, 13–14, 20, 88, 102
Simpson case, 13–14, 87–88, 102, 103, 150
Sinatra, Frank, 24, 128
Sing Sing, 12, 16, 97, 113
Sirhan, Sirhan, 17, 18
Smith, Clara Sheldon, 35
Smith, Gregg, 60
Smith, Perry, 67, 80, 88
Snyder, Ruth, 15–16, 113
Son of Sam. See Berkowitz, David

Son of Sam law, 101
Spangler, Edman, 135, 140
Spuyten Duyvil (Manhattan), 50
Stettner, Louis, 18
Stevenson, Adlai, 91
Stompanato, Johnny, 75
Stringer, John, 150, 151
Summers, Hy, 130
Sunday Times, The (London), 17
Super Bowl (2001), 25
Surratt, John, 135, 136
Surratt, Mary, 135–136, 142, 143
Surveillance cameras, 22–23, 38
Symbionese Liberation Army, 22

Tabloid journalism, 13, 15–16, 18, 88, 92, 119,
 121, 150. See also Media; Press (access);
 Press photography
Talbot, William Henry Fox, 28, 29
Talk, 19
Tate, Sharon, 42, 55, 78
Tehrani, Alex, 42, 60
Texas Department of Corrections, 115
Texas School Book Depository (Dallas), 153
Thomas, Juanita, 67, 84
Time, 20, 22
Toscani, Oliviero, 19
Turkus, Burton, 124, 126, 127, 131
Turner, Lana, 75

Unabomber, 100
United Nations Standard Minimum Rules for
 the Treatment of Prisoners, 116
Untouchables, The, 122

Van Houten, Leslie, 78
Van Meter, Homer, 121
ven der Weyde, Willem, 112
Versace, Gianni, 83
Vicious, Sid, 24
Video photography of crime scenes, 37–38
Video surveillance, 22–23, 38
Violence (Gilligan), 41, 67, 105
Violence against women, 11, 50, 51, 52, 54,
 55, 62, 103

Walker, Edwin, 152, 154
Wanted posters, 13, 135
Warren Commission (and Report), 146–147,
 149, 150, 153
Watson, Charles "Tex," 78
Weegee, 13, 18–19, 42, 43, 48
Weiss, "Little Hymie," 119
West, Will, 20–21
West, William, 20–21
Without Sanctuary, 108
Women murderers, 66, 67, 70, 72, 74, 84, 85
World Wide Web. See Internet

X Marks the Spot, 119

Youth crime, 51, 58, 65, 68, 90–91, 94–97, 105

Zapruder, Abraham, 23, 153
Zweibach, Max, 124